"THIS MANIFESTO IS NOT ISSUED IN THE
NAME OF AN ORGANIZATION OR A MOVE-
MENT. I SPEAK ONLY FOR MYSELF. THERE
IS NO ROMANTIC MOVEMENT TODAY. IF
THERE IS TO BE ONE IN THE ART OF THE
FUTURE, THIS BOOK WILL HAVE HELPED
IT TO COME INTO BEING."

In this searching and courageous work, Ayn
Rand cuts through the haze of sentimentality
and vague thinking that surrounds the subject
of art. For the first time a precise definition is
given to art, and a careful analysis made of its
nature. With the uncompromising honesty Ayn
Rand's millions of readers have come to ex-
pect, the author presents a devastating case
against both naturalistic and abstract art—and
explains the force that drives her to write, and
the goals she strives to attain. *The Romantic
Manifesto* takes its place as a keystone book
in the towering intellectual edifice raised by
one of the most remarkable writers and think-
ers of our age.

REDONDO BEACH PUBLIC LIBRARY

D0348592

Other Titles by Ayn Rand
in SIGNET Editions

☐ **ANTHEM** (#Y6594—$1.25)

☐ **ATLAS SHRUGGED** (#E6980—$2.50)

☐ **CAPITALISM: THE UNKNOWN IDEAL**
(#W6050—$1.50)

☐ **FOR THE NEW INTELLECTUAL**
(#W6592—$1.50)

☐ **THE FOUNTAINHEAD** (#E6629—$2.25)

☐ **THE NEW LEFT: THE ANTI-INDUSTRIAL REVOLU-TION** (#Y4770—$1.25)

☐ **NIGHT OF JANUARY 16TH** (#Y7308—$1.25)

☐ **THE VIRTUE OF SELFISHNESS**
(#W6624—$1.50)

☐ **WE THE LIVING** (#J6494—$1.95)

THE NEW AMERICAN LIBRARY, INC.,
P.O. Box 999, Bergenfield, New Jersey 07621

Please send me the SIGNET BOOKS I have checked above.
I am enclosing $_____(check or money order—no
currency or C.O.D.'s). Please include the list price plus 35¢ a
copy to cover handling and mailing costs. (Prices and numbers
are subject to change without notice.)

Name_____

Address_____

City_____State_____Zip Code_____
Allow at least 4 weeks for delivery

AYN RAND

THE ROMANTIC
MANIFESTO

A Philosophy of Literature

Revised Edition

A SIGNET BOOK
NEW AMERICAN LIBRARY
TIMES MIRROR

COPYRIGHT © 1966, 1968, 1969 BY THE OBJECTIVIST, INC.
COPYRIGHT © 1962, 1963, 1965 BY THE OBJECTIVIST
NEWSLETTER, INC.
COPYRIGHT © 1962, BY BANTAM BOOKS, INC.
COPYRIGHT © 1971 BY THE OBJECTIVIST, INC.

*All rights reserved. No part of this book may be reproduced
in any form without written permission from the publisher,
except for brief passages included in a review appearing in a
newspaper or magazine. For information address The World
Publishing Company, 110 East 59 Street, New York,
New York 10022.*

Library of Congress Catalog Card Number: 77-93469

Published by arrangement with
The World Publishing Company. The hardcover edition
was published simultaneously in Canada by
Nelson, Foster & Scott Ltd.

 SIGNET TRADEMARK REG. U.S. PAT. OFF. AND FOREIGN COUNTRIES
REGISTERED TRADEMARK—MARCA REGISTRADA
HECHO EN CHICAGO, U.S.A.

SIGNET, SIGNET CLASSICS, MENTOR, PLUME AND MERIDIAN BOOKS
*are published by The New American Library, Inc.,
1301 Avenue of the Americas, New York, New York 10019*

FIRST PRINTING, JANUARY, 1971
SECOND REVISED EDITION, 1975

5 6 7 8 9 10 11 12

PRINTED IN THE UNITED STATES OF AMERICA

Introduction

THE dictionary definition of "manifesto" is: "a public declaration of intentions, opinions, objectives or motives, as one issued by a government, sovereign, or organization." (*The Random House Dictionary of the English Language,* College Edition, 1968.)

I must state, therefore, that this manifesto is not issued in the name of an organization or a movement. I speak only for myself. There is no Romantic movement today. If there is to be one in the art of the future, this book will have helped it to come into being.

According to my philosophy, one must not express "intentions, opinions, objectives or motives" without stating one's reasons for them—i.e., without identifying their basis in reality. Therefore, the actual manifesto—the declaration of my personal objectives or motives—is at the end of this book, *after* the presentation of the theoretical grounds that entitle me to these particular objectives and motives. The declaration is in Chapter 11, "The Goal of My Writing," and, partly, in Chapter 10, "Introduction to *Ninety-Three.*"

Those who feel that art is outside the province of reason would be well advised to leave this book alone: it is not for them. Those who know that nothing is outside the province of reason will find in this book the base of a rational esthetics. It is the absence of such a base that has made today's obscenely grotesque degradation of art possible.

To quote from Chapter 6: "The destruction of Romanticism in esthetics—like the destruction of individualism in ethics or of capitalism in politics—was made possible by philosophical default. . . . In all three cases, the nature of the fundamental values involved had never been defined explicitly, the issues were fought in terms of non-essentials, and the values were destroyed by men who did not know what they were losing or why."

In regard to Romanticism, I have often thought that I am a bridge from the unidentified past to the future. As a child, I saw a glimpse of the pre-World War I world, the last afterglow of the most radiant *cultural* atmosphere in human history (achieved not by Russian, but by Western culture). So powerful a fire does not die at once: even under the Soviet regime, in my college years, such works as Hugo's *Ruy Blas* and Schiller's *Don Carlos* were included in theatrical repertories, not as historical revivals, but as part of the contemporary esthetic scene. Such was the level of the public's intellectual concerns and standards. If one has glimpsed that kind of art—and wider: the possibility of that kind of culture—one is unable to be satisfied with anything less.

I must emphasize that I am not speaking of concretes, nor of politics, nor of journalistic trivia, but of that period's "sense of life." Its art projected an overwhelming sense of intellectual freedom, of depth, i.e., concern with fundamental problems, of demanding standards, of inexhaustible originality, of unlimited possibilities and, above all, of profound respect for man. The existential atmosphere (which was then being destroyed by Europe's philosophical trends and political systems) still held a benevolence that would be incredi-

ble to the men of today, i.e., a smiling, confident good will of man to man, and of man to life.

It has been said and written by many commentators that the atmosphere of the Western world before World War I is incommunicable to those who have not lived in that period. I used to wonder how men could say it, know it, yet give it up—until I observed more closely the men of my own and the preceding generations. They *had* given it up and, along with it, they had given up everything that makes life worth living: conviction, purpose, values, future. They were drained, embittered hulks whimpering occasionally about the hopelessness of life.

Whatever spiritual treason they had committed, they could not accept the cultural sewer of the present, they could not forget that they had once seen a higher, nobler possibility. Unable or unwilling to grasp what had destroyed it, they kept cursing the world, or kept calling men to return to meaningless dogmas, such as religion and tradition, or kept silent. Unable to stifle their vision or to fight for it, they took the "easy" way out: they renounced valuing. To fight, in this context, means: to think. Today, I wonder at how stubbornly men cling to their vices and how easily they give up whatever they regard as the good.

Renunciation is not one of my premises. If I see that the good is possible to men, yet it vanishes, I do not take "Such is the trend of the world" as a sufficient explanation. I ask such questions as: Why?—What caused it?—What or who determines the trends of the world? (The answer is: philosophy.)

The course of mankind's progress is not a straight, automatic line, but a tortuous struggle, with long detours or relapses into the stagnant night of the irrational. Mankind moves forward by the grace of those human bridges who are able to grasp and transmit, across years or centuries, the achievements men had reached—and to carry them further. Thomas Aquinas is one illustrious example: he was the bridge between Aristotle and the Renaissance, spanning the infamous detour of the Dark and Middle Ages.

Speaking only of the pattern, with no presumptuous

comparison of stature intended, I am a bridge of that kind—between the esthetic achievements of the nineteenth century and the minds that choose to discover them, wherever and whenever such minds might exist.

It is impossible for the young people of today to grasp the reality of man's higher potential and what scale of achievement it had reached in a rational (or semi-rational) culture. But I have seen it. I know that it was real, that it existed, that it is possible. It is that knowledge that I want to hold up to the sight of men—over the brief span of less than a century—before the barbarian curtain descends altogether (if it does) and the last memory of man's greatness vanishes in another Dark Ages.

I made it my task to learn what made Romanticism, the greatest achievement in art history, possible and what destroyed it. I learned—as in other, similar cases involving philosophy—that Romanticism was defeated by its own spokesmen, that even in its own time it had never been properly recognized or identified. It is Romanticism's identity that I want to transmit to the future.

As for the present, I am not willing to surrender the world to the jerky contortions of self-inducedly brainless bodies with empty eye sockets, who perform, in stinking basements, the immemorial rituals of staving off terror, which are a dime a dozen in any jungle—and to the quavering witch doctors who call it "art."

Our day has no art and no future. The future, in the context of progress, is a door open only to those who do not renounce their conceptual faculty; it is not open to mystics, hippies, drug addicts, tribal ritualists—or to anyone who reduces himself to a subanimal, subperceptual, *sensory* level of awareness.

Will we see an esthetic Renaissance in our time? I do not know. What I do know is this: anyone who fights for the future, lives in it today.

All the essays in this book, with one exception, appeared originally in my magazine *The Objectivist*

(formerly *The Objectivist Newsletter*). The date at the end of each essay indicates the specific issue. The exception is "Introduction to *Ninety-Three*," which is a condensed version of the introduction I wrote for a new edition of *Ninety-Three* by Victor Hugo, translated by Lowell Bair, published by Bantam Books, Inc., in 1962.

The Objectivist is a magazine that deals with the application of my philosophy to the problems and issues of today's culture. For further information, those interested may write to *The Objectivist*, 201 East 34th Street, New York, N.Y. 10016.

AYN RAND

New York City
June 1969

Contents

Introduction v

1. The Psycho-Epistemology of Art 15

2. Philosophy and Sense of Life 25

3. Art and Sense of Life 34

4. Art and Cognition 45

5. Basic Principles of Literature 80

6. What Is Romanticism? 99

7. The Esthetic Vacuum of Our Age 123

8. Bootleg Romanticism 129

9. Art and Moral Treason 142

10. Introduction to *Ninety-Three* 153

11. The Goal of My Writing 162

12. The Simplest Thing in the World 173

Index 187

THE ROMANTIC MANIFESTO

A Philosophy of Literature

1. The Psycho-Epistemology of Art

THE position of art in the scale of human knowledge is, perhaps, the most eloquent symptom of the gulf between man's progress in the physical sciences and his stagnation (or, today, his retrogression) in the humanities.

The physical sciences are still ruled by some remnants of a rational epistemology (which is rapidly being destroyed), but the humanities have been virtually abandoned to the primitive epistemology of mysticism. While physics has reached the level where men are able to study subatomic particles and interplanetary space, a phenomenon such as art has remained a dark mystery, with little or nothing known about its nature, its function in human life or the cause of its tremendous psychological power. Yet art is of passionately intense importance and profoundly *personal* concern to most men—and it has existed in every known civilization, accompanying man's steps from the early hours of his prehistorical dawn, earlier than the birth of written language.

While, in other fields of knowledge, men have out-
grown the practice of seeking the guidance of mystic
oracles whose qualification for the job was unintelligi-
bility, in the field of esthetics this practice has remained
in full force and is becoming more crudely obvious
today. Just as savages took the phenomena of nature
for granted, as an irreducible primary not to be ques-
tioned or analyzed, as the exclusive domain of unknow-
able demons—so today's epistemological savages take
art for granted, as an irreducible primary not to be
questioned or analyzed, as the exclusive domain of a
special kind of unknowable demons: their emotions. The
only difference is that the prehistorical savages' error
was innocent.

One of the grimmest monuments to altruism is man's
culturally induced *selflessness*: his willingness to live
with himself as with the unknown, to ignore, evade,
repress the personal (the *non-social*) needs of his soul,
to know least about the things that matter most, and
thus to consign his deepest values to the impotent un-
derground of *subjectivity* and his life to the dreary
wasteland of chronic guilt.

The cognitive neglect of art has persisted precisely
because the function of art is non-social. (This is one
more instance of altruism's inhumanity, of its brutal
indifference to the deepest needs of man—of an actual,
individual man. It is an instance of the inhumanity of
any moral theory that regards moral values as a purely
social matter.) Art belongs to a non-socializable aspect
of reality, which is universal (i.e., applicable to all men)
but non-collective: to the nature of man's consciousness.

One of the distinguishing characteristics of a work of
art (including literature) is that it serves no practical,
material end, but is an end in itself; it serves no pur-
pose other than contemplation—and the pleasure of
that contemplation is so intense, so deeply personal that
a man experiences it as a self-sufficient, self-justifying
primary and, often, resists or resents any suggestion to
analyze it: the suggestion, to him, has the quality of an
attack on his identity, on his deepest, essential self.

No human emotion can be causeless, nor can so
intense an emotion be causeless, irreducible and unre-

lated to the source of emotions (and of values): to the needs of a living entity's survival. Art *does* have a purpose and *does* serve a human need; only it is not a material need, but a need of man's consciousness. Art *is* inextricably tied to man's survival—not to his physical survival, but to that on which his physical survival depends: to the preservation and survival of his consciousness.

The source of art lies in the fact that man's cognitive faculty is *conceptual*—i.e., that man acquires knowledge and guides his actions, not by means of single, isolated percepts, but by means of *abstractions*.

To understand the nature and function of art, one must understand the nature and function of concepts.

A *concept* is a mental integration of two or more units which are isolated by a process of abstraction and united by a specific definition. By organizing his perceptual material into concepts, and his concepts into wider and still wider concepts, man is able to grasp and retain, to identify and integrate an unlimited amount of knowledge, a knowledge extending beyond the immediate concretes of any given, immediate moment.

In any given moment, concepts enable man to hold in the focus of his conscious awareness much more than his purely perceptual capacity would permit. The range of man's perceptual awareness—the number of percepts he can deal with at any one time—is limited. He may be able to visualize four or five units—as, for instance, five trees. He cannot visualize a hundred trees or a distance of ten light-years. It is only his conceptual faculty that makes it possible for him to deal with knowledge of that kind.

Man retains his concepts by means of language. With the exception of proper names, every word we use is a concept that stands for an unlimited number of concretes of a certain kind. A concept is like a mathematical series of *specifically defined units*, going off in both directions, open at both ends and including *all* units of that particular kind. For instance, the concept "man" includes all men who live at present, who have ever lived or will ever live—a number of men so great that

one would not be able to perceive them all visually, let alone to study them or discover anything about them.

Language is a code of visual-auditory symbols that serves the psycho-epistemological function of converting abstractions into concretes or, more precisely, into the psycho-epistemological equivalent of concretes, into a manageable number of specific units.

(Psycho-epistemology is the study of man's cognitive processes from the aspect of the interaction between the conscious mind and the automatic functions of the subconscious.)

Consider the enormous conceptual integration involved in any statement, from the conversation of a child to the discourse of a scientist. Consider the long conceptual chain that starts from simple, ostensive definitions and rises to higher and still higher concepts, forming a hierarchical structure of knowledge so complex that no electronic computer could approach it. It is by means of such chains that man has to acquire and retain his knowledge of reality.

Yet this is the simpler part of his psycho-epistemological task. There is another part which is still more complex.

The other part consists of *applying* his knowledge— i.e., evaluating the facts of reality, choosing his goals and guiding his actions accordingly. To do that, man needs another chain of concepts, derived from and dependent on the first, yet separate and, in a sense, more complex: a chain of *normative* abstractions.

While cognitive abstractions identify the facts of reality, normative abstractions evaluate the facts, thus prescribing a choice of values and a course of action. Cognitive abstractions deal with that which *is*; normative abstractions deal with that which *ought to be* (in the realms open to man's choice).

Ethics, the normative science, is based on two cognitive branches of philosophy: metaphysics and epistemology. To prescribe what man ought to do, one must first know *what* he is and *where* he is—i.e., what is his nature (including his means of cognition) and the nature of the universe in which he acts. (It is irrelevant, in this context, whether the metaphysical base of a

given system of ethics is true or false; if it is false, the error will make the ethics impracticable. What concerns us here is only the dependence of ethics on metaphysics.)

Is the universe intelligible to man, or unintelligible and unknowable? Can man find happiness on earth, or is he doomed to frustration and despair? Does man have the power of *choice,* the power to choose his goals and to achieve them, the power to direct the course of his life—or is he the helpless plaything of forces beyond his control, which determine his fate? Is man, by nature, to be valued as good, or to be despised as evil? These are *metaphysical* questions, but the answers to them determine the kind of *ethics* men will accept and practice; the answers are the link between metaphysics and ethics. And although metaphysics as such is not a normative science, the answers to this category of questions assume, in man's mind, the function of metaphysical value-judgments, since they form the foundation of all of his moral values.

Consciously or subconsciously, explicitly or implicitly, man knows that he needs a comprehensive view of existence to integrate his values, to choose his goals, to plan his future, to maintain the unity and coherence of his life—and that his metaphysical value-judgments are involved in every moment of his life, in his every choice, decision and action.

Metaphysics—the science that deals with the fundamental nature of reality—involves man's widest abstractions. It includes every concrete he has ever perceived, it involves such a vast sum of knowledge and such a long chain of concepts that no man could hold it all in the focus of his immediate conscious awareness. Yet he needs that sum and that awareness to guide him—he needs the power to summon them into full, conscious focus.

That power is given to him by art.

Art is a selective re-creation of reality according to an artist's metaphysical value-judgments.

By a selective re-creation, art isolates and integrates those aspects of reality which represent man's fundamental view of himself and of existence. Out of the

countless number of concretes—of single, disorganized and (seemingly) contradictory attributes, actions and entities—an artist isolates the things which he regards as metaphysically essential and integrates them into a single new concrete that represents an embodied abstraction.

For instance, consider two statues of man: one as a Greek god, the other as a deformed medieval monstrosity. Both are metaphysical estimates of man; both are projections of the artist's view of man's nature; both are concretized representations of the philosophy of their respective cultures.

Art is a concretization of metaphysics. *Art brings man's concepts to the perceptual level of his consciousness and allows him to grasp them directly, as if they were percepts.*

This is the psycho-epistemological function of art and the reason of its importance in man's life (and the crux of the Objectivist esthetics).

Just as language converts abstractions into the psycho-epistemological equivalent of concretes, into a manageable number of specific units—so art converts man's metaphysical abstractions into the equivalent of concretes, into specific entities open to man's direct perception. The claim that "art is a universal language" is not an empty metaphor, it is literally true—in the sense of the psycho-epistemological function performed by art.

Observe that in mankind's history, art began as an adjunct (and, often, a monopoly) of religion. Religion was the primitive form of philosophy: it provided man with a comprehensive view of existence. Observe that the art of those primitive cultures was a concretization of their religion's metaphysical and ethical abstractions.

The best illustration of the psycho-epistemological process involved in art can be given by one aspect of one particular art: by characterization in literature. Human character—with all of its innumerable potentialities, virtues, vices, inconsistencies, contradictions—is so complex that man is his own most bewildering enigma. It is very difficult to isolate and integrate human traits even into purely *cognitive* abstractions and to bear

them all in mind when seeking to understand the men one meets.

Now consider the figure of Sinclair Lewis's Babbitt. He is the concretization of an abstraction that covers an incalculable sum of observations and evaluations of an incalculable number of characteristics possessed by an incalculable number of men of a certain type. Lewis has isolated their essential traits and has integrated them into the concrete form of a single character—and when you say of someone, "He's a Babbitt," your appraisal includes, in a single judgment, the enormous total conveyed by that figure.

When we come to *normative* abstractions—to the task of defining moral principles and projecting what man *ought to be*—the psycho-epistemological process required is still harder. The task demands years of study—and the results are almost impossible to communicate without the assistance of art. An exhaustive philosophical treatise defining moral values, with a long list of virtues to be practiced, will not do it; it will not convey what an ideal man would be like and how he would act: no mind can deal with so immense a sum of abstractions. When I say "deal with" I mean retranslate all the abstractions into the perceptual concretes for which they stand—i.e., reconnect them to reality—and hold it all in the focus of one's conscious awareness. There is no way to integrate such a sum without projecting an actual human figure—an integrated concretization that illuminates the theory and makes it intelligible.

Hence the sterile, uninspiring futility of a great many theoretical discussions of ethics, and the resentment which many people feel toward such discussions: moral principles remain in their minds as floating abstractions, offering them a goal they cannot grasp and demanding that they reshape their souls in its image, thus leaving them with a burden of undefinable moral guilt. *Art is the indispensable medium for the communication of a moral ideal.*

Observe that every religion has a mythology—a dramatized concretization of its moral code embodied in the figures of men who are its ultimate product. (The

fact that some of these figures are more convincing than others depends on the comparative rationality or irrationality of the moral theory they exemplify.)

This does not mean that art is a substitute for philosophical thought: without a conceptual theory of ethics, an artist would not be able successfully to concretize an image of the ideal. But without the assistance of art, ethics remains in the position of theoretical engineering: art is the model-builder.

Many readers of *The Fountainhead* have told me that the character of Howard Roark helped them to make a decision when they faced a moral dilemma. They asked themselves: "What would Roark do in this situation?"—and, faster than their mind could identify the proper application of all the complex principles involved, the image of Roark gave them the answer. They sensed, almost instantly, what he would or would not do—and this helped them to isolate and to identify the reasons, the moral principles that would have guided him. Such is the psycho-epistemological function of a personified (concretized) human ideal.

It is important to stress, however, that even though moral values are inextricably involved in art, they are involved only as a consequence, *not* as a causal determinant: the primary focus of art is metaphysical, not ethical. Art is not the "handmaiden" of morality, its *basic* purpose is not to educate, to reform or to advocate anything. The concretization of a moral ideal is not a textbook on how to become one. The basic purpose of art is *not* to teach, but to *show*—to hold up to man a concretized image of his nature and his place in the universe.

Any metaphysical issue will necessarily have an enormous influence on man's conduct and, therefore, on his ethics; and, since every art work has a theme, it will necessarily convey some conclusion, some "message," to its audience. But that influence and that "message" are only secondary consequences. *Art is not the means to any didactic end.* This is the difference between a work of art and a morality play or a propaganda poster. The greater a work of art, the more profoundly universal its theme. *Art is not the means of*

literal transcription. This is the difference between a work of art and a news story or a photograph.

The place of ethics in any given work of art depends on the metaphysical views of the artist. If, consciously or subconsciously, an artist holds the premise that man possesses the power of volition, it will lead his work to a value orientation (to Romanticism). If he holds the premise that man's fate is determined by forces beyond his control, it will lead his work to an anti-value orientation (to Naturalism). The philosophical and esthetic contradictions of determinism are irrelevant in this context, just as the truth or falsehood of an artist's metaphysical views is irrelevant to the nature of art as such. An art work may project the values man is to seek and hold up to him the concretized vision of the life he is to achieve. Or it may assert that man's efforts are futile and hold up to him the concretized vision of defeat and despair as his ultimate fate. In either case, the esthetic means—the psycho-epistemological processes involved —remain the same.

The existential consequences, of course, will differ. Amidst the incalculable number and complexity of choices that confront a man in his day-by-day existence, with the frequently bewildering torrent of events, with the alternation of successes and failures, of joys that seem too rare and suffering that lasts too long—he is often in danger of losing his perspective and the reality of his own convictions. Remember that abstractions as such do not exist: they are merely man's epistemological method of perceiving that which exists— and that which exists is concrete. To acquire the full, persuasive, irresistible power of reality, man's metaphysical abstractions have to confront him in the form of concretes—i.e., in the form of art.

Consider the difference it would make if—in his need of philosophical guidance or confirmation or inspiration—man turns to the art of Ancient Greece or to the art of the Middle Ages. Reaching his mind and emotions simultaneously, with the combined impact of abstract thought and of immediate reality, one type of art tells him that disasters are transient, that grandeur, beauty, strength, self-confidence are his proper, natural

state. The other tells him that happiness is transient and evil, that he is a distorted, impotent, miserable little sinner, pursued by leering gargoyles, crawling in terror on the brink of an eternal hell.

The consequences of both experiences are obvious—and history is their practical demonstration. It is not art alone that was responsible for the greatness or the horror of those two eras, but art as the voice of philosophy—of the particular philosophy that dominated those cultures.

As to the role of emotions in art and the subconscious mechanism that serves as the integrating factor both in artistic creation and in man's response to art, they involve a psychological phenomenon which we call a *sense of life*. A sense of life is a pre-conceptual equivalent of metaphysics, an emotional, subconsciously integrated appraisal of man and of existence. But this is a different, though corollary, subject (which I discuss in Chapters 2 and 3). The present subject is only the psycho-epistemological role of art.

A question raised at the start of this discussion should now be clear. The reason why art has such a profoundly *personal* significance for men is that art confirms or denies the efficacy of a man's consciousness, according to whether an art work supports or negates his own fundamental view of reality.

Such is the meaning and the power of a medium which, today, is predominantly in the hands of practitioners who boastfully offer, as their credentials, the fact that they do not know what they are doing.

Let us take them at their word: they don't. We do.

(*April 1965*)

2. Philosophy and Sense of Life

Since religion is a primitive form of philosophy—an attempt to offer a comprehensive view of reality—many of its myths are distorted, dramatized allegories based on some element of truth, some actual, if profoundly elusive, aspect of man's existence. One of such allegories, which men find particularly terrifying, is the myth of a supernatural recorder from whom nothing can be hidden, who lists all of a man's deeds—the good and the evil, the noble and the vile—and who confronts a man with that record on judgment day.

That myth is true, not existentially, but psychologically. The merciless recorder is the integrating mechanism of a man's subconscious; the record is his *sense of life.*

A sense of life is a pre-conceptual equivalent of metaphysics, an emotional, subconsciously integrated appraisal of man and of existence. It sets the nature of a man's emotional responses and the essence of his character.

Long before he is old enough to grasp such a con-

cept as metaphysics, man makes choices, forms value-
judgments, experiences emotions and acquires a certain
implicit view of life. Every choice and value-judgment
implies some estimate of himself and of the world
around him—most particularly, of his capacity to deal
with the world. He may draw conscious conclusions,
which may be true or false; or he may remain mentally
passive and merely react to events (i.e., merely feel).
Whatever the case may be, his subconscious mechanism
sums up his psychological activities, integrating his con-
clusions, reactions or evasions into an emotional sum
that establishes a habitual pattern and becomes his
automatic response to the world around him. What
began as a series of single, discreet conclusions (or
evasions) about his own particular problems, becomes a
generalized feeling about existence, an implicit *meta-
physics* with the compelling motivational power of a
constant, basic emotion—an emotion which is part of
all his other emotions and underlies all his experiences.
This is a sense of life.

To the extent to which a man is mentally active, i.e.,
motivated by the desire to know, to *understand*, his
mind works as the programmer of his emotional com-
puter—and his sense of life develops into a bright
counterpart of a rational philosophy. To the extent to
which a man evades, the programming of his emotional
computer is done by chance influences; by random
impressions, associations, imitations, by undigested
snatches of environmental bromides, by cultural osmo-
sis. If evasion or lethargy is a man's predominant meth-
od of mental functioning, the result is a sense of life
dominated by fear—a soul like a shapeless piece of clay
stamped by footprints going in all directions. (In later
years, such a man cries that he has lost his sense of
identity; the fact is that he never acquired it.)

Man, by his nature, cannot refrain from generaliz-
ing; he cannot live moment by moment, without con-
text, without past or future; he cannot eliminate his
integrating capacity, i.e., his *conceptual* capacity, and
confine his consciousness to an animal's perceptual
range. Just as an animal's consciousness cannot be
stretched to deal with abstractions, so man's conscious-

ness cannot be shrunk to deal with nothing but immediate concretes. The enormously powerful integrating mechanism of man's consciousness is there at birth; his only choice is to drive it or to be driven by it. Since an act of volition—a process of thought—is required to use that mechanism for a cognitive purpose, man can evade that effort. But if he evades, chance takes over: the mechanism functions on its own, like a machine without a driver; it goes on integrating, but integrating blindly, incongruously, at random—not as an instrument of cognition, but as an instrument of distortion, delusion and nightmare terror, bent on wrecking its defaulting processor's consciousness.

A sense of life is formed by a process of emotional generalization which may be described as a subconscious counterpart of a process of abstraction, since it is a method of classifying and integrating. But it is a process of *emotional* abstraction: it consists of classifying things *according to the emotions they invoke*—i.e., of tying together, by association or connotation, all those things which have the power to make an individual experience the same (or a similar) emotion. For instance: a new neighborhood, a discovery, adventure, struggle, triumph—or: the folks next door, a memorized recitation, a family picnic, a known routine, comfort. On a more adult level: a heroic man, the skyline of New York, a sunlit landscape, pure colors, ecstatic music—or: a humble man, an old village, a foggy landscape, muddy colors, folk music.

Which particular emotions will be invoked by the things in these examples, as their respective common denominators, depends on which set of things fits an individual's *view of himself*. For a man of self-esteem, the emotion uniting the things in the first part of these examples is admiration, exaltation, a sense of challenge; the emotion uniting the things in the second part is disgust or boredom. For a man who lacks self-esteem, the emotion uniting the things in the first part of these examples is fear, guilt, resentment; the emotion uniting the things in the second part is relief from fear, reassurance, the undemanding safety of passivity.

Even though such emotional abstractions grow into a

metaphysical view of man, their origin lies in an indi-
vidual's view of *himself* and of *his own* existence. The
subverbal, subconscious criterion of selection that forms
his emotional abstractions is: "That which is important
to *me*" or: "The kind of universe which is right for *me*,
in which *I* would feel at home." It is obvious what
immense psychological consequences will follow, de-
pending on whether a man's subconscious metaphysics
is consonant with the facts of reality or contradicts
them.

The key concept, in the formation of a sense of life,
is the term "*important*." It is a concept that belongs to
the realm of values, since it implies an answer to the
question: Important—to whom? Yet its meaning is diff-
erent from that of moral values. "Important" does not
necessarily mean "good." It means "a quality, character
or standing such as to entitle to attention or consider-
ation" (*The American College Dictionary*). What, in a
fundamental sense, is entitled to one's attention or con-
sideration? Reality.

"Important"—in its essential meaning, as distin-
guished from its more limited and superficial uses—is a
metaphysical term. It pertains to that aspect of meta-
physics which serves as a bridge between metaphysics
and ethics: to a fundamental view of man's nature. That
view involves the answers to such questions as whether
the universe is knowable or not, whether man has the
power of choice or not, whether he can achieve his
goals in life or not. The answers to such questions are
"metaphysical value-judgments," since they form the
base of ethics.

It is only those values which he regards or grows to
regard as "important," those which represent his implic-
it view of reality, that remain in a man's subconscious
and form his sense of life.

"It is important to understand things"—"It is impor-
tant to obey my parents"—"It is important to act on
my own"—"It is important to please other people"—
"It is important to fight for what I want"—"It is impor-
tant not to make enemies"—"My life is important"—
"Who am I to stick my neck out?" Man is a being of
self-made soul—and it is of such conclusions that the

stuff of his soul is made. (By "soul" I mean "consciousness.")

The integrated sum of a man's basic values is his sense of life.

A sense of life represents a man's early value-integrations, which remain in a fluid, plastic, easily amendable state, while he gathers knowledge to reach full *conceptual* control and thus to *drive* his inner mechanism. A full conceptual control means a consciously directed process of cognitive integration, which means: a conscious *philosophy* of life.

By the time he reaches adolescence, a man's knowledge is sufficient to deal with broad fundamentals; this is the period when he becomes aware of the need to translate his incoherent sense of life into conscious terms. This is the period when he gropes for such things as the meaning of life, for principles, ideals, values and, desperately, for self-assertion. And—since nothing is done, in our anti-rational culture, to assist a young mind in this crucial transition, and everything possible is done to hamper, cripple, stultify it—the result is the frantic, hysterical irrationality of most adolescents, particularly today. Theirs is the agony of the unborn—of minds going through a process of atrophy at the time set by nature for their growth.

The transition from guidance by a sense of life to guidance by a conscious philosophy takes many forms. For the rare exception, the fully rational child, it is a natural, absorbing, if difficult, process—the process of validating and, if necessary, correcting in conceptual terms what he had merely sensed about the nature of man's existence, thus transforming a wordless feeling into clearly verbalized knowledge, and laying a firm foundation, an intellectual roadbed, for the course of his life. The result is a fully integrated personality, a man whose mind and emotions are in harmony, whose sense of life matches his conscious convictions.

Philosophy does not replace a man's sense of life, which continues to function as the automatically integrated sum of his values. But philosophy sets the criteria of his emotional integrations according to a fully defined and consistent view of reality (if and to the

extent that a philosophy is rational). Instead of deriving, subconsciously, an implicit metaphysics from his value-judgments, he now derives, conceptually, his value-judgments from an explicit metaphysics. His emotions proceed from his *fully convinced* judgments. The mind leads, the emotions follow.

For many men, the process of transition never takes place: they make no attempt to integrate their knowledge, to acquire any conscious convictions, and are left at the mercy of their inarticulate sense of life as their only guide.

For most men, the transition is a tortured and not fully successful process, leading to a fundamental inner conflict—a clash between a man's conscious convictions and his repressed, unidentified (or only partially identified) sense of life. Very often, the transition is incomplete, as in the case of a man whose convictions are not part of a fully integrated philosophy, but are merely a collection of random, disconnected, often contradictory ideas, and, therefore, are unconvincing to his own mind against the power of his subconscious metaphysics. In some cases, a man's sense of life is better (closer to the truth) than the kind of ideas he accepts. In other cases, his sense of life is much worse than the ideas he professes to accept but is unable fully to practice. Ironically enough, it is man's emotions, in such cases, that act as the avengers of his neglected or betrayed intellect.

In order to live, man must act; in order to act, he must make choices; in order to make choices, he must define a code of values; in order to define a code of values, he must know *what* he is and *where* he is—i.e., he must know his own nature (including his means of knowledge) and the nature of the universe in which he acts—i.e., he needs metaphysics, epistemology, ethics, which means: *philosophy*. He cannot escape from this need; his only alternative is whether the philosophy guiding him is to be chosen by his mind or by chance.

If his mind does not provide him with a comprehensive view of existence, his sense of life will. If he succumbs to centuries of concerted assaults on the mind—to traditions offering vicious irrationality or unconscionable nonsense in the guise of philosophy—if

he gives up, in lethargy or in bewilderment, evades fundamental issues and concerns himself only with the concretes of his day-by-day existence, his sense of life takes over: for good or evil (and, usually, for evil), he is left at the mercy of a subconscious philosophy which he does not know, has never checked, has never been aware of accepting.

Then, as his fear, anxiety and uncertainty mount year by year, he finds himself living with a sense of unknown, undefinable doom, as if in expectation of some approaching judgment day. What he does not know is that every day of his life is judgment day—the day of paying for the defaults, the lies, the contradictions, the blank-outs recorded by his subconscious on the scrolls of his sense of life. And on that kind of psychological record, the blank entries are the blackest sins.

A sense of life, once acquired, is not a closed issue. It can be changed and corrected—easily, in youth, while it is still fluid, or by a longer, harder effort in later years. Since it is an emotional sum, it cannot be changed by a direct act of will. It changes automatically, but only after a long process of psychological retraining, when and if a man changes his conscious philosophical premises.

Whether he corrects it or not, whether it is objectively consonant with reality or not, at any stage or state of its specific content, a sense of life always retains a profoundly personal quality; it reflects a man's deepest values; it is experienced by him as a sense of his own identity.

A given person's sense of life is hard to identify conceptually, because it is hard to isolate: it is involved in everything about that person, in his every thought, emotion, action, in his every response, in his every choice and value, in his every spontaneous gesture, in his manner of moving, talking, smiling, in the total of his personality. It is that which makes him a "personality."

Introspectively, one's own sense of life is experienced as an absolute and an irreducible primary—as that which one never questions, because *the thought of*

questioning it never arises. Extrospectively, the sense of life of another person strikes one as an immediate, yet undefinable, impression—on very short acquaintance— an impression which often feels like certainty, yet is exasperatingly elusive, if one attempts to verify it.

This leads many people to regard a sense of life as the province of some sort of special intuition, as a matter perceivable only by some special, non-rational insight. The exact opposite is true: a sense of life is *not* an irreducible primary, but a very complex sum; it can be felt, but it cannot be understood, by an automatic reaction; to be understood, it has to be analyzed, identified and verified conceptually. That automatic impression—of oneself or of others—is only a lead; left untranslated, it can be a very deceptive lead. But if and when that intangible impression is supported by and unites with the conscious judgment of one's mind, the result is the most exultant form of certainty one can ever experience: it is the integration of mind and values.

There are two aspects of man's existence which are the special province and expression of his sense of life: love and art.

I am referring here to romantic love, in the serious meaning of that term—as distinguished from the superficial infatuations of those whose sense of life is devoid of any consistent values, i.e., of any lasting emotions other than fear. Love is a response to values. It is with a person's sense of life that one falls in love—with that essential sum, that fundamental stand or way of facing existence, which is the essence of a personality. One falls in love with the embodiment of the values that formed a person's character, which are reflected in his widest goals or smallest gestures, which create the *style* of his soul—the individual style of a unique, unrepeatable, irreplaceable consciousness. It is one's own sense of life that acts as the selector, and responds to what it recognizes as one's own basic values in the person of another. It is not a matter of professed convictions (though these are not irrelevant); it is a matter of much more profound, conscious *and subconscious* harmony.

Many errors and tragic disillusionments are possible

in this process of emotional recognition, since a sense of life, by itself, is not a reliable cognitive guide. And if there are degrees of evil, then one of the most evil consequences of mysticism—in terms of human suffering—is the belief that love is a matter of "the heart," not the mind, that love is an emotion independent of reason, that love is blind and impervious to the power of philosophy. Love is *the expression of philosophy*—of a subconscious philosophical sum—and, perhaps, no other aspect of human existence needs the *conscious* power of philosophy quite so desperately. When that power is called upon to verify and support an emotional appraisal, when love is a conscious integration of reason and emotion, of mind and values, then—and only then—it is the greatest reward of man's life.

Art is a selective re-creation of reality according to an artist's metaphysical value-judgments. It is the integrator and concretizer of man's metaphysical abstractions. It is the voice of his sense of life. As such, art is subject to the same aura of mystery, the same dangers, the same tragedies—and, occasionally, the same glory—as romantic love.

Of all human products, art is, perhaps, the most *personally* important to man and the least understood—as I shall discuss in the next chapter.

(February 1966)

3. Art and Sense of Life

I F ONE saw, in real life, a beautiful woman wearing an exquisite evening gown, with a cold sore on her lips, the blemish would mean nothing but a minor affliction, and one would ignore it.

But a painting of such a woman would be a corrupt, obscenely vicious attack on man, on beauty, on all values—and one would experience a feeling of immense disgust and indignation at the artist. (There are also those who would feel something like approval and who would belong to the same moral category as the artist.)

The emotional response to that painting would be instantaneous, much faster than the viewer's mind could identify all the reasons involved. The psychological mechanism which produces that response (and which produced the painting) is a man's sense of life.

(A sense of life is a pre-conceptual equivalent of metaphysics, an emotional, subconsciously integrated appraisal of man and of existence.)

It is the artist's sense of life that controls and integrates his work, directing the innumerable choices he

has to make, from the choice of subject to the subtlest details of style. It is the viewer's or reader's sense of life that responds to a work of art by a complex, yet automatic reaction of acceptance and approval, or rejection and condemnation.

This does not mean that a sense of life is a valid criterion of esthetic merit, either for the artist or the viewer. A sense of life is *not* infallible. But a sense of life is the source of art, the psychological mechanism which enables man to create a realm such as art.

The emotion involved in art is not an emotion in the ordinary meaning of the term. It is experienced more as a "sense" or a "feel," but it has two characteristics pertaining to emotions: it is automatically immediate and it has an intense, profoundly personal (yet undefined) value-meaning to the individual experiencing it. The value involved is life, and the words naming the emotion are: "*This* is what life means to *me*."

Regardless of the nature or content of an artist's metaphysical views, what an art work expresses, fundamentally, under all of its lesser aspects is: "*This* is life as *I* see it." The essential meaning of a viewer's or reader's response, under all of its lesser elements, is: "*This* is (or is *not*) life as I see it."

The psycho-epistemological process of communication between an artist and a viewer or reader goes as follows: the artist starts with a broad abstraction which he has to concretize, to bring into reality by means of the appropriate particulars; the viewer perceives the particulars, integrates them and grasps the abstraction from which they came, thus completing the circle. Speaking metaphorically, the creative process resembles a process of deduction; the viewing process resembles a process of induction.

This does not mean that communication is the primary purpose of an artist: his primary purpose is to bring his view of man and of existence into reality; but to be brought into reality, it has to be translated into objective (therefore, communicable) terms.

In Chapter 1, I discussed why man needs art—why, as a being guided by *conceptual* knowledge, he needs the power to summon the long chain and complex total

of his metaphysical concepts into his immediate conscious awareness. "He needs a comprehensive view of existence to integrate his values, to choose his goals, to plan his future, to maintain the unity and coherence of his life." Man's sense of life provides him with the integrated sum of his metaphysical abstractions; art concretizes them and allows him to perceive—to *experience*—their immediate reality.

The function of psychological integrations is to make certain connections automatic, so that they work as a unit and do not require a conscious process of thought every time they are evoked. (All learning consists of automatizing one's knowledge in order to leave one's mind free to pursue further knowledge.) There are many special or "cross-filed" chains of abstractions (of interconnected concepts) in man's mind. Cognitive abstractions are the fundamental chain, on which all the others depend. Such chains are mental integrations, serving a special purpose and formed accordingly by a special criterion.

Cognitive abstractions are formed by the criterion of: what is *essential*? (epistemologically essential to distinguish one class of existents from all others). *Normative* abstractions are formed by the criterion of: what is *good*? *Esthetic* abstractions are formed by the criterion of: what is *important*?

An artist does not fake reality—he *stylizes* it. He selects those aspects of existence which he regards as metaphysically significant—and by isolating and stressing them, by omitting the insignificant and accidental, he presents *his* view of existence. His concepts are not divorced from the facts of reality—they are concepts which integrate the facts *and* his metaphysical evaluation of the facts. His selection constitutes his evaluation: everything included in a work of art—from theme to subject to brushstroke or adjective—acquires metaphysical significance by the mere fact of being included, of being *important* enough to include.

An artist (as, for instance, the sculptors of Ancient Greece) who presents man as a god-like figure is aware of the fact that men may be crippled or diseased or helpless; but he regards these conditions as accidental,

as irrelevant to the essential nature of man—and he presents a figure embodying strength, beauty, intelligence, self-confidence, as man's proper, natural state.

An artist (as, for instance, the sculptors of the Middle Ages) who presents man as a deformed monstrosity is aware of the fact that there are men who are healthy, happy or confident; but he regards *these* conditions as accidental or illusory, as irrelevant to man's essential nature and he presents a tortured figure embodying pain, ugliness, terror, as man's proper, natural state.

Now consider the painting described at the start of this discussion. The cold sore on the lips of a beautiful woman, which would be insignificant in real life, acquires a monstrous metaphysical significance by virtue of being included in a painting. It declares that a woman's beauty and her efforts to achieve glamor (the beautiful evening gown) are a futile illusion undercut by a seed of corruption which can mar and destroy them at any moment—that this is reality's mockery of man—that all of man's values and efforts are impotent against the power, not even of some great cataclysm, but of a miserable little physical infection.

The Naturalistic type of argument—to the effect that, in real life, a beautiful woman *might* get a cold sore—is irrelevant esthetically. Art is not concerned with actual occurrences or events as such, but with their metaphysical significance to man.

An indication of the metaphysical slant of art can be seen in the popular notion that a reader of fiction "identifies himself with" some character or characters of the story. "To identify with" is a colloquial designation for a process of abstraction: it means to observe a common element between the character and oneself, to draw an abstraction from the character's problems and apply it to one's own life. Subconsciously, without any knowledge of esthetic theory, but by virtue of the implicit nature of art, this *is* the way in which most people react to fiction and to all other forms of art.

This illustrates one important aspect of the difference between a real-life news story and a fiction story: a news story is a concrete from which one may or may not draw an abstraction, which one may or may not find

relevant to one's own life; a fiction story is an abstraction that claims universality, i.e., application to every human life, including one's own. Hence one may be impersonal and indifferent in regard to a news story, even though it is real; and one feels an intensely personal emotion about a fiction story, even though it is invented. This emotion may be positive, when one finds the abstraction applicable to oneself—or resentfully negative, when one finds it inapplicable and inimical.

It is not journalistic information or scientific education or moral guidance that man seeks from a work of art (though these may be involved as secondary consequences), but the fulfillment of a more profound need: a confirmation of his view of existence—a confirmation, not in the sense of resolving cognitive doubts, but in the sense of permitting him to contemplate his abstractions outside his own mind, in the form of existential concretes.

Since man lives by reshaping his physical background to serve his purpose, since he must first define and then create his values—a rational man needs a concretized projection of these values, an image in whose likeness he will re-shape the world and himself. Art gives him that image; it gives him the experience of seeing the full, immediate, concrete reality of his distant goals.

Since a rational man's ambition is unlimited, since his pursuit and achievement of values is a lifelong process—and the higher the values, the harder the struggle—he needs a moment, an hour or some period of time in which he can experience the sense of his completed task, the sense of living in a universe where his values have been successfully achieved. It is like a moment of rest, a moment to gain fuel to move farther. Art gives him that fuel; the pleasure of contemplating the objectified reality of one's own sense of life is the pleasure of feeling what it would be like to live in one's ideal world.

"The importance of that experience is not in *what* man learns from it, but in *that* he experiences it. The fuel is not a theoretical principle, not a didactic 'message,' but the life-giving fact of experiencing a moment

of *metaphysical* joy—a moment of love for existence."
(See Chapter 11.)

The same principle applies to an irrational man,
though in different terms, according to his different
views and responses. For an irrational man, the concre-
tized projection of his malevolent sense of life serves,
not as fuel and inspiration to move forward, but as
permission to stand still: it declares that values are
unattainable, that the struggle is futile, that fear, guilt,
pain and failure are mankind's predestined end—and
that *he* couldn't help it. Or, on a lower level of irration-
ality, the concretized projection of a malignant sense of
life provides a man with an image of triumphant mal-
ice, of hatred for existence, of vengeance against life's
best exponents, of the defeat and destruction of all
human values; his kind of art gives him a moment's
illusion that *he* is right that evil is metaphysically
potent.

Art is man's metaphysical mirror; what a rational
man seeks to see in that mirror is a salute; what an
irrational man seeks to see is a justification—even if
only a justification of his depravity, as a last convulsion
of his betrayed self-esteem.

Between these two extremes, there lies the immense
continuum of men of mixed premises—whose sense of
life holds unresolved, precariously balanced or openly
contradictory elements of reason and unreason—and
works of art that reflect these mixtures. Since art is the
product of philosophy (and mankind's philosophy is
tragically mixed), most of the world's art, including
some of its greatest examples, falls into this category.

The truth or falsehood of a given artist's philosophy
as such, is not an esthetic matter; it may affect a given
viewer's enjoyment of his work, but it does not negate
its esthetic merit. Some sort of philosophical meaning,
however, some *implicit* view of life, is a necessary
element of a work of art. The absence of any meta-
physical values whatever, i.e., a gray, uncommitted,
passively indeterminate sense of life, results in a soul
without fuel, motor or voice, and renders a man impo-
tent in the field of art. Bad art is, predominantly, the

product of imitation, of secondhand copying, not of creative expression.

Two distinct, but interrelated, elements of a work of art are the crucial means of projecting its sense of life: the *subject* and the *style—what* an artist chooses to present and *how* he presents it.

The subject of an art work expresses a view of man's existence, while the style expresses a view of man's consciousness. The subject reveals an artist's *metaphysics*, the style reveals his *psycho-epistemology*.

The choice of subject declares what aspects of existence the artist regards as important—as worthy of being re-created and contemplated. He may choose to present heroic figures, as exponents of man's nature— or he may choose statistical composites of the average, the undistinguished, the mediocre—or he may choose crawling specimens of depravity. He may present the triumph of heroes, in fact or in spirit (Victor Hugo), or their struggle (Michelangelo), or their defeat (Shakespeare). He may present the folks next door: next door to palaces (Tolstoy), or to drugstores (Sinclair Lewis), or to kitchens (Vermeer), or to sewers (Zola). He may present monsters as objects of moral denunciation (Dostoevsky), or as objects of terror (Goya)—or he may demand sympathy for his monsters, and thus crawl outside the limits of the realm of values, including esthetic ones.

Whatever the case may be, it is the subject (qualified by the theme) that projects an art work's view of man's place in the universe.

The theme of an art work is the link uniting its subject and its style. "Style" is a particular, distinctive or characteristic mode of execution. An artist's style is the product of his own psycho-epistemology—and, by implication, a projection of his view of man's consciousness, of its efficacy or impotence, of its proper method and level of functioning.

Predominantly (though not exclusively), a man whose normal mental state is a state of full focus, will create and respond to a style of radiant clarity and ruthless precision—a style that projects sharp outlines, cleanliness, purpose, an intransigent commitment to full

awareness and clear-cut identity—a level of awareness appropriate to a universe where A is A, where everything is open to man's consciousness and demands its constant functioning.

A man who is moved by the fog of his feelings and spends most of his time out of focus will create and respond to a style of blurred, "mysterious" murk, where outlines dissolve and entities flow into one another, where words connote anything and denote nothing, where colors float without objects, and objects float without weight—a level of awareness appropriate to a universe where A can be any non-A one chooses, where nothing can be known with certainty and nothing much is demanded of one's consciousness.

Style is the most complex element of art, the most revealing and, often, the most baffling psychologically. The terrible inner conflicts from which artists suffer as much as (or, perhaps, more than) other men are magnified in their work. As an example: Salvador Dali, whose style projects the luminous clarity of a rational psycho-epistemology, while most (though not all) of his subjects project an irrational and revoltingly evil metaphysics. A similar, but less offensive, conflict may be seen in the paintings of Vermeer, who combines a brilliant clarity of style with the bleak metaphysics of Naturalism. At the other extreme of the stylistic continuum, observe the deliberate blurring and visual distortions of the so-called "painterly" school, from Rembrandt on down—down to the rebellion against consciousness, expressed by a phenomenon such as Cubism which seeks specifically to disintegrate man's consciousness by painting objects as man *does not* perceive them (from several perspectives at once).

A writer's style may project a blend of reason and passionate emotion (Victor Hugo)—or a chaos of floating abstractions, of emotions cut off from reality (Thomas Wolfe)—or the dry, bare, concrete-bound, humor-tinged raucousness of an intelligent reporter (Sinclair Lewis)—or the disciplined, perceptive, lucid, yet muted understatement of a represser (John O'Hara) —or the carefully superficial, over-detailed precision of an amoralist (Flaubert)—or the mannered artificiality

of a second-hander (several moderns not worthy of mention).

Style conveys what may be called a "psycho-epistemological sense of life," i.e., an expression of that level of mental functioning on which the artist feels most at home. This is the reason why style is crucially important in art—both to the artist and to the reader or viewer—and why its importance is experienced as a profoundly *personal* matter. To the artist, it is an expression, to the reader or viewer a confirmation, of his own consciousness—which means: of his efficacy—which means: of his self-esteem (or pseudo-self-esteem).

Now a word of warning about the criteria of esthetic judgment. A sense of life is the source of art, but it is *not* the sole qualification of an artist or of an esthetician, and it is *not* a criterion of esthetic judgment. Emotions are not tools of cognition. Esthetics is a branch of philosophy—and just as a philosopher does not approach any other branch of his science with his feelings or emotions as his criterion of judgment, so he cannot do it in the field of esthetics. A sense of life is not sufficient professional equipment. An esthetician—as well as any man who attempts to evaluate art works—must be guided by more than an emotion.

The fact that one agrees or disagrees with an artist's philosophy is irrelevant to an *esthetic* appraisal of his work *qua* art. One does not have to agree with an artist (nor even to enjoy him) in order to evaluate his work. In essence, an objective evaluation requires that one identify the artist's theme, the abstract meaning of his work (exclusively by identifying the evidence contained in the work and allowing no other, outside considerations), then evaluate the means by which he conveys it—i.e., taking *his* theme as criterion, evaluate the purely esthetic elements of the work, the technical mastery (or lack of it) with which he projects (or fails to project) *his* view of life.

(The esthetic principles which apply to all art, regardless of an individual artist's philosophy, and which must guide an objective evaluation, are outside the scope of this discussion. I will mention only that such

principles are defined by the science of esthetics—a task at which modern philosophy has failed dismally.)

Since art is a philosophical composite, it is not a contradiction to say: "This is a great work of art, but I don't like it,"—provided one defines the exact meaning of that statement: the first part refers to a purely esthetic appraisal, the second to a deeper philosophical level which includes more than esthetic values.

Even in the realm of personal choices, there are many different aspects from which one may enjoy a work of art—other than sense-of-life affinity. One's sense of life is fully involved only when one feels a profoundly *personal* emotion about a work of art. But there are many other levels or degrees of liking; the differences are similar to the difference between romantic love and affection or friendship.

For instance: I love the work of Victor Hugo, in a deeper sense than admiration for his superlative literary genius, and I find many similarities between his sense of life and mine, although I disagree with virtually all of his explicit philosophy—I like Dostoevsky, for his superb mastery of plot structure and for his merciless dissection of the psychology of evil, even though his philosophy *and* his sense of life are almost diametrically opposed to mine—I like the early novels of Mickey Spillane, for his plot ingenuity and moralistic style, even though his sense of life clashes with mine, and no explicit philosophical element is involved in his work—I cannot stand Tolstoy, and reading him was the most boring literary duty I ever had to perform, his philosophy and his sense of life are not merely mistaken, but evil, and yet, from a purely literary viewpoint, on his own terms, I have to evaluate him as a good writer.

Now, to demonstrate the difference between an intellectual approach and a sense of life, I will restate the preceding paragraph in sense-of-life terms: Hugo gives me the feeling of entering a cathedral—Dostoevsky gives me the feeling of entering a chamber of horrors, but with a powerful guide—Spillane gives me the feeling of hearing a military band in a public park—Tolstoy gives me the feeling of an unsanitary backyard which I do not care to enter.

When one learns to translate the meaning of an art work into objective terms, one discovers that nothing is as potent as art in exposing the essence of a man's character. An artist reveals his naked soul in his work— and so, gentle reader, do you when you respond to it.

(March 1966)

4. Art and Cognition

A frequent question, which the estheticians have failed to answer, is: What kinds of objects may be properly classified as works of art? What are the valid forms of art—and why these?

An examination of the major branches of art will give a clue to the answer.

Art is a selective re-creation of reality according to an artist's metaphysical value-judgments. Man's profound need of art lies in the fact that his cognitive faculty is conceptual, i.e., that he acquires knowledge by means of abstractions, and needs the power to bring his widest metaphysical abstractions into his immediate, perceptual awareness. Art fulfills this need: by means of a selective re-creation, it concretizes man's fundamental view of himself and of existence. It tells man, in effect, which aspects of his experience are to be regarded as essential, significant, important. In this sense, art teaches man how to use his consciousness. It conditions or stylizes man's consciousness by conveying to him a certain way of looking at existence.

Bearing this in mind, consider the nature of the ma-

jor branches of art, and of the specific physical media they employ.

Literature re-creates reality by means of language—*Painting*, by means of color on a two-dimensional surface—*Sculpture*, by means of a three-dimensional form made of a solid material. *Music* employs the sounds produced by the *periodic* vibrations of a sonorous body, and evokes man's sense-of-life emotions. *Architecture* is in a class by itself, because it combines art with a utilitarian purpose and does not re-create reality, but creates a structure for man's habitation or use, expressing man's values. (There are also the performing arts, whose medium is the person of the artist; we shall discuss them later.)

Now observe the relation of these arts to man's cognitive faculty: Literature deals with the field of *concepts*—Painting, with the field of *sight*—Sculpture, with the combined fields of *sight* and *touch*—Music, with the field of *hearing*. (Architecture, qua art, is close to sculpture: its field is three-dimensional, i.e., sight and touch, but transposed to a grand spatial scale.)

The development of human cognition starts with the ability to perceive *things,* i.e., *entities*. Of man's five cognitive senses, only two provide him with a direct awareness of entities: sight and touch. The other three senses—hearing, taste and smell—give him an awareness of some of an entity's attributes (or of the consequences produced by an entity): they tell him that something makes sounds, or something tastes sweet, or something smells fresh; but in order to perceive this something, he needs sight and/or touch.

The concept "entity" is (implicitly) the start of man's conceptual development and the building-block of his entire conceptual structure. It is by perceiving entities that man perceives the universe. And *in order to concretize his view of existence, it is by means of concepts (language) or by means of his entity-perceiving senses (sight and touch) that he has to do it.*

Music does not deal with entities, which is the reason why its psycho-epistemological function is different from that of the other arts, as we shall discuss later.

The relation of literature to man's cognitive faculty is

obvious: literature re-creates reality by means of words, i.e., *concepts*. But in order to re-create reality, it is the sensory-perceptual level of man's awareness that literature has to convey conceptually: the reality of concrete, individual men and events, of specific sights, sounds, textures, etc.

The so-called visual arts (painting, sculpture, architecture) produce concrete, perceptually available entities and make them convey an abstract, conceptual meaning.

All these arts are *conceptual* in essence, all are products of and addressed to the conceptual level of man's consciousness, and they differ only in their means. Literature starts with concepts and integrates them to percepts—painting, sculpture and architecture start with percepts and integrate them to concepts. The ultimate psycho-epistemological function is the same: a process that integrates man's forms of cognition, unifies his consciousness and clarifies his grasp of reality.

The visual arts do not deal with the sensory field of awareness as such, but with *the sensory field as perceived by a conceptual consciousness.*

The sensory-perceptual awareness of an adult does not consist of mere sense data (as it did in his infancy), but of automatized integrations that combine sense data with a vast context of conceptual knowledge. The visual arts refine and direct the sensory elements of these integrations. By means of selectivity, of emphasis and omission, these arts lead man's sight to the conceptual context intended by the artist. They teach man to see more precisely and to find deeper meaning in the field of his vision.

It is a common experience to observe that a particular painting—for example, a still life of apples—makes its subject "more real than it is in reality." The apples seem brighter and firmer, they seem to possess an almost self-assertive character, a kind of heightened reality which neither their real-life models nor any color photograph can match. Yet if one examines them closely, one sees that no real-life apple ever looked like that. What is it, then, that the artist has done? He has created a *visual abstraction.*

He has performed the process of concept-formation—of isolating and integrating—but in exclusively visual terms. He has isolated the *essential*, distinguishing characteristics of apples, and integrated them into a single visual unit. He has brought the conceptual method of functioning to the operations of a single sense organ, the organ of sight.

No one can perceive literally and indiscriminately every accidental, inconsequential detail of every apple he happens to see; everyone perceives and remembers only some aspects, which are not necessarily the essential ones; most people carry in mind a vaguely approximate image of an apple's appearance. The painting concretizes that image by means of visual essentials, which most men have not focused on or identified, but recognize at once. What they feel, in effect, is: "Yes, that's how an apple looks to me!" In fact, no apple ever looked that way to them—only to the selectively focused eye of an artist. But, psycho-epistemologically, their sense of heightened reality is not an illusion: it comes from the greater clarity which the artist has given to their mental image. The painting has integrated the sum of their countless random impressions, and thus has brought order to the visual field of their experience.

Apply the same process to the paintings of more complex subjects—of landscapes, of cities, of human figures, of human faces—and you will see the psycho-epistemological power of the art of painting.

The closer an artist comes to a conceptual method of functioning visually, the greater his work. The greatest of all artists, Vermeer, devoted his paintings to a single theme: light itself. The guiding principle of his compositions is: the *contextual* nature of our perception of light (and of color). The physical objects in a Vermeer canvas are chosen and placed in such a way that their combined interrelationships feature, lead to and make possible the painting's brightest patches of light, sometimes blindingly bright, in a manner which no one has been able to render before or since.

(Compare the radiant austerity of Vermeer's work to the silliness of the dots-and-dashes Impressionists who

allegedly intended to paint pure light. He raised perception to the conceptual level; they attempted to disintegrate perception into sense data.)

One might wish (and I do) that Vermeer had chosen better subjects to express his theme, but to him, apparently, the subjects were only the means to his end. What his *style* projects is a concretized image of an immense, nonvisual abstraction: the psycho-epistemology of a rational mind. It projects clarity, discipline, confidence, purpose, power—a universe open to man. When one feels, looking at a Vermeer painting: "This is *my* view of life," the feeling involves much more than mere visual perception.

As I have mentioned in "Art and Sense of Life," all the other elements of painting, such as theme, subject, composition, are involved in projecting an artist's view of existence, but for this present discussion, style is the most important element: it demonstrates in what manner an art confined to a single sense modality, using exclusively visual means, can express and affect the total of man's consciousness.

In this connection, I should like to relate, without comment, a personal incident. At the age of 16, for one summer, I joined a drawing class given by a man who would have become a great artist had he survived, which I doubt (this was in Russia); his paintings were magnificent, even then. He forbade the class ever to draw a curved line; he taught us that every curve must be broken into facets of intersecting straight lines. I fell in love with this style; I still am. Today, I know the reason fully. What I felt then (and still do) was not: "This is for me," but: "This *is* me."

Compared to painting, sculpture is more limited a form of art. It expresses an artist's view of existence through his treatment of the human figure, but it is confined to the human figure. (For a discussion of sculpture's means, I will refer you to "Metaphysics in Marble" by Mary Ann Sures, *The Objectivist,* February–March 1969.)

Dealing with two senses, sight and touch, sculpture is restricted by the necessity to present a three-dimensional shape as man does *not* perceive it: without color.

Visually, sculpture offers shape as an abstraction; but touch is a somewhat concrete-bound sense and confines sculpture to concrete entities. Of these, only the figure of man can project a metaphysical meaning. There is little that one can express in the statue of an animal or of an inanimate object.

Psycho-epistemologically, it is the requirements of the sense of touch that make the *texture* of a human body a crucial element in sculpture, and virtually a hallmark of great sculptors. Observe the manner in which the softness, the smoothness, the pliant resiliency of the skin is conveyed by rigid marble in such statues as the Venus de Milo or Michelangelo's Pietà.

It is worth noting that sculpture is almost a dead art. Its great day was in ancient Greece which, philosophically, was a man-centered civilization. A Renaissance is always possible, but the future of sculpture depends to a large extent on the future of architecture. The two arts are closely allied; one of the problems of sculpture lies in the fact that one of its most effective functions is to serve as architectural ornament.

I shall not include architecture in this discussion—I assume the reader knows which book I will refer him to.

This brings us to the subject of *music*.

The fundamental difference between music and the other arts lies in the fact that music is experienced as if it reversed man's normal psycho-epistemological process.

The other arts create a physical object (i.e., an object perceived by man's senses, be it a book or a painting) and the psycho-epistemological process goes from the perception of the object to the conceptual grasp of its meaning, to an appraisal in terms of one's basic values, to a consequent emotion. The pattern is: from perception—to conceptual understanding—to appraisal—to emotion.

The pattern of the process involved in music is: from perception—to emotion—to appraisal—to conceptual understanding.

Music is experienced as if it had the power to reach man's emotions directly.

As in the case of all emotions, existential or esthetic,

the psycho-epistemological processes involved in the response to music arc automatized and are experienced as a single, instantaneous reaction, faster than one can identify its components.

It is possible to observe introspectively (up to a certain point) what one's mind does while listening to music: it evokes subconscious material—images, actions, scenes, actual or imaginary experiences—that seems to flow haphazardly, without direction, in brief, random snatches, merging, changing and vanishing, like the progression of a dream. But, in fact, this flow is selective and consistent: the emotional meaning of the subconscious material corresponds to the emotions projected by the music.

Subconsciously (i.e., implicitly), man knows that he cannot experience an actually causeless and objectless emotion. When music induces an emotional state without external object, his subconscious suggests an internal one. The process is wordless, directed, in effect, by the equivalent of the words: "I would feel this way if . . ." if I were in a beautiful garden on a spring morning . . . if I were dancing in a great, brilliant ballroom . . . if I were seeing the person I love . . . "I would feel this way if . . ." if I were fighting a violent storm at sea . . . if I were climbing up the crumbling side of a mountain . . . if I were on the barricades . . . "I would feel this way if . . ." if I reached the top of that mountain . . . if I stood in full sunlight . . . if I leaped over that barrier, as I did today . . . as I will tomorrow . . .

Observe three aspects of this phenomenon: (1) It is induced by deliberately suspending one's conscious thoughts and surrendering to the guidance of one's emotions. (2) The subconscious material has to flow because no single image can capture the meaning of the musical experience, the mind needs a succession of images, it is groping for that which they have in common, i.e., for an emotional *abstraction*. (3) The process of emotional abstraction—i.e., the process of classifying things according to the emotions they evoke—is the process by which one formed one's sense of life.

A sense of life is a preconceptual equivalent of metaphysics, an emotional, subconsciously integrated ap-

praisal of man and of existence. It is in terms of his
fundamental emotions—i.e., the emotions produced by
his own metaphysical value-judgments—that man re-
sponds to music.

Music cannot tell a story, it cannot deal with con-
cretes, it cannot convey a specific existential phenome-
non, such as a peaceful countryside or a stormy sea. The
theme of a composition entitled "Spring Song" is not
spring, but the *emotions* which spring evoked in the
composer. Even concepts which, intellectually, belong
to a complex level of abstraction, such as "peace,"
"revolution," "religion," are too specific, too *concrete* to
be expressed in music. All that music can do with such
themes is convey the emotions of serenity, or defiance,
or exaltation. Liszt's "St. Francis Walking on the
Waters" was inspired by a specific legend, but what it
conveys is a passionately dedicated struggle and
triumph—by whom and in the name of what, is for
each individual listener to supply.

Music communicates emotions, which one grasps,
but does not actually feel; what one feels is a sugges-
tion, a kind of distant, dissociated, depersonalized emo-
tion—until and unless it unites with one's own sense of
life. But since the music's emotional content is not
communicated conceptually or evoked existentially, one
does feel it in some peculiar, subterranean way.

Music conveys the same categories of emotions to
listeners who hold widely divergent views of life. As a
rule, men agree on whether a given piece of music is
gay or sad or violent or solemn. But even though, in a
generalized way, they experience the same emotions in
response to the same music, there are radical differ-
ences in how they *appraise* this experience—i.e., how
they feel about these feelings.

On a number of occasions, I made the following ex-
periment: I asked a group of guests to listen to a record-
ed piece of music, then describe what image, action or
event it evoked in their minds spontaneously and inspi-
rationally, without conscious devising or thought (it was
a kind of auditory Thematic Apperception Test). The
resulting descriptions varied in concrete details, in clar-
ity, in imaginative color, but all had grasped the same

basic emotion—with eloquent differences of appraisal.
For example, there was a continuum of mixed responses
between two pure extremes which, condensed, were:
"I felt exalted because this music is so light-heartedly
happy," and: "I felt irritated because this music is so
light-heartedly happy and, therefore, superficial."

Psycho-epistemologically, the pattern of the response
to music seems to be as follows: one perceives the mu-
sic, one grasps the suggestion of a certain emotional
state and, with one's sense of life serving as the cri-
terion, one appraises this state as enjoyable or painful,
desirable or undesirable, significant or negligible, ac-
cording to whether it corresponds to or contradicts
one's fundamental feeling about life.

When the emotional abstraction projected by the
music corresponds to one's sense of life, the abstraction
acquires a full, bright, almost violent reality—and one
feels, at times, an emotion of greater intensity than any
experienced existentially. When the emotional abstrac-
tion projected by the music is irrelevant to or contra-
dicts one's sense of life, one feels nothing except a dim
uneasiness or resentment or a special kind of enervating
boredom.

As corroborating evidence: I have observed a num-
ber of cases involving persons who, over a period of
time, underwent a significant change in their fundamen-
tal view of life (some, in the direction of improvement;
others, of deterioration). Their musical preferences
changed accordingly; the change was gradual, automa-
tic and subconscious, without any decision or conscious
intention on their part.

It must be stressed that the pattern is *not* so gross
and simple as preferring gay music to sad music or vice
versa, according to a "benevolent" or "malevolent"
view of the universe. The issue is much more complex
and much more specifically *musical* than that: it is not
merely *what* particular emotion a given composition
conveys, but *how* it conveys it, by what musical means
or method. (For instance, I like operetta music of a cer-
tain kind, but I would take a funeral march in prefer-
ence to "The Blue Danube Waltz" or to the Nelson
Eddy-Jeanette MacDonald kind of music.)

As in the case of any other art or any human product, the historical development of music followed the development of philosophy. But the differences in the music produced by various cultures in the various eras of history are deeper than those among the other arts (even the sounds used and the scales are different). Western man can understand and enjoy Oriental painting; but Oriental music is unintelligible to him, it evokes nothing, it sounds like noise. In this respect, the differences in the music of various cultures resemble the differences in language; a given language is unintelligible to foreigners. But language expresses concepts, and different languages can be translated into one another; different kinds of music cannot. There is no common vocabulary of music (not even among the individual members of the same culture). Music communicates emotions—and it is highly doubtful whether the music of different cultures communicates the same emotions. Man's emotional capacity as such is universal, but the actual experience of particular emotions is not: the experience of certain sense-of-life emotions precludes the experience of certain others.

This brings us to the great, unanswered question: *Why does music make us experience emotions?*

In the other arts, whose works are perceived by the normal cognitive process, the answer can be found in the work itself by a conceptual analysis of its nature and meaning; a common vocabulary and an objective criterion of esthetic judgment can be established. There is no such vocabulary or criterion, at present, in the field of music—neither among different cultures nor within the same culture.

It is obvious that the answer lies in the nature of the work, since it is the work that evokes the emotions. But how does it do it? Why does a succession of sounds produce an emotional reaction? Why does it involve man's deepest emotions and his crucial, metaphysical values? How can sounds reach man's emotions directly, in a manner that seems to by-pass his intellect? What does a certain combination of sounds do to man's consciousness to make him identify it as gay or sad?

No one has yet discovered the answers and, I hasten

to add, neither have I. The formulation of a common vocabulary of music would require these answers. It would require: a translation of the musical experience, the inner experience, into *conceptual* terms; an explanation of why certain sounds strike us a certain way; a definition of the axioms of musical perception, from which the appropriate esthetic principles could be derived, which would serve as a base for the objective validation of esthetic judgments.

This means that we need a clear, conceptual distinction and separation of object from subject in the field of musical perception, such as we do possess in the other arts and in the wider field of our cognitive faculty. Conceptual cognition necessitates this separation: until a man is able to distinguish his inner processes from the facts which he perceives, he remains on the perceptual level of awareness. An animal cannot grasp such a distinction; neither can a very young child. Man has grasped it in regard to his other senses and his other arts; he can tell whether a blurring of his vision is produced by a thick fog or by his failing eyesight. It is only in the field of specifically *musical* perception that man is still in a state of early infancy.

In listening to music, a man cannot tell clearly, neither to himself nor to others—and, therefore, cannot prove—which aspects of his experience are inherent in the music and which are contributed by his own consciousness. He experiences it as an indivisible whole, he feels as if the magnificent exaltation were there, in the music—and he is helplessly bewildered when he discovers that some men do experience it and some do not. In regard to the nature of music, mankind is still on the perceptual level of awareness.

Until a conceptual vocabulary is discovered and defined, *no objectively valid criterion of esthetic judgment is possible in the field of music*. (There are certain technical criteria, dealing mainly with the complexity of harmonic structures, but there are no criteria for identifying the *content*, i.e., the emotional meaning of a given piece of music and thus demonstrating the esthetic objectivity of a given response.)

At present, our understanding of music is confined to

the gathering of material, i.e., to the level of descriptive observations. Until it is brought to the stage of conceptualization, we have to treat musical tastes or preferences as a subjective matter—not in the metaphysical, but in the epistemological sense; i.e., not in the sense that these preferences are, in fact, causeless and arbitrary, but in the sense that we do not know their cause. No one, therefore, can claim the *objective* superiority of his choices over the choices of others. Where no objective proof is available, it's every man for himself—and *only* for himself.

The nature of musical perception has not been discovered because the key to the secret of music is *physiological*—it lies in the nature of the process by which man perceives sounds—and the answer would require the joint effort of a physiologist, a psychologist and a philosopher (an esthetician).

The start of a scientific approach to this problem and the lead to an answer were provided by Helmholtz, the great physiologist of the nineteenth century. He concludes his book, *On the Sensations of Tone as a Physiological Basis for the Theory of Music,* with the following statement: "Here I close my work. It appears to me that I have carried it as far as the physiological properties of the sensation of hearing exercise a direct influence on the construction of a musical system, that is, as far as the work especially belongs to natural philosophy. . . . The real difficulty would lie in the development of the psychical motives which here [in the esthetics of music] assert themselves. Certainly this is the point where the more interesting part of musical esthetics begins, the aim being to explain the wonders of great works of art, and to learn the utterances and actions of the various affections of the mind. But, however alluring such an aim may be, I prefer leaving others to carry out such investigations, in which I should feel myself too much of an amateur, while I myself remain on the safe ground of natural philosophy, in which I am at home." (New York, Dover Publications, 1954, p. 371.)

To my knowledge, no one has attempted "to carry out such investigations." The context and the shrinking

scale of modern psychology and philosophy, would have made an undertaking of this kind impossible.

From the standpoint of psycho-epistemology, I can offer a hypothesis on the nature of man's response to music, but I urge the reader to remember that it is only a hypothesis.

If man experiences an emotion without existential object, its only other possible object is the state or actions of his own consciousness. What is the mental action involved in the perception of music? (I am not referring to the emotional reaction, which is the consequence, but to the process of perception.)

We must remember that *integration* is a cardinal function of man's consciousness on all the levels of his cognitive development. First, his brain brings order into his sensory chaos by integrating sense data into percepts; this integration is performed automatically; it requires effort, but no conscious volition. His next step is the integration of percepts into concepts, as he learns to speak. Thereafter, his cognitive development consists in integrating concepts into wider and ever wider concepts, expanding the range of his mind. This stage is fully volitional and demands an unremitting effort. The automatic processes of *sensory* integration are completed in his infancy and closed to an adult.

The single exception is in the field of sounds produced by periodic vibrations, i.e., music.

The sounds produced by nonperiodic vibrations are noise. One may listen to noise for an hour, a day or a year, and it remains just noise. But musical tones heard in a certain kind of succession produce a different result—the human ear and brain *integrate* them into a new cognitive experience, into what may be called an auditory entity: a melody. The integration is a physiological process; it is performed unconsciously and automatically. Man is aware of the process only by means of its results.

Helmholtz has demonstrated that the essence of musical perception is mathematical: the consonance or dissonance of harmonies depends on the ratios of the frequencies of their tones. The brain can integrate a ratio of one to two, for instance, but not of eight to nine.

(This does not mean that dissonances cannot be integrated; they can, in the proper musical context.)

Helmholtz was concerned mainly with tones heard simultaneously. But his demonstration indicates the possibility that the same principles apply to the process of hearing and integrating a succession of musical tones, i.e., a melody—and that the psycho-epistemological meaning of a given composition lies in the kind of work it demands of a listener's ear and brain.

A composition may demand the active alertness needed to resolve complex mathematical relationships—or it may deaden the brain by means of monotonous simplicity. It may demand a process of building an integrated sum—or it may break up the process of integration into an arbitrary series of random bits—or it may obliterate the process by a jumble of sounds mathematically-physiologically impossible to integrate, and thus turn into noise.

The listener becomes aware of this process in the form of a sense of efficacy, or of strain, or of boredom, or of frustration. His reaction is determined by his *psycho-epistemological* sense of life—i.e., by the level of cognitive functioning on which he feels at home.

Epistemologically, a man who has an active mind regards mental effort as an exciting challenge; metaphysically, he seeks intelligibility. He will enjoy the music that requires a process of complex calculations and successful resolution. (I refer not merely to the complexities of harmony and orchestration, but primarily to their core, the complexity of melody, on which they depend.) He will be bored by too easy a process of integration, like an expert in higher mathematics who is put to the task of solving problems in kindergarten arithmetic. He will feel a mixture of boredom and resentment when he hears a series of random bits with which his mind can do nothing. He will feel anger, revulsion and rebellion against the process of hearing jumbled musical sounds; he will experience it as an attempt to destroy the integrating capacity of his mind.

A man of mixed cognitive habits has, epistemologically, a limited interest in mental effort and, metaphysically, tolerates a great deal of fog in his field of

awareness. He will feel strain when listening to the more demanding type of music, but will enjoy the simpler types. He may enjoy the broken, random kind of music (if he is pretentious)—and may even become conditioned to accept the jumbled music (if he is sufficiently lethargic).

There may be many other kinds of reactions, according to the many different aspects of musical compositions and to the many variants of men's cognitive habits. The above examples merely indicate the hypothetical pattern of man's response to music.

Music gives man's consciousness the same experience as the other arts: a concretization of his sense of life. But the abstraction being concretized is primarily epistemological, rather than metaphysical; the abstraction is man's consciousness, i.e., his method of cognitive functioning, which he experiences in the concrete form of hearing a specific piece of music. A man's acceptance or rejection of that music depends on whether it calls upon or clashes with, confirms or contradicts, his mind's way of working. The metaphysical aspect of the experience is the sense of a world which he is able to grasp, to which his mind's working is appropriate.

Music is the only phenomenon that permits an adult to experience the process of dealing with pure sense data. Single musical tones are not percepts, but pure sensations; they become percepts only when integrated. Sensations are man's first contact with reality; when integrated into percepts, they are the given, the self-evident, the not-to-be-doubted. Music offers man the singular opportunity to reenact, on the adult level, the primary process of his method of cognition: the automatic integration of sense data into an intelligible, meaningful entity. To a conceptual consciousness, it is a unique form of rest and reward.

Conceptual integrations require constant effort and impose a permanent responsibility: they involve the risk of error and failure. The process of musical integration is automatic and effortless. (It is experienced as effortless, since it is unconscious; it is a process of cashing in on the kinds of mental habits one has, or has not, spent effort to acquire.) One's reaction to music

carries a sense of total certainty, as if it were simple, self-evident, not to be doubted; it involves one's emotions, i.e., one's values, and one's deepest sense of oneself—it is experienced as a magic union of sensations and thought, as if thought had acquired the immediate certainty of direct awareness.

(Hence all the mystic clamor about the "spiritual" or supernatural character of music. Mysticism, the perennial parasite, here appropriates a phenomenon which is a product of the union, not the dichotomy, of man's body and mind: it is part physiological, part intellectual.)

In regard to the relationship of music to man's state of mind, Helmholtz indicates the following, in a discussion of the difference between the major and minor keys: "The major mode is well suited for all frames of mind which are completely formed and clearly understood, for strong resolve, and for soft and gentle or even for sorrowing feelings, when the sorrow has passed into the condition of dreamy and yielding regret. But it is quite unsuited for indistinct, obscure, unformed frames of mind, or for the expression of the dismal, the dreary, the enigmatic, the mysterious, the rude, and whatever offends against artistic beauty;— and it is precisely for these that we require the minor mode, with its veiled harmoniousness, its changeable scale, its ready modulation, and less intelligible basis of construction. The major mode would be an unsuitable form for such purposes, and hence the minor mode has its own proper artistic justification as a separate system." (*On the Sensations of Tone*, p. 302.)

My hypothesis would explain why men hear the same emotional content in a given piece of music even though they differ in their evaluations. Cognitive processes affect man's emotions which affect his body, and the influence is reciprocal. For instance, the successful solution of an intellectual problem creates a joyous, triumphant mood; failure to solve a problem creates a painful mood of dejection or discouragement. And conversely: a joyous mood tends to sharpen, accelerate, energize one's mind; a mood of sadness tends to blur the mind, to burden it, to slow it down. Observe the melod-

ic and rhythmic characteristics of the types of music we regard as gay or sad. If a given process of musical integration taking place in a man's brain resembles the cognitive processes that produce and/or accompany a certain emotional state, he will recognize it, in effect, physiologically, then intellectually. Whether he will accept that particular emotional state, and experience it fully, depends on his sense-of-life evaluation of its significance.

The epistemological aspect of music is the fundamental, but not the exclusive, factor in determining one's musical preferences. Within the general category of music of equal complexity, it is the emotional element that represents the *metaphysical* aspect controlling one's enjoyment. The issue is not merely that one is able to perceive successfully, i.e., to integrate a series of sounds into a musical entity, but also: what sort of entity does one perceive? The process of integration represents the concretized abstraction of one's consciousness, the nature of the music represents the concretized abstraction of existence—i.e., a world in which one feels joyous or sad or triumphant or resigned, etc. According to one's sense of life, one feels: "Yes, *this* is *my* world and *this* is how I should feel!" or: "No, this is not the world as I see it." (As in the other arts, one may appreciate the esthetic value of a given composition, yet neither like nor enjoy it.)

The scientific research that would be needed to *prove* this hypothesis is enormous. To indicate just a few of the things which proof would require: a computation of the mathematical relationships among the tones of a melody—a computation of the time required by the human ear and brain to integrate a succession of musical sounds, including the progressive steps, the duration and the time limits of the integrating process (which would involve the relationship of tones to rhythm)—a computation of the relationships of tones to bars, of bars to musical phrases, of phrases to ultimate resolution—a computation of the relationships of melody to harmony, and of their sum to the sounds of various musical instruments, etc. The work involved is staggering, yet this is what the human brain—the composer's,

the performer's and the listener's—does, though not consciously.

If such calculations were made and reduced to a manageable number of equations, i.e., of principles, we would have an objective vocabulary of music. It would be a mathematical vocabulary, based on the nature of sound and on the nature of man's faculty of hearing (i.e., on what is possible to this faculty). The esthetic criterion to be derived from such a vocabulary would be: integration—i.e., the range (or complexity) of the integration achieved by a given composition. Integration—because it is the essence of music, as distinguished from noise; range—because it is the measure of any intellectual achievement.

Until my theory is proved or disproved by scientific evidence of this kind, it has to be regarded as a mere hypothesis.

There is, however, a great deal of evidence pertaining to the nature of music which we can observe, not on the physiological, but on the psychological-existential level (which tends to support my hypothesis).

The connection of music to man's cognitive faculty is supported by the fact that certain kinds of music have a paralyzing, narcotic effect on man's mind. They induce a state of trancelike stupor, a loss of context, of volition, of self-awareness. Primitive music and most Oriental music fall into this category. The enjoyment of such music is the opposite of the emotional state that a Western man would call enjoyment: to the Western man, music is an intensely personal experience and a confirmation of his cognitive power—to the primitive man, music brings the dissolution of self and of consciousness. In both cases, however, music is the means of evoking that psycho-epistemological state which their respective philosophies regard as proper and desirable for man.

The deadly monotony of primitive music—the endless repetition of a few notes and of a rhythmic pattern that beats against the brain with the regularity of the ancient torture of water drops falling on a man's skull—paralyzes cognitive processes, obliterates awareness and disintegrates the mind. Such music produces

a state of *sensory deprivation*, which—as modern scientists are beginning to discover—is caused by the absence or the monotony of sense stimuli.

There is no evidence to support the contention that the differences in the music of various cultures are caused by innate physiological differences among various races. There is a great deal of evidence to support the hypothesis that the cause of the musical differences is psycho-epistemological (and, therefore, ultimately philosophical).

A man's psycho-epistemological method of functioning is developed and automatized in his early childhood; it is influenced by the dominant philosophy of the culture in which he grows up. If, explicitly and implicitly (through the general emotional attitude), a child grasps that the pursuit of knowledge, i.e., the independent work of his cognitive faculty, is important and required of him by his nature, he is likely to develop an active, independent mind. If he is taught passivity, blind obedience, fear and the futility of questioning or knowing, he is likely to grow up as a mentally helpless savage, whether in the jungle or in New York City. But—since one cannot destroy a human mind totally, so long as its possessor remains alive—his brain's frustrated needs become a restless, incoherent, unintelligible groping that frightens him. Primitive music becomes his narcotic: it wipes out the groping, it reassures him and reinforces his lethargy, it offers him temporarily the sense of a reality to which his stagnant stupor is appropriate.

Now observe that the modern diatonic scale used in Western civilization is a product of the Renaissance. It was developed over a period of time by a succession of musical innovators. What motivated them? This scale permits the greatest number of consonant harmonies—i.e., of sound-combinations pleasant to the human ear (i.e., integratable by the human brain). The man-reason-science-oriented culture of the Renaissance and post-Renaissance periods represented the first era in history when such a concern as man's pleasure could motivate composers, who had the freedom to create.

Today, when the influence of Western civilization is

breaking up the static, tradition-bound culture of Japan, young Japanese composers are doing talented work in the Western style of music.

The products of America's anti-rational, anti-cognitive "Progressive" education, the hippies, are reverting to the music and the drumbeat of the jungle.

Integration is the key to more than music; it is the key to man's consciousness, to his conceptual faculty, to his basic premises, to his life. And lack of integration will lead to the same existential results in anyone born with a potentially human mind, in any century, in any place on earth.

A brief word about so-called modern music: no further research or scientific discoveries are required to know with full, objective certainty that it is *not* music. The proof lies in the fact that music is the product of *periodic vibrations*—and, therefore, the introduction of nonperiodic vibrations (such as the sounds of street traffic or of machine gears or of coughs and sneezes), i.e., of noise, into an allegedly musical composition eliminates it automatically from the realm of art and of consideration. But a word of warning in regard to the vocabulary of the perpetrators of such "innovations" is in order: they spout a great deal about the necessity of "conditioning" your ear to an appreciation of their "music." Their notion of conditioning is unlimited by reality and by the law of identity; man, in their view, is infinitely conditionable. But, in fact, you can condition a human ear to different types of music (it is not the ear, but the *mind* that you have to condition in such cases); you cannot condition it to hear noise as if it were music; it is not personal training or social conventions that make it impossible, but the physiological nature, the *identity*, of the human ear and brain.

Let us turn now to the performing arts (acting, playing a musical instrument, singing, dancing).

In these arts, the medium employed is the person of the artist. His task is not to re-create reality, but to implement the re-creation made by one of the primary arts.

This does not mean that the performing arts are secondary in esthetic value or importance, but only that

they are an extension of and dependent on the primary arts. Nor does it mean that performers are mere "interpreters": on the higher levels of his art, a performer contributes a creative element which the primary work could not convey by itself; he becomes a partner, almost a co-creator—if and when he is guided by the principle that *he* is the means to the end set by the work.

The basic principles which apply to all the other arts, apply to the performing artist as well, particularly stylization, i.e., selectivity: the choice and emphasis of essentials, the structuring of the progressive steps of a performance which lead to an ultimately meaningful sum. The performing artist's own metaphysical value-judgments are called upon to create and apply the kind of technique his performance requires. For instance, an actor's view of human grandeur or baseness or courage or timidity will determine how he projects these qualities on the stage. A work intended to be performed leaves a wide latitude of creative choice to the artist who will perform it. In an almost literal sense, he has to *embody* the soul created by the author of the work; a special kind of creativeness is required to bring that soul into full physical reality.

When the performance and the work (literary or musical) are perfectly integrated in meaning, style and intention, the result is a magnificent esthetic achievement and an unforgettable experience for the audience.

The psycho-epistemological role of the performing arts—their relationship to man's cognitive faculty—lies in the full concretization of the metaphysical abstractions projected by a work of the primary arts. The distinction of the performing arts lies in their immediacy—in the fact that they translate a work of art into existential *action*, into a concrete event open to direct awareness. This is also their danger. Integration is the hallmark of art—and unless the performance and the primary work are fully integrated, the result is the opposite of the cognitive function of art: it gives the audience an experience of psycho-epistemological disintegration.

A performed event may contain a certain degree of

imbalance among its many elements, yet still be regarded as art. For example, a great actor is often able to impart some stature and meaning to an undistinguished play—or a great play may project its power in spite of an undistinguished cast. Such events leave the audience with a sense of wistful frustration, but they still offer some partial element of esthetic value. When, however, the imbalance becomes outright contradiction, the event falls apart and tumbles outside the boundaries of art. For example, an actor may decide to rewrite the play without changing a line, merely by playing a villain as a hero or vice versa (because he disagrees with the author's ideas, or wants to play a different kind of role, or simply doesn't know any better)—and proceeds to present a characterization that clashes with every line he utters; the result is an incoherent mess, the more so the better the lines and the performance. In such a case, the event degenerates into meaningless posturing or lower: into clowning.

The disastrously inverted approach to the performing arts is exemplified by the mentality that regards plays as "vehicles" for stars. The traffic smash-ups of such vehicles and their riders are written all over the esthetic police blotters, and are not confined to Hollywood. The wreckage includes great actors performing trashy plays—great plays rewritten for a performance by simpering amateurs—pianists mangling compositions to show off their virtuosity, etc.

The common denominator is a crude reversal of ends and means. The "how" can never replace the "what"—neither in the primary nor in the performing arts, neither in the form of an exquisite style of writing used to say nothing, nor in the form of Greta Garbo exquisitely uttering a truck driver's idea of a love scene.

Among the performing arts, dancing requires a special discussion. Is there an abstract meaning in dancing? What does dancing express?

The dance is the silent partner of music and participates in a division of labor: music presents a stylized version of man's consciousness in action—the dance presents a stylized version of man's body in action.

"Stylized" means condensed to essential characteristics, which are chosen according to an artist's view of man.

Music presents an abstraction of man's emotions in the context of his cognitive processes—the dance presents an abstraction of man's emotions in the context of his physical movements. The task of the dance is not the projection of single, momentary emotions, *not* a pantomime version of joy or sorrow or fear, etc., but a more profound issue: the projection of metaphysical value-judgments, the stylization of man's movements by the continuous power of a fundamental emotional state—and thus the use of man's body to express his sense of life.

Every strong emotion has a kinesthetic element, experienced as an impulse to leap or cringe or stamp one's foot, etc. Just as a man's sense of life is part of all his emotions, so it is part of all his movements and determines his manner of using his body: his posture, his gestures, his way of walking, etc. We can observe a different sense of life in a man who characteristically stands straight, walks fast, gestures decisively—and in a man who characteristically slumps, shuffles heavily, gestures limply. This particular element—the overall manner of moving—constitutes the material, the special province of the dance. The dance stylizes it into *a system of motion* expressing a metaphysical view of man.

A *system* of motion is the essential element, the precondition of the dance as an art. An indulgence in random movements, such as those of children romping in a meadow, may be a pleasant game, but it is not art. The creation of a consistently stylized, metaphysically expressive system is so rare an achievement that there are very few distinctive forms of dancing to qualify as art. Most dance performances are conglomerations of elements from different systems and of random contortions, arbitrarily thrown together, signifying nothing. A male or a female skipping, jumping or rolling over a stage is no more artistic than the children in the meadow, only more pretentious.

Consider two distinctive systems, ballet and the Hindu dance, which are examples of the dance as an art.

The keynote of the stylization achieved in ballet is: weightlessness. Paradoxically, ballet presents man as almost disembodied: it does not distort man's body, it selects the kinds of movements that are normally possible to man (such as walking on tiptoe) and exaggerates them, stressing their beauty—and defying the law of gravitation. A gracefully effortless floating, flowing and flying are the essentials of the ballet's image of man. It projects a fragile kind of strength and a certain inflexible precision, but it is man with a fine steel skeleton and without flesh, man the spirit, not controlling, but transcending this earth.

By contrast, the Hindu dance presents a man of flesh without skeleton. The keynote of its stylization is: flexibility, undulation, writhing. It does distort man's body, imparting to it the motions of a reptile; it includes dislocations normally impossible to man and uncalled for, such as the sideways jerking of the torso and of the head which momentarily suggests decapitation. This is an image of man as infinitely pliable, man adapting himself to an incomprehensible universe, pleading with unknowable powers, reserving nothing, not even his identity.

Within each system, specific emotions may be projected or faintly suggested, but only as the basic style permits. Strong passions or negative emotions cannot be projected in ballet, regardless of its librettos; it cannot express tragedy or fear—or sexuality; it is a perfect medium for the expression of spiritual love. The Hindu dance can project passions, but not positive emotions; it cannot express joy or triumph, it is eloquent in expressing fear, doom—and a physicalistic kind of sexuality.

I want to mention a form of dancing that has not been developed into a full system, but possesses the key elements on which a full, distinctive system could be built: tap dancing. It is of American Negro origin; it is singularly appropriate to America and distinctly un-European. Its best exponents are Bill Robinson and Fred Astaire (who combines it with some elements of the ballet).

Tap dancing is completely synchronized with, responsive and obedient to the music—by means of a

common element crucial to music and to man's body: rhythm. This form permits the dancer no pause, no stillness: his feet can touch the ground only long enough to accent the rhythm's beat. From start to finish, no matter what the action of his body, his feet continue that even, rapid tapping; it is like a long series of dashes underscoring his movements; he can leap, whirl, kneel, yet never miss a beat. It looks, at times, as if it is a contest between the man and the music, as if the music is daring him to follow—and he is following lightly, effortlessly, almost casually. Complete obedience to the music? The impression one gets is: complete control—man's mind in effortless control of his expertly functioning body. The keynote is: precision. It conveys a sense of purpose, discipline, clarity—a mathematical kind of clarity—combined with an unlimited freedom of movement and an inexhaustible inventiveness that dares the sudden, the unexpected, yet never loses the central, integrating line: the music's rhythm. No, the emotional range of tap dancing is not unlimited: it cannot express tragedy or pain or fear or guilt; all it can express is gaiety and every shade of emotion pertaining to the joy of living. (Yes, it is my favorite form of the dance.)

Music is an independent, primary art; the dance is not. In view of their division of labor, the dance is entirely dependent on music. With the emotional assistance of music, it expresses an abstract meaning; without music, it becomes meaningless gymnastics. It is music, the voice of man's consciousness, that integrates the dance to man and to art. Music sets the terms; the task of the dance is to follow, as closely, obediently and expressively as possible. The tighter the integration of a given dance to its music—in rhythm, in mood, in style, in theme—the greater its esthetic value.

A clash between dance and music is worse than a clash between actor and play: it is an obliteration of the entire performance. It permits neither the music nor the dance to be integrated into an esthetic entity in the viewer's mind—and it becomes a series of jumbled motions superimposed on a series of jumbled sounds.

Observe that the modern anti-art trend takes pre-

cisely this form in the field of the dance. (I am not
speaking of the so-called modern dance, which is nei-
ther modern nor dance.) Ballet, for instance, is being
"modernized" by being danced to inappropriate, un-
danceable music, which is used as a mere accompani-
ment, like the tinkling piano in the days of the silent
movies, only less synchronized with the action. Add to
it the vast infusion of pantomime, which is not an art,
but a childish game (it is not acting, but expository sig-
naling), and you get a form of self-affronting compro-
mise more abject than anything seen in politics. I submit
in evidence *Marguerite and Armand* as presented by
the Royal Ballet. (Even the pratfalls or the walking-
heels-first of the so-called modern dance seem innocent
by comparison: their perpetrators have nothing to be-
tray or to disfigure.)

Dancers are performing artists; music is the primary
work they perform—with the help of an important in-
termediary: the choreographer. His creative task is sim-
ilar to that of a stage director, but carries a more
demanding responsibility: a stage director translates a
primary work, a play, into physical action—a choreog-
rapher has to translate a primary work, a composition
of sounds, into another medium, into a composition of
movements, and create a structured, integrated work: a
dance.

This task is so difficult and its esthetically qualified
practitioners so rare that the dance has always been slow
in its development and extremely vulnerable. Today, it
is all but extinct.

Music and/or literature are the base of the perform-
ing arts and of the large-scale combinations of all the
arts, such as opera or motion pictures. The base, in this
context, means that primary art which provides the
metaphysical element and enables the performance to
become a concretization of an abstract view of man.

Without this base, a performance may be entertain-
ing, in such fields as vaudeville or the circus, but it has
nothing to do with art. The performance of an aerialist,
for instance, demands an enormous physical skill
—greater, perhaps, and harder to acquire than the skill
demanded of a ballet dancer—but what it offers is

merely an exhibition of that skill, with no further meaning, i.e., a concrete, not a concretization of anything.

In operas and operettas, the esthetic base is music, with the libretto serving only to provide an appropriate emotional context or opportunity for the musical score, and an integrating line for the total performance. (In this respect, there are very few good librettos.) In motion pictures or television, literature is *the* ruler and term-setter, with music serving only as an incidental, background accompaniment. Screen and television plays are subcategories of the drama, and in the dramatic arts *"the play is the thing."* The play is that which makes it art; the play provides the end, to which all the rest is the means.

In all the arts that involve more than one performer, a crucially important artist is the *director*. (In music, his counterpart is the conductor.) The director is the link between the performing and the primary arts. He is a performer in relation to the primary work, in the sense that his task is the means to the end set by the work—he is a primary artist in relation to the cast, the set designer, the cameramen, etc., in the sense that they are the means to his end, which is the translation of the work into physical action as a meaningful, stylized, integrated whole. In the dramatic arts, the director is the esthetic *integrator*.

This task requires a first-hand understanding of all the arts, combined with an unusual power of abstract thought and of creative imagination. Great directors are extremely rare. An average director alternates between the twin pitfalls of abdication and usurpation. Either he rides on the talents of others and merely puts the actors through random motions signifying nothing, which results in a hodgepodge of clashing intentions—or he hogs the show, putting everyone through senseless tricks unrelated to or obliterating the play (if any), on the inverted premise that the play is the means to the end of exhibiting *his* skill, thus placing himself in the category of circus acrobats, except that he is much less skillful and much less entertaining.

As an example of film direction at its best, I shall

mention Fritz Lang, particularly in his earlier work; his silent film *Siegfried* is as close to a great work of art as the films have yet come. Though other directors seem to grasp it occasionally, Lang is the only one who has fully understood the fact that *visual* art is an intrinsic part of films in a much deeper sense than the mere selection of sets and camera angles—that a "motion picture" is literally *that*, and has to be a stylized visual composition in motion.

It has been said that if one stopped the projection of *Siegfried* and cut out a film frame at random, it would be as perfect in composition as a great painting. Every action, gesture and movement in this film is calculated to achieve that effect. Every inch of the film is *stylized*, i.e., condensed to those stark, bare essentials which convey the nature and spirit of the story, of its events, of its locale. The entire picture was filmed indoors, including the magnificent legendary forests whose every branch was man-made (but does not look so on the screen). While Lang was making *Siegfried*, it is reported, a sign hung on the wall of his office: "Nothing in this film is accidental." *This* is the motto of great art. Very few artists, in any field, have ever been able to live up to it. Fritz Lang did.

There are certain flaws in *Siegfried*, particularly the nature of the story which is a tragic, "malevolent universe" legend—but this is a metaphysical, not an esthetic, issue. From the aspect of a director's creative task, this film is an example of the kind of visual stylization that makes the difference between a work of art and a glorified newsreel.

Potentially, motion pictures are a great art, but that potential has not as yet been actualized, except in single instances and random moments. An art that requires the synchronization of so many esthetic elements and so many different talents cannot develop in a period of philosophical-cultural disintegration such as the present. Its development requires the creative cooperation of men who are united, not necessarily by their formal philosophical convictions, but by their fundamental view of man, i.e., by their sense of life.

Whatever the variety and the vast potential of the

performing arts, one must always remember that they are a consequence and an extension of the primary arts —and that the primary arts give them the abstract meaning without which no human product or activity can be classified as art.

The question asked at the start of this discussion was: What are the valid forms of art—and why these? It can now be answered: the proper forms of art present a selective re-creation of reality in terms needed by man's *cognitive faculty*, which includes his entity-perceiving senses, and thus assist the integration of the various elements of a *conceptual* consciousness. Literature deals with concepts, the visual arts with sight and touch, music with hearing. Each art fulfills the function of bringing man's concepts to the perceptual level of his consciousness and allowing him to grasp them directly, as if they were percepts. (The performing arts are a means of further concretization.) The different branches of art serve to unify man's consciousness and offer him a coherent view of existence. Whether that view is true or false is not an esthetic matter. The crucially esthetic matter is psycho-epistemological: *the integration of a conceptual consciousness*.

This is the reason why all the arts were born in prehistoric times, and why man can never develop a *new* form of art. The forms of art do not depend on the *content* of man's consciousness, but on its *nature*—not on the extent of man's knowledge, but on the means by which he acquires it. (In order to develop a new form of art, man would have to acquire a new sense organ.)

The growth of man's knowledge makes possible an unlimited growth and development of the arts. Scientific discoveries give rise to new subcategories in the various branches of art. But these are variants and subcategories (or combinations) of the same fundamental arts. Such variants require new rules, new methods, new techniques, but *not* a change of basic principles. For example, different techniques are required to write for the stage or screen or television; but all these media are subcategories of the drama (which is a subcategory of literature) and all are subject to the same basic principles. The wider a given principle, the more innova-

tions and variations it permits and subsumes; but it it-
self is changeless. The breach of a basic principle is not
a "new form of art," but merely the destruction of that
particular art.

For example, the change from Classicism to Roman-
ticism in the theater was a legitimate esthetic innova-
tion; so was the change from Romanticism to Natural-
ism, even if motivated by false metaphysical views. But
the introduction of a narrator into a stage play is not an
innovation, but a breach of the theater's basic principle,
which demands that a story be dramatized, i.e., pre-
sented in action; such a breach is not a "new form of
art," but simply an encroachment by incompetence on
a very difficult form, and a wedge for the eventual de-
struction of that particular form.

A certain type of confusion about the relationship be-
tween scientific discoveries and art, leads to a frequently
asked question: Is photography an art? The answer is:
No. It is a technical, not a creative, skill. Art requires a
selective re-creation. A camera cannot perform the basic
task of painting: a visual conceptualization, i.e., the cre-
ation of a concrete in terms of abstract essentials. The
selection of camera angles, lighting or lenses is merely a
selection of the means to reproduce various aspects of
the given, i.e., of an existing concrete. There is an artis-
tic element in some photographs, which is the result of
such selectivity as the photographer can exercise, and
some of them can be very beautiful—but the same artis-
tic element (purposeful selectivity) is present in many
utilitarian products: in the better kinds of furniture,
dress design, automobiles, packaging, etc. The commer-
cial art work in ads (or posters or postage stamps) is
frequently done by real artists and has greater esthetic
value than many paintings, but utilitarian objects can-
not be classified as works of art.

(If it is asked, at this point: But why, then, is a film
director to be regarded as an artist?—the answer is: It
is the *story* that provides an abstract meaning which
the film concretizes; without a story, a director is
merely a pretentious photographer.)

A similar type of confusion exists in regard to the
decorative arts. The task of the decorative arts is to or-

nament utilitarian objects, such as rugs, textiles, lighting fixtures, etc. This is a valuable task, often performed by talented artists, but it is not an art in the esthetic-philosophical meaning of the term. The psycho-epistemological base of the decorative arts is not conceptual, but purely sensory: their standard of value is appeal to the senses of sight and/or touch. Their material is colors and shapes in nonrepresentational combinations conveying no meaning other than visual harmony; the meaning or purpose is concrete and lies in the specific object which they decorate.

As a re-creation of reality, a work of art has to be representational; its freedom of stylization is limited by the requirement of intelligibility; if it does not present an intelligible subject, it ceases to be art. On the other hand, a representational element is a detriment in the decorative arts, it is an irrelevant distraction, a clash of intentions. And although designs of little human figures or landscapes or flowers are often used to decorate textiles or wallpaper, they are artistically inferior to the nonrepresentational designs. When recognizable objects are subordinated to and treated as a mere pattern of colors and shapes, they become incongruous.

(Color harmony is a legitimate element, but only one out of many more significant elements, in the art of painting. But, in painting, colors and shapes are not treated as a decorative pattern.)

Visual harmony is a sensory experience and is determined primarily by physiological causes. There is a crucial difference between the perception of musical sounds and the perception of colors: the integration of musical sounds produces a new cognitive experience which is sensory-conceptual, i.e., the awareness of a melody; the integration of colors does not, it conveys nothing beyond the awareness of pleasant or unpleasant relationships. Cognitively, the sensation of color qua color is of no significance because color serves an incomparably more important function: the sensation of color is the central element of the faculty of sight, it is one of the fundamental means of perceiving entities. Color as such (and its physical causes) is not an entity, but an *attribute* of entities and cannot exist by itself.

This fact is ignored by the men who make pretentious attempts to create "a new art" in the form of "color symphonies" which consist in projecting moving blobs of color on a screen. This produces nothing, in a viewer's consciousness, but the boredom of being unemployed. It could conceivably produce an appropriate *decorative* effect at a carnival or in a night club on New Year's Eve, but it has no relation to art.

Such attempts, however, can be classified as anti-art for the following reason: the essence of art is integration, a kind of super-integration in the sense that art deals with man's widest abstractions, his metaphysics, and thus expands the power of man's consciousness. The notion of "color symphonies" is a trend in the opposite direction: it is an attempt to *disintegrate* man's consciousness and reduce it to a pre-perceptual level by breaking up percepts into mere sensations.

This brings us to the subject of modern art.

If a gang of men—no matter what its slogans, motives or goals—were roaming the streets and gouging out people's eyes, people would rebel and would find the words of a righteous protest. But when such a gang is roaming the culture, bent on annihilating men's minds, people remain silent. The words they need can be supplied only by philosophy, but modern philosophy is the sponsor and spawner of that gang.

Man's mind is much more complex than the best computer, and much more vulnerable. If you have seen a news photograph of brutes smashing a computer, you have seen a physical concretization of the psychological process now going on, which is initiated in the plate-glass windows of art galleries, on the walls of fashionable restaurants and of multibillion-dollar business offices, in the glossy pages of popular magazines, in the technological radiance of movie and television screens.

Decomposition is the postscript to the death of a human body; disintegration is the preface to the death of a human mind. Disintegration is the keynote and goal of modern art—the disintegration of man's conceptual faculty, and the retrogression of an adult mind to the state of a mewling infant.

To reduce man's consciousness to the level of sensa-

tions, with no capacity to integrate them, is the intention behind the reducing of language to grunts, of literature to "moods," of painting to smears, of sculpture to slabs, of music to noise.

But there is a philosophically and psychopathologically instructive element in the spectacle of that gutter. It demonstrates—by the negative means of an absence—the relationships of art to philosophy, of reason to man's survival, of hatred for reason to hatred for existence. After centuries of the philosophers' war against reason, they have succeeded—by the method of vivisection—in producing exponents of what man is like when deprived of his rational faculty, and these in turn are giving us images of what existence is like to a being with an empty skull.

While the alleged advocates of reason oppose "system-building" and haggle apologetically over concrete-bound words or mystically floating abstractions, its enemies seem to know that *integration* is the psychoepistemological key to reason, that art is man's psychoepistemological conditioner, and that if reason is to be destroyed, it is man's integrating capacity that has to be destroyed.

It is highly doubtful that the practitioners and admirers of modern art have the intellectual capacity to understand its philosophical meaning; all they need to do is indulge the worst of their subconscious premises. But their leaders do understand the issue consciously: the father of modern art is Immanuel Kant (see his *Critique of Judgment*).

I do not know which is worse: to practice modern art as a colossal fraud or to do it sincerely.

Those who do not wish to be the passive, silent victims of frauds of this kind, can learn from modern art the *practical* importance of philosophy, and the consequences of philosophical default. Specifically, it is the destruction of logic that disarmed the victims, and, more specifically, the destruction of definitions. Definitions are the guardians of rationality, the first line of defense against the chaos of mental disintegration.

Works of art—like everything else in the universe—are entities of a specific nature: the concept requires a

definition by their essential characteristics, which distinguish them from all other existing entities. The *genus* of art works is: man-made objects which present a selective re-creation of reality according to the artist's metaphysical value-judgments, by means of a specific material medium. The *species* are the works of the various branches of art, defined by the particular media which they employ and which indicate their relation to the various elements of man's cognitive faculty.

Man's need of precise definitions rests on the Law of Identity: A is A, a thing is itself. A work of art is a specific entity which possesses a specific nature. If it does not, it is not a work of art. If it is merely a material object, it belongs to some category of material objects—and if it does not belong to any particular category, it belongs to the one reserved for such phenomena: junk.

"Something made by an artist" is *not* a definition of art. A beard and a vacant stare are *not* the defining characteristics of an artist.

"Something in a frame hung on a wall" is *not* a definition of painting.

"Something with a number of pages in a binding" is *not* a definition of literature.

"Something piled together" is *not* a definition of sculpture.

"Something made of sounds produced by anything" is *not* a definition of music.

"Something glued on a flat surface" is *not* a definition of any art. There is no art that uses glue as a medium. Blades of grass glued on a sheet of paper to represent grass might be good occupational therapy for retarded children—though I doubt it—but it is *not* art.

"Because I felt like it" is *not* a definition or validation of anything.

There is no place for *whim* in any human activity—if it is to be regarded as human. There is no place for the unknowable, the unintelligible, the undefinable, the non-objective in any human product. This side of an insane asylum, the actions of a human being are motivated by a conscious purpose; when they are not, they are of no interest to anyone outside a psychotherapist's

office. And when the practitioners of modern art declare that they don't know what they are doing or what makes them do it, we should take their word for it and give them no further consideration.

(April-June 1971)

5. Basic Principles
of Literature

THE MOST important principle of the esthetics of literature was formulated by Aristotle, who said that fiction is of greater philosophical importance than history, because "history represents things as they are, while fiction represents them as they might be and ought to be."

This applies to all forms of literature and most particularly to a form that did not come into existence until twenty-three centuries later: the novel.

A novel is a long, fictional story about human beings and the events of their lives. The four essential attributes of a novel are: Theme—Plot—Characterization—Style.

These are *attributes*, not separable parts. They can be isolated conceptually for purposes of study, but one must always remember that they are interrelated and that a novel is their sum. (If it is a good novel, it is an indivisible sum.)

These four attributes pertain to all forms of literature, i.e., of fiction, with one exception. They pertain to

novels, plays, scenarios, librettos, short stories. The single exception is poems. A poem does not have to tell a story; its basic attributes are theme and style.

A novel is *the* major literary form—in respect to its scope, its inexhaustible potentiality, its almost unlimited freedom (including the freedom from physical limitations of the kind that restrict a stage play) and, most importantly, in respect to the fact that a novel is a purely *literary* form of art which does not require the intermediary of the performing arts to achieve its ultimate effect.

I shall discuss the four major attributes of a novel, but I shall ask you to remember that the same basic principles apply, with appropriate qualifications, to the other literary forms.

1. Theme. A theme is the summation of a novel's abstract meaning. For instance, the theme of *Atlas Shrugged* is: "The role of the mind in man's existence." The theme of Victor Hugo's *Les Misérables* is: "The injustice of society toward its lower classes." The theme of *Gone With the Wind* is: "The impact of the Civil War on Southern society."

A theme may be specifically philosophical or it may be a narrower generalization. It may present a certain moral-philosophical position or a purely historical view, such as the portrayal of a certain society in a certain era. There are no rules or restrictions on the choice of a theme, provided it is communicable in the form of a novel. But if a novel has no discernible theme—if its events add up to nothing—it is a bad novel; its flaw is lack of integration.

Louis H. Sullivan's famous principle of architecture, "Form follows function," can be translated into: "Form follows purpose." The theme of a novel defines its purpose. The theme sets the writer's standard of selection, directing the innumerable choices he has to make and serving as the integrator of the novel.

Since a novel is a re-creation of reality, its theme has to be dramatized, i.e., presented in terms of action. Life is a process of action. The entire content of man's consciousness—thought, knowledge, ideas, values—has only one ultimate form of expression: in his actions; and

only one ultimate purpose: to guide his actions. Since the theme of a novel is an idea about or pertaining to human existence, it is in terms of its effects on or expression in human actions that that idea has to be presented.

This leads to *the* crucial attribute of a novel—the *plot.*

2. Plot. To present a story in terms of action means: to present it in terms of events. A story in which nothing happens is not a story. A story whose events are haphazard and accidental is either an inept conglomeration or, at best, a chronicle, a memoir, a reportorial recording, *not* a novel.

A chronicle, real or invented, may possess certain values; but these values are primarily informative— historical or sociological or psychological—not primarily esthetic or literary; they are only partly literary. Since art is a selective re-creation and since events are the building blocks of a novel, a writer who fails to exercise selectivity in regard to events defaults on the most important aspect of his art.

The means of exercising that selectivity and of integrating the events of a story is the plot.

A plot is a purposeful progression of logically connected events leading to the resolution of a climax.

The word "purposeful" in this definition has two applications: it applies to the author and to the characters of a novel. It demands that the author devise a logical structure of events, a sequence in which every major event is connected with, determined by and proceeds from the preceding events of the story—a sequence in which nothing is irrelevant, arbitrary or accidental, so that the logic of the events leads inevitably to a final resolution.

Such a sequence cannot be constructed unless the main characters of the novel are engaged in the pursuit of some purpose—unless they are motivated by some goals that direct their actions. In real life, only a process of final causation—i.e., the process of choosing a goal, then taking the steps to achieve it—can give logical continuity, coherence and meaning to a man's

actions. Only men striving to achieve a purpose can move through a meaningful series of events.

Contrary to the prevalent literary doctrines of today, it is *realism* that demands a plot structure in a novel. All human actions are goal-directed, consciously or subconsciously; purposelessness is contrary to man's nature: it is a state of neurosis. Therefore, if one is to present man *as he is*—as he is metaphysically, by his nature, in reality—one has to present him in goal-directed action.

The Naturalists object that a plot is an artificial contrivance, because in "real life" events do not fall into a logical pattern. That claim depends on the observer's viewpoint, in the literal sense of the word "viewpoint." A nearsighted man standing two feet away from the wall of a house and staring at it, would declare that the map of the city's streets is an artificial, invented contrivance. That is not what an airplane pilot would say, flying two thousand feet above the city. The events of men's lives follow the logic of men's premises and values—as one can observe if one looks past the range of the immediate moment, past the trivial irrelevancies, repetitions and routines of daily living, and sees the essentials, the turning points, the direction of a man's life. And, from that viewpoint, one can also observe that the accidents or disasters, which interfere with or defeat human goals, are a minor and marginal, not a major and determining, element in the course of human existence.

The Naturalists object that most men do not lead purposeful lives. But it has been said that if a writer writes about dull people, he does not have to be dull. In the same way, if a writer writes about purposeless people, his story structure does not have to be purposeless (provided some of his characters do have a purpose).

The Naturalists object that the events of men's lives are inconclusive, diffuse and seldom fall into the clear-cut, dramatic situations required by a plot structure. This is predominantly true—and this is the chief esthetic argument *against* the Naturalist position. Art is a selective re-creation of reality, its means are evaluative

abstractions, its task is the concretization of metaphysical essentials. To isolate and bring into clear focus, into a single issue or a single scene, the essence of a conflict which, in "real life," might be atomized and scattered over a lifetime in the form of meaningless clashes, to condense a long, steady drizzle of buckshot into the explosion of a blockbuster—*that* is the highest, hardest and most demanding function of art. To default on that function is to default on the essence of art and to engage in child's play along its periphery.

For example: most men have inner conflicts of values; these conflicts, in most lives, take the form of small irrationalities, petty inconsistencies, mean little evasions, shabby little acts of cowardice, with no crucial moments of choice, no vital issues or great, decisive battles—and they add up to the stagnant, wasted life of a man who has betrayed all his values by the method of a leaking faucet. Compare that to Gail Wynand's conflict of values in regard to Howard Roark's trial in *The Fountainhead*—and decide which, esthetically, is the right way to present the ravages of a conflict of values.

From the aspect of universality as an important attribute of art, I will add that Gail Wynand's conflict, being a wide abstraction, can be reduced in scale and made applicable to the value-conflicts of a grocery clerk. But the value-conflicts of a grocery clerk cannot be made applicable to Gail Wynand, nor even to another grocery clerk.

The plot of a novel serves the same function as the steel skeleton of a skyscraper: it determines the use, placement and distribution of all the other elements. Matters such as number of characters, background, descriptions, conversations, introspective passages, etc. have to be determined by what the plot can carry, i.e., have to be integrated with the events and contribute to the progression of the story. Just as one cannot pile extraneous weight or ornamentation on a building without regard for the strength of its skeleton, so one cannot burden a novel with irrelevancies without regard for its plot. The penalty, in both cases, is the same: the collapse of the structure.

If the characters of a novel engage in lengthy ab-

stract discussions of their ideas, but their ideas do not affect their actions or the events of the story, it is a bad novel. An example of that kind is *The Magic Mountain* by Thomas Mann. Its characters periodically interrupt the story to philosophize about life, after which the story—or lack of it—goes on.

A related, though somewhat different, example of a bad novel is *An American Tragedy* by Theodore Dreiser. Here, the author attempts to give significance to a trite story by tacking on to it a theme which is not related to or demonstrated by its events. The events deal with an age-old subject: the romantic problem of a rotten little weakling who murders his pregnant sweetheart, a working girl, in order to attempt to marry a rich heiress. The alleged theme, according to the author's assertions, is: "The evil of capitalism."

In judging a novel, one must take the events as expressing its *meaning*, because it is the events that present what the story is about. No amount of esoteric discussions on transcendental topics, attached to a novel in which nothing happens except "boy meets girl," will transform it into anything other than "boy meets girl."

This leads to a cardinal principle of good fiction: *the theme and the plot of a novel must be integrated*—as thoroughly integrated as mind and body or thought and action in a rational view of man.

The link between the theme and the events of a novel is an element which I call the *plot-theme*. It is the first step of the translation of an abstract theme into a story, without which the construction of a plot would be impossible. A "plot-theme" is the central conflict or "situation" of a story—a conflict in terms of action, corresponding to the theme and complex enough to create a purposeful progression of events.

The *theme* of a novel is the core of its abstract meaning—the *plot-theme* is the core of its events.

For example, the theme of *Atlas Shrugged* is: "The role of the mind in man's existence." The plot-theme is: "The men of the mind going on strike against an altruist-collectivist society."

The theme of *Les Misérables* is: "The injustice of

society toward its lower classes." The plot-theme is:
"The life-long flight of an ex-convict from the pursuit
of a ruthless representative of the law."

The theme of *Gone With the Wind* is: "The impact of
the Civil War on Southern society." The plot-theme is:
"The romantic conflict of a woman who loves a man
representing the old order, and is loved by another
man, representing the new." (Margaret Mitchell's skill,
in this novel, lies in the fact that the developments of
the romantic triangle are determined by the events of
the Civil War and involve, in a single plot structure,
other characters who are representative of the various
levels of Southern society.)

The integration of an important theme with a com-
plex plot structure is the most difficult achievement
possible to a writer, and the rarest. Its great masters are
Victor Hugo and Dostoevsky. If you wish to see liter-
ary art at its highest, study the manner in which the
events of their novels proceed from, express, illustrate
and dramatize their themes: the integration is so perfect
that no other events could have conveyed the theme,
and no other theme could have created the events.

(I must mention, parenthetically, that Victor Hugo
interrupts his stories to insert historical essays dealing
with various aspects of his subject. It is a very bad
literary error, but it was a convention shared by many
writers of the nineteenth century. It does not detract
from Hugo's achievement, because these essays can be
omitted without affecting the structure of the novels.
And, although they do not properly belong in a novel,
these essays, as such, are brilliant literarily.)

Since a plot is the dramatization of goal-directed
action, it has to be based on *conflict*; it may be one
character's inner conflict or a conflict of goals and
values between two or more characters. Since goals are
not achieved automatically, the dramatization of a pur-
poseful pursuit has to include obstacles; it has to in-
volve a clash, a struggle—an action struggle, but not a
purely physical one. Since art is a concretization of
values, there are not many errors as bad esthetically—
or as dull—as fist fights, chases, escapes and other
forms of physical action, divorced from any psychologi-

cal conflict or intellectual value-meaning. Physical action, as such, is not a plot nor a substitute for a plot—as many bad writers attempt to make it, particularly in today's television dramas.

This is the other side of the mind-body dichotomy that plagues literature. Ideas or psychological states divorced from action do not constitute a story—and neither does physical action divorced from ideas and values.

Since the nature of an action is determined by the nature of the entities that act, the action of a novel has to proceed from and be consistent with the nature of its characters. This leads to the third major attribute of a novel—

3. **Characterization.** Characterization is the portrayal of those essential traits which form the unique, distinctive personality of an individual human being.

Characterization requires an extreme degree of selectivity. A human being is the most complex entity on earth; a writer's task is to select the essentials out of that enormous complexity, then proceed to create an individual figure, endowing it with all the appropriate details down to the telling small touches needed to give it full reality. That figure has to be an abstraction, yet look like a concrete; it has to have the universality of an abstraction and, simultaneously, the unrepeatable uniqueness of a *person*.

In real life, we have only two sources of information about the character of the people around us: we judge them by what they do and by what they say (particularly the first). Similarly, characterization in a novel can be achieved only by two major means: *action* and *dialogue*. Descriptive passages dealing with a character's appearance, manner, etc. can contribute to a characterization; so can introspective passages dealing with a character's thoughts and feelings; so can the comments of other characters. But all these are merely auxiliary means, which are of no value without the two pillars: action and dialogue. To re-create the reality of a character, one must show what he does and what he says.

One of the worst errors that a writer can make in the field of characterization is to assert the nature of his

characters in narrative passages, with no evidence to support his assertions in the characters' actions. For instance, if an author keeps telling us that his hero is "virtuous," "benevolent," "sensitive," "heroic," but the hero does nothing except that he loves the heroine, smiles at the neighbors, contemplates the sunset and votes for the Democratic Party—the result can hardly be called characterization.

A writer, like any other artist, must present an evaluative re-creation of reality, not merely assert his evaluations without any image of reality. In the field of characterization, one action is worth a thousand adjectives.

Characterization requires the portrayal of *essential* traits. Now what are the essentials of a man's character?

What do we mean, in real life, when we say that we do not understand a person? We mean that we do not understand why he acts as he does. And when we say that we know a person well, we mean that we understand his actions and know what to expect of him. What is it that we know? His *motivation*.

Motivation is a key-concept in psychology and in fiction. It is a man's basic premises and values that form his character and move him to action—and in order to understand a man's character, it is the motivation behind his actions that we must understand. To know "what makes a man tick," we must ask: "What is he after?"

To re-create the reality of his characters, to make both their nature and their actions intelligible, it is their motivation that a writer has to reveal. He may do it gradually, revealing it bit by bit, building up the evidence as the story progresses, but at the end of the novel the reader must know *why* the characters did the things they did.

The depth of a characterization depends on the psychological level of motivation which a writer regards as sufficient to illuminate human behavior. For instance, in an average detective story, the criminals are motivated by the superficial notion of "material greed"—but a novel such as Dostoevsky's *Crime and Punishment* reveals the soul of a criminal all the way down to his philosophical premises.

Consistency is a major requirement of characterization. This does not mean that a character has to hold nothing but consistent premises—some of the most interesting characters in fiction are men torn by inner conflicts. It means that the author has to be consistent in his view of a character's psychology and permit him no inexplicable actions, no actions unprepared by or contradictory to the rest of his characterization. It means that a character's contradictions should never be *unintentional* on the part of the author.

To maintain the inner logic of his characterizations, a writer must understand the logical chain that leads from the motives of his characters to their actions. To maintain their motivational consistency, he must know their basic premises and the key actions to which these premises will lead them in the course of the story. When he writes the actual scenes in which the characters appear, their premises act as the selectors of all the details and small touches he decides to include. Such details are innumerable, the opportunities for revealing a character's nature are virtually inexhaustible, and it is the knowledge of what he has to reveal that guides the writer's selections.

The best way to demonstrate what the process of characterization accomplishes, the means by which it is done, and the disastrous consequences of contradictions, is to illustrate it in action on a specific example.

I shall do it by means of two scenes reproduced below: one is a scene from *The Fountainhead*, as it stands in the novel—the other is the same scene, as I rewrote it for the purpose of this demonstration. Both versions present only the bare skeleton of the scene, only the dialogue, omitting the descriptive passages. It will be sufficient to illustrate the process.

It is the first scene in which Howard Roark and Peter Keating appear together. It takes place on the evening of the day when Roark was expelled from college and Keating graduated with high honors. The action of the scene consists of one young man asking the advice of another about a professional choice he has to make. But what kind of young men are they? What are their attitudes, premises and motives? Observe what

one can learn from a single scene and how much your, the reader's, mind registers automatically.

Here is the scene as originally written, as it stands in the novel:

"Congratulations, Peter," said Roark.

"Oh . . . Oh, thanks . . . I mean . . . do you know or . . . Has mother been telling you?"

"She has."

"She shouldn't have!"

"Why not?"

"Look, Howard, you know that I'm terribly sorry about your being . . ."

"Forget it."

"I . . . there's something I want to speak to you about, Howard, to ask your advice. Mind if I sit down?"

"What is it?"

"You won't think that it's awful of me to be asking about my business, when you've just been . . . ?"

"I said forget about that. What is it?"

"You know, I've often thought that you're crazy. But I know that you know many things about it— architecture, I mean—which those fools never knew. And I know that you love it as they never will."

"Well?"

"Well, I don't know why I should come to you, but —Howard, I've never said it before, but you see, I'd rather have your opinion on things than the Dean's— I'd probably follow the Dean's, but it's just that yours means more to me myself, I don't know why. I don't know why I'm saying this, either."

"Come on, you're not being afraid of me, are you? What do you want to ask about?"

"It's about my scholarship. The Paris prize I got."

"Yes?"

"It's for four years. But, on the other hand, Guy Francon offered me a job with him some time ago. Today he said it's still open. And I don't know which to take."

"If you want my advice, Peter, you've made a mistake already. By asking me. By asking anyone. Never ask people. Not about your work. Don't you know what you want? How can you stand it, not to know?"

"You see, that's what I admire about you, Howard. You always know."

"Drop the compliments."

"But I mean it. How do you always manage to decide?"

"How can you let others decide for you?"

This was the scene as it stands in the novel. Now here is the same scene, *rewritten:*

"Congratulations, Peter," said Roark.

"Oh . . . Oh, thanks . . . I mean . . . do you know or . . . Has mother been telling you?"

"She has."

"She shouldn't have!"

"Oh well, I didn't mind it."

"Look, Howard, you know that I'm terribly sorry about your being expelled."

"Thank you, Peter."

"I . . . there's something I want to speak to you about, Howard, to ask your advice. Mind if I sit down?"

"Go right ahead. I'll be glad to help you, if I can."

"You won't think that it's awful of me to be asking about my business, when you've just been expelled?"

"No. But it's nice of you to say that, Peter. I appreciate it."

"You know, I've often thought that you're crazy."

"Why?"

"Well, the kind of ideas you've got about architecture—there's nobody that's ever agreed with you, nobody of importance, not the Dean, not any of the professors . . . and they know their business. They're always right. I don't know why I should come to you."

"Well, there are many different opinions in the world. What did you want to ask me?"

"It's about my scholarship. The Paris prize I got."

"Personally, I wouldn't like it. But I know it's important to you."

"It's for four years. But, on the other hand, Guy Francon offered me a job with him some time ago. Today he said it's still open. And I don't know which to take."

"If you want my advice, Peter, take the job with Guy Francon. I don't care for his work, but he's a very prominent architect and you'll learn how to build."

"You see, that's what I admire about you, Howard. You always know how to decide."

"I try my best."

"How do you do it?"

"I guess I just do it."

"But you see, I'm not sure, Howard. I'm never sure of myself. You always are."

"Oh, I wouldn't say that. But I guess I'm sure about my work."

This is an example of "humanizing" a character.

A young reader to whom I showed this scene said with astonished indignation: "He's not awful—he's just completely ordinary!"

Let us analyze what the two scenes have conveyed.

In the *original scene,* Roark is impervious to Keating's or the world's view of his expulsion. He does not even conceive of any "comparative standard," of any relation between his expulsion and Keating's success.

Roark is courteous to Keating, but completely indifferent.

Roark relents and shows a touch of friendliness only when Keating acknowledges his respect for Roark's architectural ideas and only when Keating shows an earnest sincerity.

Roark's advice to Keating about independence shows the generosity of taking Keating's problem seriously— Roark gives him advice, not about a specific choice, but about a crucial basic principle. The essence of the difference between their fundamental premises is focused in two lines of dialogue. *Keating:* "How do you always manage to decide?"—*Roark:* "How can you let others decide for you?"

In the *rewritten scene,* Roark accepts the standards of Keating and his mother—the estimate of his expulsion as disaster and of Keating's graduation as triumph —but he is generously tolerant about it.

Roark shows interest in Keating's future and eagerness to help him.

Roark accepts the charity of Keating's condolences.

At Keating's insulting comment on his ideas, Roark shows concern by asking: "Why?"

Roark shows a tolerant respect for all differences of opinion, thus confessing a non-objective, relativistic view of ideas and values.

Roark gives Keating specific advice about his choice,

finding nothing wrong in Keating's reliance on another man's judgment.

Roark is modest about his self-confidence and tries to minimize it. He does not hold self-confidence as a major virtue, he sees no wider principle, no reason why he should be confident in issues other than his work. Thus he indicates that he is merely a superficial, concrete-bound professional man, who might have some integrity in regard to his work, but no wider concept of integrity, no wider principles, no philosophical convictions or values.

If Roark were that type of man, he would not be able to withstand for more than a year or two the kind of battle he had to fight for the next eighteen years; nor would he be able to win it. If that rewritten scene were used in the novel, instead of the original scene (with a few other "softening" touches to match it), none of the subsequent events of the story would make sense, Roark's later actions would become incomprehensible, unjustifiable, psychologically impossible, his characterization would fall apart, and so would the story, and so would the novel.

Now it should be clear why the major elements of a novel are attributes, not separable parts, and in what manner they are interrelated. The theme of a novel can be conveyed only through the events of the plot, the events of the plot depend on the characterization of the men who enact them—and the characterization cannot be achieved except through the events of the plot, and the plot cannot be constructed without a theme.

This is the kind of integration required by the nature of a novel. And this is why a good novel is an indivisible sum: every scene, sequence and passage of a good novel has to involve, contribute to and advance all three of its major attributes: theme, plot, characterization.

There is no rule about which of these three attributes should come first to a writer's mind and initiate the process of constructing a novel. A writer may begin by choosing a theme, then translate it into the appropriate plot and the kind of characters needed to enact it. Or he may begin by thinking of a plot, that is, a plot-theme,

then determine the characters he needs and define the abstract meaning his story will necessarily imply. Or he may begin by projecting certain characters, then determine what conflicts their motives will lead to, what events will result, and what will be the story's ultimate meaning. It does not matter where a writer begins, provided he knows that all three attributes have to unite into so well integrated a sum that no starting point can be discerned.

As to the fourth major attribute of a novel, the *style*, it is the means by which the other three are presented.

4. Style. The subject of style is so complex that it cannot be covered in a single discussion. I shall merely indicate a few essentials.

A literary style has two fundamental elements (each subsuming a large number of lesser categories): the "choice of content" and the "choice of words." By "choice of content" I mean those aspects of a given passage (whether description, narrative or dialogue) which a writer chooses to communicate (and which involve the consideration of what to include or to omit). By "choice of words" I mean the particular words and sentence structures a writer uses to communicate them.

For instance, when a writer describes a beautiful woman, his stylistic "choice of content" will determine whether he mentions (or stresses) her face or body or manner of moving or facial expression, etc.; whether the details he includes are essential and significant or accidental and irrelevant; whether he presents them in terms of facts or of evaluations; etc. His "choice of words" will convey the emotional implications or connotations, the value-slanting, of the particular content he has chosen to communicate. (He will achieve a different effect if he describes a woman as "slender" or "thin" or "svelte" or "lanky," etc.)

Let us compare the literary style of two excerpts from two different novels, reproduced below. Both are descriptions of the same subject: New York City at night. Observe which one of them re-creates the visual reality of a specific scene, and which one deals with vague, emotional assertions and floating abstractions.

First excerpt:

Nobody ever walked across the bridge, not on a night like this. The rain was misty enough to be almost fog-like, a cold gray curtain that separated me from the pale ovals of white that were faces locked behind the steamed-up windows of the cars that hissed by. Even the brilliance that was Manhattan by night was reduced to a few sleepy, yellow lights off in the distance.

Some place over there I had left my car and started walking, burying my head in the collar of my raincoat, with the night pulled in around me like a blanket. I walked and I smoked and I flipped the spent butts ahead of me and watched them arch to the pavement and fizzle out with one lost wink.

Second excerpt:

That hour, that moment, and that place struck with a peerless co-incision upon the very heart of his own youth, the crest and zenith of his own desire. The city had never seemed as beautiful as it looked that night. For the first time he saw that New York was supremely, among the cities of the world, the city of the night. There had been achieved here a loveliness that was astounding and incomparable, a kind of modern beauty, inherent to its place and time, that no other place nor time could match. He realized suddenly that the beauty of other cities of the night—of Paris spread below one from the butte of Sacré-Coeur, in its vast, mysterious blossoms of nocturnal radiance; of London with its smoky nimbus of fogged light, which was so peculiarly thrilling because it was so vast, so lost in the illimitable—had each its special quality, so lovely and mysterious, but had yet produced no beauty that could equal this.

The first excerpt is by Mickey Spillane, from his novel *One Lonely Night*. The second excerpt is by Thomas Wolfe, from his novel *The Web and the Rock*.

Both writers had to re-create a visual scene and convey a certain mood. Observe the difference in their methods. There is not a single emotional word or adjective in Spillane's description; he presents nothing save visual facts; but he selects only those facts, only those

eloquent details, which convey the visual reality of the
scene and create a mood of desolate loneliness. Wolfe
does not describe the city; he does not give us a single
characteristic visual detail. He asserts that the city is
"beautiful," but does not tell us *what* makes it beauti-
ful. Such words as "beautiful," "astounding," "incom-
parable," "thrilling," "lovely" are estimates; in the ab-
sence of any indication of what aroused these estimates,
they are arbitrary assertions and meaningless generali-
ties.

Spillane's style is reality-oriented and addressed to an
objective psycho-epistemology: he provides the facts
and expects the reader to react accordingly. Wolfe's
style is emotion-oriented and addressed to a subjective
psycho-epistemology: he expects the reader to accept
emotions divorced from facts, and to accept them
second-hand.

Spillane has to be read in full focus, because the
reader's own mind has to estimate the given facts and
evoke an appropriate emotion; if one reads him out of
focus, one gets nothing—there are no loose, ready-
made generalizations, no pre-digested emotions. If one
reads Wolfe out of focus, one gets a vague, grandilo-
quent approximation, suggesting that he has said some-
thing important or uplifting; if one reads him in full
focus, one sees that he has said nothing.

These are not the only attributes of a literary style. I
have used these examples only to indicate some very
broad categories. A great many other elements are in-
volved in these two excerpts and in any piece of writ-
ing. Style is the most complex aspect of literature and,
psychologically, the most revealing.

But style is not an end in itself, it is only a means to
an end—the means of telling a story. The writer who
develops a beautiful style, but has nothing to say, rep-
resents a kind of arrested esthetic development; he is
like a pianist who acquires a brilliant technique by
playing finger-exercises, but never gives a concert.

The typical literary product of such writers—and of
their imitators, who possess no style—are so-called
"mood-studies," popular among today's literati, which
are little pieces conveying nothing but a certain mood.

Such pieces are not an art-form, they are merely finger-exercises that never develop into art.

Art is a re-creation of reality, which can and does affect a reader's mood; this, however, is merely one of the by-products of art. But the attempt to affect the reader's mood, by-passing any meaningful re-creation of reality, is an attempt to divorce consciousness from existence—to make consciousness, not reality, the focal point of art, to regard a momentary emotion, a *mood,* as an end in itself.

Observe that a modern painter offers some smears of paint over a crudely inept drawing and boasts about his "color-harmonies"—while to a real painter color-harmony is only one of the means he has to master for the achievement of a much more complex and important end. Similarly, a modern writer offers some evocative sentences, adding up to a trivial vignette, and boasts about the "mood" he has created—while to a real writer the re-creation of a mood is only one of the means he has to master for the achievement of such complex elements as theme, plot, characterization, which have to be integrated into so gigantic an end as a *novel.*

This particular issue is an eloquent illustration of the relationship between philosophy and art. Just as modern philosophy is dominated by the attempt to destroy the conceptual level of man's consciousness and even the perceptual level, reducing man's awareness to mere sensations—so modern art and literature are dominated by the attempt to disintegrate man's consciousness and reduce it to mere sensations, to the "enjoyment" of meaningless colors, noises and moods.

The art of any given period or culture is a faithful mirror of that culture's philosophy. If you see obscene, dismembered monstrosities leering at you from today's esthetic mirrors—the aborted creations of mediocrity, irrationality and panic—you are seeing the embodied, *concretized* reality of the philosophical premises that dominate today's culture. Only in this sense can those manifestations be called "art"—not by the intention or accomplishment of their perpetrators, but only by grace

of the fact that even in usurping the field of art, one cannot escape from its revelatory power.

It is a frightening sight, but it has a certain didactic value: those who do not wish to surrender their future to the mercy and power of unfocused gargoyles, can learn from them what swamp is their breeding ground and what disinfectant is needed to fight them. The swamp is modern philosophy; the disinfectant is reason.

(July–August 1968)

6. What Is Romanticism?

SHE STRAYS TOO FAR
FROM REALITY I DON'T SEE
VOLITION & NATALISM AS
OPPOSITES JK 1991

ROMANTICISM is a category of art based on the recognition of the principle that man possesses the faculty of volition.

Art is a selective re-creation of reality according to an artist's metaphysical value-judgments. An artist re-creates those aspects of reality which represent his fundamental view of man and of existence. In forming a view of man's nature, a fundamental question one must answer is whether man possesses the faculty of volition —because one's conclusions and evaluations in regard to all the characteristics, requirements and actions of man depend on the answer.

Their opposite answers to this question constitute the respective basic premises of two broad categories of art: Romanticism, which recognizes the existence of man's volition—and Naturalism, which denies it.

In the field of literature, the logical consequences of these basic premises (whether held consciously or subconsciously) determine the form of the key elements of a literary work.

1. If man possesses volition, then the crucial aspect of his life is his choice of values—if he chooses values, then he must act to gain and/or keep them—if so, then he must set his goals and engage in purposeful action to achieve them. The literary form expressing the essence of such action is the *plot*. (A plot is a purposeful progression of logically connected events leading to the resolution of a climax.)

The faculty of volition operates in regard to the two fundamental aspects of man's life: consciousness and existence, i.e., his psychological action and his existential action, i.e., the formation of his own character and the course of action he pursues in the physical world. Therefore, in a literary work, both the characterizations and the events are to be created by the author, according to his view of the role of values in human psychology and existence (and according to the code of values he holds to be right). His characters are abstract projections, not reproductions of concretes; they are invented conceptually, not copied reportorially from the particular individuals he might have observed. The specific characters of particular individuals are merely the evidence of their particular value-choices and have no wider metaphysical significance (except as material for the study of the general principles of human psychology); they do not exhaust man's characterological potential.

2. If man does not possess volition, then his life and his character are determined by forces beyond his control—if so, then the choice of values is impossible to him—if so, then such values as he appears to hold are only an illusion, predetermined by the forces he has no power to resist—if so, then he is impotent to achieve his goals or to engage in purposeful action—and if he attempts the illusion of such action, he will be defeated by those forces, and his failure (or occasional success) will have no relation to his actions. The literary form expressing the essence of this view is plotlessness (since there can be no purposeful progression of events, no logical continuity, no resolution, no climax).

If man's character and the course of his life are the product of unknown (or unknowable) forces, then, in a

literary work, both the characterizations and the events are not to be invented by the author, but are to be copied from such particular characters and events as he has observed. Since he denies the existence of any effective motivational principle in human psychology, he cannot create his characters conceptually. He can only observe the people he meets, as he observes inanimate objects, and reproduce them—in the implicit hope that some clue to the unknown forces controlling human destiny may be discovered in such reproductions.

These basic premises of Romanticism and Naturalism (the volition or anti-volition premise) affect all the other aspects of a literary work, such as the choice of theme and the quality of the style, but it is the nature of the story structure—the attribute of plot or plotlessness—that represents the most important difference between them and serves as the main distinguishing characteristic for classifying a given work in one category or the other.

This is not to say that a writer identifies and applies all the consequences of his basic premise by a conscious process of thought. Art is the product of a man's subconscious integrations, of his sense of life, to a larger extent than of his conscious philosophical convictions. Even the choice of the basic premise may be subconscious—since artists, like any other men, seldom translate their sense of life into conscious terms. And, since an artist's sense of life may be as full of contradictions as that of any other man, these contradictions become apparent in his work; the dividing line between Romanticism and Naturalism is not always maintained consistently in every aspect of every given work of art (particularly since one of these basic premises is false). But if one surveys the field of art and studies the works produced, one will observe that the degree of consistency in the consequences of these two basic premises is a remarkably eloquent demonstration of the power of metaphysical premises in the realm of art.

With very rare (and partial) exceptions, Romanticism is non-existent in today's literature. This is not astonishing when one considers the crushing weight of the philosophical wreckage under which generations of men

have been brought up—a wreckage dominated by the doctrines of irrationalism and determinism. In their formative years, young people could not find much evidence on which to develop a rational, benevolent, value-oriented sense of life, neither in philosophical theory nor in its cultural echoes nor in the daily practice of the passively deteriorating society around them.

But observe the psychological symptoms of an unrecognized, unidentified issue: the virulently intense antagonism of today's esthetic spokesmen to any manifestation of the Romantic premise in art. It is particularly the attribute of plot in literature that arouses an impassioned hostility among them—a hostility with deeply personal overtones, too violent for a mere issue of literary canons. If plot were a negligible and inappropriate element of literature, as they claim it to be, why the hysterical hatred in their denunciations? This type of reaction pertains to *metaphysical* issues, i.e., to issues that threaten the foundations of a person's entire view of life (if that view is irrational). What they sense in a plot structure is the implicit premise of volition (and, therefore, of moral values). The same reaction, for the same subconscious reason, is evoked by such elements as heroes or happy endings or the triumph of virtue, or, in the visual arts, beauty. Physical beauty is not a moral or volitional issue—but the *choice* to paint a beautiful human being rather than an ugly one, implies the existence of volition: of choice, standards, values.

The destruction of Romanticism in esthetics—like the destruction of individualism in ethics or of capitalism in politics—was made possible by philosophical default. It is one more demonstration of the principle that that which is not known explicitly is not in man's conscious control. In all three cases, the nature of the fundamental values involved had never been defined explicitly, the issues were fought in terms of nonessentials, and the values were destroyed by men who did not know what they were losing or why.

This was the predominant pattern of issues in the field of esthetics, which, throughout history, has been a virtual monopoly of mysticism. The definition of Romanticism given here is mine—it is not a generally

known or accepted one. There is no generally accepted definition of Romanticism (nor of any key element in art, nor of art itself).

Romanticism is a product of the nineteenth century—a (largely subconscious) result of two great influences: Aristotelianism, which liberated man by validating the power of his mind—and capitalism, which gave man's mind the freedom to translate ideas into practice (the second of these influences was itself the result of the first). But while the practical consequences of Aristotelianism were reaching men's daily existence, its theoretical influence was long since gone: philosophy, since the Renaissance, had been retrogressing overwhelmingly to the mysticism of Plato. Thus the historically unprecedented events of the nineteenth century—the Industrial Revolution, the child-prodigy speed in the growth of science, the skyrocketing standard of living, the liberated torrent of human energy—were left without intellectual direction or evaluation. The nineteenth century was guided, not by an Aristotelian philosophy, but by *an Aristotelian sense of life.* (And, like a brilliantly violent adolescent who fails to translate his sense of life into conscious terms, it burned itself out, choked by the blind confusions of its own overpowering energy.)

Whatever their conscious convictions, the artists of that century's great new school—the Romanticists—picked their sense of life out of the cultural atmosphere: it was an atmosphere of men intoxicated by the discovery of freedom, with all the ancient strongholds of tyranny—of church, state, monarchy, feudalism—crumbling around them, with unlimited roads opening in all directions and no barriers set to their newly unleashed energy. It was an atmosphere best expressed by that century's naive, exuberant and tragically blind belief that human progress, from here on, was to be irresistible and *automatic.*

Esthetically, the Romanticists were the great rebels and innovators of the nineteenth century. But, in their conscious convictions, they were for the most part anti-Aristotelian and leaning toward a kind of wild, freewheeling mysticism. They did not see their own rebel-

lion in fundamental terms; they were rebelling—in the name of the individual artist's freedom—not against determinism, but, much more superficially, against the esthetic "Establishment" of the time: against *Classicism.*

Classicism (an example of a much deeper superficiality) was a school that had devised a set of arbitrary, *concretely* detailed rules purporting to represent the final and absolute criteria of esthetic value. In literature, these rules consisted of specific edicts, loosely derived from the Greek (and French) tragedies, which prescribed every formal aspect of a play (such as the unity of time, place and action) down to the number of acts and the number of verses permitted to a character in every act. Some of that stuff was based on Aristotle's esthetics and can serve as an example of what happens when concrete-bound mentalities, seeking to by-pass the responsibility of thought, attempt to transform abstract principles into concrete prescriptions and to replace creation with imitation. (For an example of Classicism that survived well into the twentieth century, I refer you to the architectural dogmas represented by Howard Roark's antagonists in *The Fountainhead.*)

Even though the Classicists had no answer to *why* their rules were to be accepted as valid (except the usual appeal to tradition, to scholarship and to the prestige of antiquity), this school was regarded as the representative of *reason.*(!)

Such were the roots of one of the grimmest ironies in cultural history: the early attempts to define the nature of Romanticism declared it to be an esthetic school based on *the primacy of emotions*—as against the champions of the primacy of reason, which were the Classicists (and, later, the Naturalists). In various forms, this definition has persisted to our day. It is an example of the intellectually disastrous consequences of definitions by non-essentials—and an example of the penalty one pays for a non-philosophical approach to cultural phenomena.

One can observe the misapprehended element of truth that gave rise to that early classification. What the Romanticists brought to art was *the primacy of values,* an element that had been missing in the stale, arid,

third- and fourth-hand (and rate) repetitions of the Classicists' formula-copying. Values (and value-judgments) are the source of emotions; a great deal of emotional intensity was projected in the work of the Romanticists and in the reactions of their audiences, as well as a great deal of color, imagination, originality, excitement and all the other consequences of a value-oriented view of life. This emotional element was the most easily perceivable characteristic of the new move-ment and it was taken as its defining characteristic, without deeper inquiry.

Such issues as the fact that the primacy of values in human life is not an irreducible primary, that it rests on man's faculty of volition, and, therefore, that the Ro-manticists, philosophically, were the champions of vo-lition (which is the root of values) and not of emotions (which are merely the consequences)—were issues to be defined by philosophers, who defaulted in regard to esthetics as they did in regard to every other crucial aspect of the nineteenth century.

The still deeper issue, the fact that the faculty of *reason* is the faculty of volition, was not known at the time, and the various theories of free will were for the most part of an anti-rational character, thus reinforcing the association of volition with mysticism.

The Romanticists saw their cause primarily as a battle for their right to individuality and—unable to grasp the deepest metaphysical justification of their cause, unable to identify their values in terms of rea-son—they fought for individuality in terms of *feelings*, surrendering the banner of reason to their enemies.

There were other, lesser consequences of this funda-mental error, all of them symptoms of the intellectual confusion of the age. Groping blindly for a metaphysi-cally oriented, grand-scale, exalted way of life, the Ro-manticists, predominantly, were enemies of capitalism, which they regarded as a prosaic, materialistic "petty bourgeois" system—never realizing that it was the only system that could make freedom, individuality and the pursuit of values possible in practice. Some of them chose to be advocates of socialism; some turned for inspiration to the Middle Ages and became shameless

glamorizers of that nightmare era; some ended up where most champions of the non-rational end up: in religion. All of it served to accelerate Romanticism's growing break with reality.

When, in the later half of the nineteenth century, Naturalism rose to prominence and, assuming the mantle of reason and reality, proclaimed the artists' duty to portray "things as they are"—Romanticism did not have much of an opposition to offer.

It must be noted that philosophers contributed to the confusion surrounding the term "Romanticism." They attached the name "Romantic" to certain philosophers (such as Schelling and Schopenhauer) who were avowed mystics advocating the supremacy of emotions, instincts or *will* over reason. This movement in philosophy had no significant relation to Romanticism in esthetics, and the two movements must not be confused. The common nomenclature, however, is significant in one respect: it indicates the depth of the confusion on the subject of *volition*. The "Romantic" philosophers' theories were a viciously malevolent, existence-hating attempt to uphold volition in the name of whim worship, while the esthetic Romanticists were groping blindly to uphold volition in the name of man's life and values here, on earth. In terms of essentials, the brilliant sunlight of Victor Hugo's universe is the diametrical opposite of the venomous muck of Schopenhauer's. It was only philosophical package-dealing that could throw them in the same category. But the issue demonstrates the profound importance of the subject of volition, and the grotesque distortions it assumes when men are unable to grasp its nature. This issue may also serve as an illustration of the importance of establishing that volition is a function of man's rational faculty.

In recent times, some literary historians have discarded, as inadequate, the definition of Romanticism as an emotion-oriented school and have attempted to redefine it, but without success. Following the rule of fundamentality, it is as a *volition*-oriented school that Romanticism must be defined—and it is in terms of this essential characteristic that the nature and history of Romantic literature can be traced and understood.

The (implicit) standards of Romanticism are so demanding that in spite of the abundance of Romantic writers at the time of its dominance, this school has produced very few pure, consistent Romanticists of the top rank. Among novelists, the greatest are Victor Hugo and Dostoevsky, and, as single novels (whose authors were not always consistent in the rest of their works), I would name Henryk Sienkiewicz's *Quo Vadis* and Nathaniel Hawthorne's *The Scarlet Letter*. Among playwrights, the greatest are Friedrich Schiller and Edmond Rostand.

The distinguishing characteristic of this top rank (apart from their purely literary genius) is their full commitment to the premise of volition in *both of its fundamental areas*: in regard to consciousness and to existence, in regard to man's character and to his actions in the physical world. Maintaining a perfect integration of these two aspects, unmatched in the brilliant ingenuity of their plot structures, these writers are enormously concerned with man's soul (i.e., his consciousness). They are *moralists* in the most profound sense of the word; their concern is not merely with values, but specifically with *moral* values and with the power of moral values in shaping human character. Their characters are "larger than life," i.e., they are abstract projections in terms of essentials (not always successful projections, as we shall discuss later). In their stories, one will never find action for action's sake, unrelated to moral values. The events of their plots are shaped, determined and motivated by the characters' values (or treason to values), by their struggle in pursuit of spiritual goals and by profound value-conflicts. Their themes are fundamental, universal, timeless issues of man's existence—and they are the only consistent creators of the rarest attribute of literature: the perfect integration of theme and plot, which they achieve with superlative virtuosity.

If philosophical significance is the criterion of what is to be taken seriously, then these are the most serious writers in world literature.

The second rank of Romanticists (who are still writers of considerable merit, but of lesser stature) indicates

the direction of Romanticism's future decline. This
rank is represented by such writers as Walter Scott and
Alexander Dumas. The distinguishing characteristic of
their work is the emphasis on action, without spiritual
goals or significant moral values. Their stories have
well-built, imaginative, suspenseful plot structures, but
the values pursued by their characters and motivating
the action are of a primitive, superficial, emphatically
non-metaphysical order: loyalty to a king, the reclaim-
ing of a heritage, personal revenge, etc. The conflicts
and story lines are predominantly external. The char-
acters are abstractions, they are not Naturalistic copies,
but they are abstractions of loosely generalized virtues
or vices, and characterization is minimal. In time, they
become a writer's own self-made bromides, such as "a
brave knight," "a noble lady," "a vicious courtier"—so
that they are neither created nor drawn from life, but
picked from a kind of ready-to-wear collection of stock
characters of Romanticism. The absence of any meta-
physical meaning (apart from the affirmation of volition
implicit in a plot structure) is evident in the fact that
these novels have plots, but no abstract themes—with
the story's central conflict serving as the theme, usually
in the form of some actual or fictionalized historical
event.

Going farther down, one can observe the breakup of
Romanticism, the contradictions that proceed from a
premise held subconsciously. On this level, there emer-
ges a class of writers whose basic premise, in effect, is
that man possesses volition *in regard to existence, but
not to consciousness,* i.e., in regard to his physical
actions, but not in regard to his own character. The
distinguishing characteristic of this class is: stories of
unusual events enacted by *conventional* characters. The
stories are abstract projections, involving actions one
does not observe in "real life," the characters are com-
monplace concretes. The stories are Romantic, the
characters Naturalistic. Such novels seldom have plots
(since value-conflicts are not their motivational princi-
ple), but they do have a form resembling a plot: a
coherent, imaginative, often suspenseful story held to-

gether by some one central goal or undertaking of the characters.

The contradictions in such a combination of elements are obvious; they lead to a total breach between action and characterization, leaving the action unmotivated and the characters unintelligible. The reader is left to feel: "These people couldn't do these things!"

With its emphasis on sheer physical action and neglect of human psychology, this class of novels stands on the borderline between serious and popular literature. No top-rank novelists belong to this category; the better-known ones are writers of science fiction, such as H. G. Wells or Jules Verne. (Occasionally, a good writer of the Naturalistic school, with a repressed element of Romanticism, attempts a novel on an abstract theme that requires a Romantic approach; the result falls into this category. For example, Sinclair Lewis's *It Can't Happen Here*.) It is obvious why the novels of this category are enormously unconvincing. And, no matter how skillfully or suspensefully their action is presented, they always have an unsatisfying, uninspiring quality.

On the other side of the same dichotomy, there are Romanticists whose basic premise, in effect, is that man possesses volition *in regard to consciousness, but not to existence,* i.e., in regard to his own character and choice of values, but not in regard to the possibility of achieving his goals in the physical world. The distinguishing characteristics of such writers are grand-scale themes and characters, no plots and an overwhelming sense of tragedy, the sense of a "malevolent universe." The chief exponents of this category were poets. The leading one is Byron, whose name has been attached to this particular, "Byronic," view of existence: its essence is the belief that man must lead a heroic life and fight for his values even though he is doomed to defeat by a malevolent fate over which he has no control.

Today, the same view is advocated philosophically by the existentialists, but without the grand-scale element and with Romanticism replaced by a kind of sub-Naturalism.

Philosophically, Romanticism is a crusade to glorify

man's existence; psychologically, it is experienced simply as the desire to make life interesting.

This desire is the root and motor of Romantic imagination. Its greatest example, in popular literature, is O. Henry, whose unique characteristic is the pyrotechnical virtuosity of an inexhaustible imagination projecting the gaiety of a benevolent, almost childlike sense of life. More than any other writer, O. Henry represents the spirit of youth—specifically, the cardinal element of youth: the expectation of finding something wonderfully unexpected around all of life's corners.

In the field of popular literature, Romanticism's virtues and potential flaws may be seen in a simplified, more obvious form.

Popular literature is fiction that does not deal with abstract problems; it takes moral principles as the given, accepting certain generalized, *common-sense* ideas and values as its base. (Common-sense values and conventional values are not the same thing; the first can be justified rationally, the second cannot. Even though the second may include some of the first, they are justified, not on the ground of reason, but on the ground of social conformity.)

Popular fiction does not raise or answer abstract questions; it assumes that man knows what he needs to know in order to live, and it proceeds to show his adventures in living (which is one of the reasons for its popularity among all types of readers, including the problem-laden intellectuals). The distinctive characteristic of popular fiction is the absence of an *explicitly* ideational element, of the intent to convey intellectual information (or misinformation).

Detective, adventure, science-fiction novels and Westerns belong, for the most part, to the category of popular fiction. The best writers of this category come close to the Scott-Dumas group: their emphasis is on action, but their heroes and villains are abstract projections, and a loosely generalized view of moral values, of a struggle between good and evil, motivates the action. (As contemporary examples of the best in this class: Mickey Spillane, Ian Fleming, Donald Hamilton.)

When we go below the top level of popular fiction,

we descend into a kind of no man's land where literary principles are barely applicable (particularly if we include the field of movies and television). Here, the distinctive characteristics of Romanticism become almost indistinguishable. On this level, writing is not the product of subconscious premises: it is a mixture of elements picked by random imitation rather than by sense-of-life creation.

A certain characteristic is typical of this level: it is not merely the use of conventional, Naturalistic characters to enact Romantic events, but worse: the use of characters who are romanticized embodiments of *conventional* values. Such embodiments represent *canned* values, empty stereotypes that serve as an automatic substitute for value-judgments. This method lacks the essential attribute of Romanticism: the independent, creative projection of an individual writer's values—and it lacks the reportorial honesty of the (better) Naturalists: it does not present concrete men "as they are," it presents human pretensions (a collective role-playing or an indiscriminate collective daydream) and palms this off as reality.

Most of the "slick-magazine" fiction popular before World War II belongs to this class, with its endless variations on the Cinderella theme, the motherhood theme, the costume-drama theme, or the common-man-with-a-heart-of-gold theme. (For example, Edna Ferber, Fannie Hurst, Barry Benefield.) This type of fiction has no plots, only more or less cohesive stories, and no discernible characterizations; the characters are false journalistically, and meaningless metaphysically. (It is an open question whether this group belongs to the category of Romanticism; it is usually regarded as Romantic simply because it is far removed from anything perceivable in reality concretely or abstractly.)

As far as their fiction aspects are concerned, movies and television, by their nature, are media suited exclusively to Romanticism (to abstractions, essentials and drama). Unfortunately, both media came too late: the great day of Romanticism was gone, and only its sunset rays reached a few exceptional movies. (Fritz Lang's *Siegfried* is the best among them.) For a while, the

movie field was dominated by the equivalent of the slick-magazine Romanticism, with a still less discriminating level of taste and imagination, and an incommunicable vulgarity of spirit.

Partly in reaction against this debasement of values, but mainly in consequence of the general philosophical-cultural disintegration of our time (with its anti-value trend), Romanticism vanished from the movies and never reached television (except in the form of a few detective series, which are now gone also). What remains is the occasional appearance of cowardly pieces, whose authors apologize for their Romantic attempts, by means of comedy—or mongrel pieces, whose authors beg not to be mistaken for advocates of human values (or human greatness), by means of coyly, militantly commonplace characters who enact world-shaking events and perform fantastic feats, particularly in the realm of science. The nature of this type of scenario can best be encapsulated by a line of dialogue on the order of: "Sorry, baby, I can't take you to the pizza joint tonight, I've got to go back to the lab and split the atom."

The next, and final, level of disintegration is the attempt to eliminate Romanticism from Romantic fiction—i.e., to dispense with the element of values, morality and volition. This used to be called the "hard-boiled" school of detective fiction; today, it is plugged as "realistic." This school makes no distinction between heroes and villains (or detectives and criminals, or victims and executioners) and presents, in effect, two mobs of gangsters fighting savagely and incomprehensibly (no motivation is offered) for the same territory, neither side being able to do otherwise.

This is the dead end where, arriving by different roads, Romanticism and Naturalism meet, blend and vanish: deterministically helpless, compulsively evil characters go through a series of inexplicably exaggerated events and engage in purposeful conflicts without purpose.

Beyond this point, the field of literature, both "serious" and popular, is taken over by a genre compared to which Romanticism and Naturalism are clean, civilized

and innocently rational: the Horror Story. The modern ancestor of this phenomenon is Edgar Allan Poe; its archetype or purest esthetic expression is Boris Karloff movies.

Popular literature, more honest in this respect, presents its horrors in the form of physical monstrosities. In "serious" literature, the horrors become psychological and bear less resemblance to anything human; this is the literary cult of depravity.

The Horror Story, in either variant, represents the metaphysical projection of a single human emotion: blind, stark, primitive terror. Those who live in such terror seem to find a momentary sense of relief or control in the process of reproducing that which they fear—as savages find a sense of mastery over their enemies by reproducing them in the form of dolls. Strictly speaking, this is not a metaphysical, but a purely psychological projection; such writers are not presenting their view of life; they are not looking at life; what they are saying is that they *feel* as if life consisted of werewolves, Draculas and Frankenstein monsters. In its basic motivation, this school belongs to psychopathology more than to esthetics.

Historically, neither Romanticism nor Naturalism could survive the collapse of philosophy. There are individual exceptions, but I am speaking of these schools as broad, active, creative movements. Since art is the expression and product of philosophy, it is the first to mirror the vacuum at the base of a culture and the first to crumble.

This general cause had special consequences affecting Romanticism, which hastened its decline and collapse. There were also special consequences affecting Naturalism, which were of a different character and their destructive potential worked at a slower rate.

The archenemy and destroyer of Romanticism was the altruist morality.

Since Romanticism's essential characteristic is the projection of values, particularly *moral* values, altruism introduced an insolvable conflict into Romantic literature from the start. The altruist morality cannot be practiced (except in the form of self-destruction) and,

therefore, cannot be projected or dramatized convincingly in terms of man's life on earth (particularly in the realm of psychological motivation). With altruism as the criterion of value and virtue, it is impossible to create an image of man at his best—"as he might be and ought to be." The major flaw that runs through the history of Romantic literature is the failure to present a convincing hero, i.e., a convincing image of a virtuous man.

It is the abstract intention—the grandeur of the author's view of man—that one admires in the characters of Victor Hugo, not their actual characterizations. The greatest Romanticist never succeeded in projecting an ideal man or any convincing major characters of a positive nature. His most ambitious attempt, Jean Valjean in *Les Misérables*, remains a giant abstraction that never integrates into a person, in spite of isolated touches of profound psychological perceptiveness on the part of the author. In the same novel, Marius, the young man who is supposed to be Hugo's autobiographical projection, acquires a certain stature only by means of what the author *says* about him, not by means of what he *shows*. As far as characterization is concerned, Marius is not a person, but the suggestion of a person squeezed into a straitjacket of cultural bromides. The best-drawn and most interesting characters in Hugo's novels are the semi-villains (his benevolent sense of life made him unable to create a real villain): Javert in *Les Misérables*, Josiana in *The Man Who Laughs*, Claude Frollo in *Notre-Dame de Paris*.

Dostoevsky (whose sense of life was the diametrical opposite of Hugo's) was a passionate moralist whose blind quest for values was expressed only in the fiercely merciless condemnation with which he presented evil characters; no one has equaled him in the psychological depth of his images of human evil. But he was totally incapable of creating a positive or virtuous character; such attempts as he made were crudely inept (for example, Alyosha in *The Brothers Karamazov*). It is significant that according to Dostoevsky's preliminary notes for *The Possessed*, his original intention was to create Stavrogin as an ideal man—an embodiment of the Rus-

sian-Christian-altruist soul. As the notes progressed, that intention changed gradually, in logically inexorable steps dictated by Dostoevsky's artistic integrity. In the final result, in the actual novel, Stavrogin is one of Dostoevsky's most repulsively evil characters.

In Sienkiewicz's *Quo Vadis*, the best-drawn, most colorful character, who dominates the novel, is Petronius, the symbol of Roman decadence—while Vinicius, the author's hero, the symbol of the rise of Christianity, is a cardboard figure.

This phenomenon—the fascinating villain or colorful rogue, who steals the story and the drama from the anemic hero—is prevalent in the history of Romantic literature, serious or popular, from top to bottom. It is as if, under the dead crust of the altruist code officially adopted by mankind, an illicit, subterranean fire were boiling chaotically and erupting once in a while; forbidden to the hero, the fire of self-assertiveness burst forth from the apologetic ashes of a "villain."

The highest function of Romanticism—the projection of moral values—is an extremely difficult task under any moral code, rational or not, and, in literary history, only the top rank of Romanticists were able to attempt it. Given the added burden of an irrational code, such as altruism, the majority of Romantic writers had to avoid that task—which led to the weakness and neglect of the element of characterization in their writing. In addition, the impossibility of applying altruism to reality, to men's actual existence, led many Romantic writers to avoid the problem by escaping into history, i.e., by choosing to place their stories in some distant past (such as the Middle Ages). Thus, the emphasis on action, the neglect of human psychology, the lack of convincing motivation were progressively dissociating Romanticism from reality—until the final remnants of Romanticism became a superficial, meaningless, "unserious" school that had nothing to say about human existence.

The disintegration of Naturalism brought it to the same state, for different reasons.

Although Naturalism is a product of the nineteenth century, its spiritual father, in modern history, was

Shakespeare. The premise that man does not possess
volition, that his destiny is determined by an innate
"tragic flaw," is fundamental in Shakespeare's work.
But, granted this false premise, his approach is meta-
physical, not journalistic. His characters are not drawn
from "real life," they are not copies of observed con-
cretes nor statistical averages: they are grand-scale ab-
stractions of the character traits which a determinist
would regard as inherent in human nature: ambition,
power-lust, jealousy, greed, etc.

Some of the famous Naturalists attempted to
maintain Shakespeare's abstract level, i.e., to present
their views of human nature in metaphysical terms (for
example, Balzac, Tolstoy). But the majority, following
the lead of Emile Zola, rejected metaphysics, as they
rejected values, and adopted the method of journalism:
the recording of observed concretes.

The contradictions inherent in determinism were ob-
vious in this movement from the start. One does not
read fiction except on the implicit premise of volition—
i.e., on the premise that some element (some abstrac-
tion) of the fiction story is applicable to oneself, that
one will learn, discover or contemplate something of
value and that this experience will make a difference. If
one were to accept the deterministic premise fully and
literally—if one were to believe that the characters of a
fiction story are as distant and irrelevant to oneself as
the unknowable inhabitants of another galaxy and that
they cannot affect one's life in any way whatever, since
neither they nor the reader have any power of choice—
one would not be able to read beyond the first chapter.

Nor would one be able to write. Psychologically, the
whole of the Naturalist movement rode on the premise
of volition as on an unidentified, subconscious "stolen
concept." Choosing "society" as the factor that deter-
mines man's fate, most of the Naturalists were social
reformers, advocating social changes, claiming that man
has no volition, but society, somehow, has. Tolstoy
preached resignation and passive obedience to society's
power. In *Anna Karenina*, the most evil book in serious
literature, he attacked man's desire for happiness and
advocated its sacrifice to *conformity*.

No matter how concrete-bound their theories forced them to be, the writers of the Naturalist school still had to exercise their power of abstraction to a significant extent: in order to reproduce "real-life" characters, they had to select the characteristics they regarded as essential, differentiating them from the non-essential or accidental. Thus they were led to substitute statistics for values as a criterion of selectivity: that which is statistically prevalent among men, they held, is metaphysically significant and representative of man's nature; that which is rare or exceptional, is not. (See Chapter 7.)

At first, having rejected the element of plot and even of story, the Naturalists concentrated on the element of characterization—and psychological perceptiveness was the chief value that the best of them had to offer. With the growth of the statistical method, however, that value shrank and vanished: characterization was replaced by indiscriminate recording and buried under a catalogue of trivia, such as minute inventories of a character's apartment, clothing and meals. Naturalism lost the attempted universality of Shakespeare or Tolstoy, descending from metaphysics to photography with a rapidly shrinking lens directed at the range of the immediate moment—until the final remnants of Naturalism became a superficial, meaningless, "unserious" school that had nothing to say about human existence.

There were several reasons why Naturalism outlasted Romanticism, even if not for long. Chief among them is the fact that Naturalism's standards are much less demanding. A third-rate Naturalist may still have some perceptive observations to offer; a third-rate Romanticist has nothing.

Romanticism demands mastery of the primary element of fiction: the art of storytelling—which requires three cardinal qualities: ingenuity, imagination, a sense of drama. All this (and more) goes into the construction of an original plot integrated to theme and characterization. Naturalism discards these elements and demands nothing but characterization, in as shapeless a narrative, as "uncontrived" (i.e., purposeless) a progression of events (if any) as a given author pleases.

The value of a Romanticist's work has to be created

by its author; he owes no allegiance to men (only to
man), only to the metaphysical nature of reality and to
his own values. The value of a Naturalist's work de-
pends on the specific characters, choices and actions of
the men he reproduces—and he is judged by the fideli-
ty with which he reproduces them.

The value of a Romanticist's story lies in *what* might
happen; the value of a Naturalist's story lies in *that* it
did happen. If the spiritual ancestor or symbol of the
Romanticist is the medieval troubadour who roamed
the countryside, inspiring men with visions of life's
potential beyond the dreary boundaries of their daily
toil—then the symbol of the Naturalist is the back-
fence gossip (as one contemporary Naturalist has some-
what boastfully admitted).

Contributing to the (temporary) dominance of Natu-
ralism was the fact that precious stones attract a greater
number of seekers of the unearned than do the more
commonly available minerals. The essential element of
Romanticism, the plot, can be purloined and disguised
by recutting, even though it loses fire, brilliance and
value with every stroke of a dime-store chisel. The
original plots of Romantic literature have been bor-
rowed in countless variations by countless imitators,
losing color and meaning with each successive copy.

For example, compare the dramatic structure of *The
Lady of the Camellias* (*Camille*) by Alexander Dumas
fils, which is an unusually good play, to the endless
series of dramas about a prostitute caught between her
true love and her past, from Eugene O'Neill's *Anna
Christie* on down (or, properly speaking, on up) to
Hollywood variants. The esthetic parasites of Romanti-
cism helped to run it into the ground, turning its exam-
ples of inventiveness into worn-out bromides. This,
however, does not detract from the original authors'
achievements; if anything, it underscores them.

Naturalism does not offer such opportunities to imi-
tators. The essential element of Naturalism—the
presentation of "a slice of life" at a specific time and
place—cannot be borrowed literally. A writer cannot
copy the Russian society of 1812 as presented in Tol-
stoy's *War and Peace*. He has to employ some thought

and effort of his own, at least in the sense of using his own observations to present the people of his own time and place. Thus, paradoxically, on its lower levels Naturalism offers a chance for some minimal originality, which Romanticism does not. In this respect, Naturalism would appeal to some writers seeking the possibility of a literary achievement on a modest scale.

There were, however, many imitators (of a less obvious kind) among the Naturalists, and many pretentious mediocrities, particularly in Europe. (For example, Romain Rolland, a romanticizing Naturalist who, in intellectual stature, belongs with the slick-magazine Romanticists.) But at Naturalism's height, the movement included writers of genuine literary talent, particularly in America. Its best representative is Sinclair Lewis, whose novels display a perceptive, critical, first-rate intelligence at work. The best of Naturalism's contemporary survivors is John O'Hara, who combines a sensitive intelligence with a beautifully disciplined style.

Just as there was a kind of naively innocent, optimistic benevolence in the great Romanticists of the nineteenth century, so there was in the better Naturalists of the twentieth. The first were individual-oriented; the second, society-oriented. World War I marked the end of the great era of Romanticism, and accelerated the fading of individualism. (One may take as a tragic symbol the fact that Edmond Rostand died in 1918, in the flu epidemic following that war.) World War II marked the end of Naturalism, exposing the bankruptcy of collectivism, blasting the vague hopes and illusions of achieving a "benevolent" welfare state. These wars demonstrated existentially what their literary consequences demonstrated psychologically: that man cannot live without philosophy, and neither can he write.

In the eclectic shambles of today's literature, it is hard to tell which is worse: a Western that explains the deeds of a cattle rustler by reference to his Oedipus complex—or a gory, cynical, "realistic" account of sundry horrors which reveals the message that love is the solution to everything.

Except for the exceptions, there is no literature (and no art) today—in the sense of a broad, vital cultural

movement and influence. There are only bewildered
imitators with nothing to imitate—and charlatans who
rise to split-second notoriety, as they always did in
periods of cultural collapse.

Some remnants of Romanticism may still be found in
the popular media—but in such a mangled, disfigured
form that they achieve the opposite of Romanticism's
original purpose.

The best symbolic projection of these remnants'
meaning (whether the author intended it or not) was
given in a brief television story of *The Twilight Zone*
series, some years ago. In some indeterminate world of
another dimension, the shadowy, white-clad, authori-
tarian figures of doctors and social scientists are deeply
concerned with the problem of a young girl who looks
so different from everyone else that she is shunned as a
freak, a disfigured outcast unable to lead a normal life.
She has appealed to them for help, but all plastic
surgery operations have failed—and now the doctors
are grimly preparing to give her a last chance: one more
attempt at plastic surgery; if it fails, she will remain a
monstrosity for life. In heavily tragic tones, the doctors
speak of the girl's need to be like others, to belong, to
be loved, etc. We are not shown any of the characters'
faces, but we hear the tense, ominous, oddly lifeless
voices of their dim figures, as the last operation pro-
gresses. The operation fails. The doctors declare, with
contemptuous compassion, that they will have to find a
young man as deformed as this girl, who might be able
to accept her. Then, for the first time, we see the girl's
face: lying motionless on the pillow of a hospital bed, it
is a face of perfect, radiant beauty. The camera moves
to the faces of the doctors: it is an unspeakably horrify-
ing row, not of human faces, but of mangled, distorted,
disfigured pigs' heads, recognizable only by their
snouts. Fade-out.

The last remnants of Romanticism are sneaking apol-
ogetically on the outskirts of our culture, wearing the
masks of a similar plastic surgery operation which has
been partially successful.

Under the pressure of conformity to the pigs' snouts
of decadence, today's Romanticists are escaping, not

into the past, but into the supernatural—explicitly giving up reality and this earth. The exciting, the dramatic, the unusual—their policy is declaring, in effect—do not exist; please don't take us seriously, what we're offering is only a spooky daydream.

Rod Serling, one of the most talented writers of television, started as a Naturalist, dramatizing controversial journalistic issues of the moment, never taking sides, conspicuously avoiding value-judgments, writing about ordinary people—except that these people spoke the most beautifully, eloquently romanticized dialogue, a purposeful, intellectual, sharply focused dialogue-by-essentials, of a kind that people do not speak in "real life," but should. Prompted, apparently, by the need to give full scope to his colorful imagination and brilliant sense of drama, Rod Serling turned to Romanticism—but placed his stories in another dimension, in *The Twilight Zone.*

Ira Levin, who started with an excellent first novel (*A Kiss Before Dying*), now comes out with *Rosemary's Baby*, which goes beyond the physical trappings of the Middle Ages, straight to that era's spirit, and presents (seriously) a story about witchcraft in a modern setting; and, since the original version of the Virgin Birth, involving God, would probably be regarded as "camp" by today's intellectual establishment, this story revolves around the obscenity of a Virgin Birth authored by the Devil.

Fredric Brown, an unusually ingenious writer, had been devoting his ingenuity to turning science fiction into stories of earthly or supernatural evil; now, he has stopped writing.

Alfred Hitchcock, the last movie-maker who has managed to preserve his stature and his following, gets away with Romanticism by means of an overemphasis on malevolence or on sheer horror.

This is the manner in which men of imagination now express their need to make life interesting. Romanticism—which started, in defiance of primordial evils, as a violent, passionate torrent of righteous self-assertiveness—ends up by dribbling through the fingers

of tottering heirs who disguise their works and motives by paying lip service to evil.

I do not mean to imply that this type of appeasement is the product of conscious cowardice; I do not believe it is: which makes it worse.

Such is the esthetic state of our day. But so long as men exist, the need of art will exist, since that need is rooted metaphysically in the nature of man's consciousness—and it will survive a period when, under the reign of irrationality run amuck, men produce and accept tainted scraps to satisfy that need.

As in the case of an individual, so in the case of a culture: disasters can be accomplished subconsciously, but a cure cannot. A cure in both cases requires conscious knowledge, i.e., a consciously grasped, explicit philosophy.

It is impossible to predict the time of a philosophical Renaissance. One can only define the road to follow, but not its length. What is certain, however, is that every aspect of Western culture needs a new code of ethics—a *rational ethics*—as a precondition of rebirth. And, perhaps, no aspect needs it more desperately than the realm of art.

When reason and philosophy are reborn, literature will be the first phoenix to rise out of today's ashes. And, armed with a code of rational values, aware of its own nature, confident of the supreme importance of its mission, Romanticism will have come of age.

(May–July 1969)

7. The Esthetic Vacuum of Our Age

P RIOR to the nineteenth century, literature present-
ed man as a helpless being whose life and actions were
determined by forces beyond his control: either by
fate and the gods, as in the Greek tragedies, or by an
innate weakness, "a tragic flaw," as in the plays of
Shakespeare. Writers regarded man as metaphysically
impotent; their basic premise was *determinism*. On
that premise, one could not project what might happen
to men; one could only record what *did* happen—and
chronicles were the appropriate literary form of such
recording.

Man as a being who possesses the faculty of volition
did not appear in literature until the nineteenth centu-
ry. The *novel* was his proper literary form—and Ro-
manticism was the great new movement in art. Roman-
ticism saw man as a being able to choose his values, to
achieve his goals, to control his own existence. The
Romantic writers did not record the events that *had*
happened, but projected the events that *should* happen;

they did not record the choices men *had* made, but projected the choices men *ought to make*.

With the resurgence of mysticism and collectivism, in the later part of the nineteenth century, the Romantic novel and the Romantic movement vanished gradually from the cultural scene.

Man's new enemy, in art, was Naturalism. Naturalism rejected the concept of volition and went back to a view of man as a helpless creature determined by forces beyond his control; only now the new ruler of man's destiny was held to be *society*. The Naturalists proclaimed that values have no power and no place, neither in human life nor in literature, that writers must present men "as they are," which meant: must record whatever they happen to see around them—that they must not pronounce value-judgments nor project abstractions, but must content themselves with a faithful transcription, a carbon copy, of any existing concretes.

This was a return to the literary principle of the chronicle—but since a novel was to be an *invented* chronicle, the novelist was faced with the problem of what to use as his standard of selection. When values are declared to be impossible, how is one to know what to record, what to regard as important or significant? Naturalism solved the problem by substituting *statistics* for a standard of value. That which could be claimed to be typical of a large number of men, in any given geographical area or period of time, was regarded as metaphysically significant and worthy of being recorded. That which was rare, unusual, exceptional, was regarded as unimportant and *unreal*.

Just as the new schools of philosophy became progressively dedicated to the negation of philosophy, so Naturalism was dedicated to the negation of art. Instead of presenting a *metaphysical* view of man and of existence, the Naturalists presented a *journalistic* view. In answer to the question: "What is man?"—they said: "This is what the village grocers are, in the south of France, in the year 1887," or: "This is what the inhabitants of the slums are, in New York, in 1921," or: "These are the folks next door."

Art—the integrator of metaphysics, the concretizer

of man's widest abstractions—was shrinking to the level of a plodding, concrete-bound dolt who has never looked past the block he lives on or beyond the range of the moment.

It did not take long for the philosophical roots of Naturalism to come out into the open. At first, by the standard that substituted the *collective* for the *objective*, the Naturalists consigned the exceptional man to unreality and presented only the men who could be taken as typical of some group or another, high or low. Then, since they saw more misery than prosperity on earth, they began to regard prosperity as unreal and to present only misery, poverty, the slums, the lower classes. Then, since they saw more mediocrity than greatness around them, they began to regard greatness as unreal, and to present only the mediocre, the average, the common, the undistinguished. Since they saw more failure than success, they took success to be unreal and presented only human failure, frustration, defeat. Since they saw more suffering than happiness, they took happiness to be unreal and presented only suffering. Since they saw more ugliness than beauty, they took beauty to be unreal and presented only ugliness. Since they saw more vice than virtue, they took virtue to be unreal and presented only vice, crime, corruption, perversion, depravity.

Now take a look at modern literature.

Man—the nature of man, the metaphysically significant, important, essential in man—is now represented by dipsomaniacs, drug addicts, sexual perverts, homicidal maniacs and psychotics. The subjects of modern literature are such themes as: the hopeless love of a bearded lady for a mongoloid pinhead in a circus side show—or: the problem of a married couple whose child was born with six fingers on her left hand—or: the tragedy of a gentle young man who just can't help murdering strangers in the park, for kicks.

All this is still presented to us under the Naturalistic heading of "a slice of life" or "*real* life"—but the old slogans have worn thin. The obvious question, to which the heirs of statistical Naturalism have no answer, is: if heroes and geniuses are not to be regarded as represent-

ative of mankind, by reason of their numerical rarity, why are freaks and monsters to be regarded as representative? Why are the problems of a bearded lady of greater universal significance than the problems of a genius? Why is the soul of a murderer worth studying, but not the soul of a hero?

The answer lies in the basic metaphysical premise of Naturalism, whether its practitioners ever chose it consciously or not: as an outgrowth of modern philosophy, that basic premise is anti-man, anti-mind, anti-life; and, as an outgrowth of the altruist morality, Naturalism is a frantic escape from moral judgment—a long, wailing plea for pity, for tolerance, for the forgiveness of anything.

The literary cycle has swung all the way around. What one reads today is not Naturalism any longer: it is Symbolism; it is the presentation of a *metaphysical* view of man, as opposed to a journalistic or statistical view. But it is the Symbolism of primitive terror. According to this modern view, *depravity* represents man's real, essential, metaphysical nature, while virtue does not; virtue is only an accident, an exception or an illusion; therefore, a *monster* is an appropriate projection of man's essence, but a *hero* is not.

The Romanticists did not present a hero as a statistical average, but as an abstraction of man's best and highest potentiality, applicable to and achievable by all men, in various degrees, according to their individual choices. For the same reasons, in the same manner, but on an opposite metaphysical premise, today's writers do not present a monster as a statistical average, but as an abstraction of man's worst and lowest potentiality, which they regard as applicable to and essential in all men—not, however, as a potentiality, but as a hidden actuality. The Romanticists presented heroes as "larger than life"; now, monsters are presented as "larger than life"—or, rather, *man* is presented as "*smaller* than life."

If men hold a rational philosophy, including the conviction that they possess volition, the image of a hero guides and inspires them. If men hold an irrational philosophy, including the conviction that they are

helpless automatons, the image of a monster serves to reassure them; they feel, in effect: "I am not *that* bad."

The philosophical meaning or the vested interest of presenting man as a loathsome monstrosity is the hope and the demand for a moral blank check.

Now consider a curious paradox: the same estheticians and intellectuals who advocate collectivism, with the subordination of all values and of everyone's life to the rule of "the masses," with art as the voice of "the people"—these same men are resentfully antagonistic toward all popular values in art. They engage in virulent denunciations of the mass media, of the so-called "commercial" producers or publishers who happen to attract large audiences and to please the public. They demand government subsidies for the artistic ventures which "the people" do not enjoy and do not choose to support voluntarily. They feel that any financially successful, that is, *popular*, work of art is automatically worthless, while any unpopular failure is automatically great—provided it is unintelligible. Anything that can be understood, they feel, is vulgar and primitive; only inarticulate language, smears of paint and the noise of radio static are civilized, sophisticated and profound.

The popularity or unpopularity, the box-office success or failure, of a work of art is not, of course, a criterion of esthetic merit. No value—esthetic, philosophical or moral—can be established by counting noses; fifty million Frenchmen can be as wrong as one. But while a crude "philistine," who takes financial *success* as proof of artistic merit, can be regarded merely as a mindless parasite on art—what is one to think of the standards, motives and intentions of those who take financial *failure* as the proof of artistic merit? If the snobbery of mere financial success is reprehensible, what is the meaning of a snobbery of failure? Draw your own conclusions.

If you wonder what is the ultimate destination toward which modern philosophy and modern art are leading you, you may observe its advance symptoms all around us. Observe that literature is returning to the art form of the pre-industrial ages, to the *chronicle*—that fictionalized biographies of "real" people, of politicians,

baseball players or Chicago gangsters, are given preference over works of imaginative fiction, in the theater, in the movies, in television—and that a favored literary form is *the documentary*. Observe that in painting, sculpture and music the current fashion and inspirational model is the primitive art of the jungle.

If you rebel against reason, if you succumb to the old bromides of the Witch Doctors, such as: "Reason is the enemy of the artist" or "The cold hand of reason dissects and destroys the joyous spontaneity of man's creative imagination"—I suggest that you take note of the following fact: by rejecting reason and surrendering to the unhampered sway of their unleashed emotions (and whims), the apostles of irrationality, the existentialists, the Zen Buddhists, the non-objective artists, have not achieved a free, joyous, triumphant sense of life, but a sense of doom, nausea and screaming, cosmic terror. Then read the stories of O. Henry or listen to the music of Viennese operettas and remember that these were the products of the spirit of the nineteenth century—a century ruled by the "cold, dissecting" hand of reason. And then ask yourself: which psycho-epistemology is appropriate to man, which is consonant with the facts of reality and with man's nature?

Just as a man's esthetic preferences are the sum of his metaphysical values and the barometer of his soul, so art is the sum and the barometer of a culture. Modern art is the most eloquent demonstration of the cultural bankruptcy of our age.

(November 1962)

8. Bootleg Romanticism

ART (including literature) is the barometer of a culture. It reflects the sum of a society's deepest philosophical values: not its professed notions and slogans, but its actual view of man and of existence. The image of an entire society stretched out on a psychologist's couch, revealing its naked subconscious, is an impossible concept; yet *that* is what art accomplishes: it presents the equivalent of such a session, a transcript which is more eloquent and easier to diagnose than any other set of symptoms.

This does not mean that an entire society is bound by the mediocrities who may choose to posture in the field of art at any given time; but it does mean that if no better men chose to enter the field, this tells us something about the state of that society. There are always exceptions who rebel against the dominant trend in the art of their age; but the fact that they are exceptions tells us something about the state of that age. The dominant trend may not, in fact, express the soul of an entire people; it may be rejected, resented or

ignored by an overwhelming majority; but if it is the dominant voice of a given period, this tells us something about the state of the people's souls.

In politics, the panic-blinded advocates of today's status quo, clinging to the shambles of their mixed economy in a rising flood of statism, are now adopting the line that there's nothing wrong with the world, that this is a century of progress, that we are morally and mentally healthy, that we never had it so good. If you find political issues too complex to diagnose, take a look at today's art: it will leave you no doubt in regard to the health or disease of our culture.

The composite picture of man that emerges from the art of our time is the gigantic figure of an aborted embryo whose limbs suggest a vaguely anthropoid shape, who twists his upper extremity in a frantic quest for a light that cannot penetrate its empty sockets, who emits inarticulate sounds resembling snarls and moans, who crawls through a bloody muck, red froth dripping from his jaws, and struggles to throw the froth at his own non-existent face, who pauses periodically and, lifting the stumps of his arms, screams in abysmal terror at the universe at large.

Engendered by generations of anti-rational philosophy, three emotions dominate the sense of life of modern man: fear, guilt and pity (more precisely, self-pity). Fear, as the appropriate emotion of a creature deprived of his means of survival, his mind; guilt, as the appropriate emotion of a creature devoid of moral values; pity, as the means of escape from these two, as the only response such a creature could beg for. A sensitive, discriminating man, who has absorbed that sense of life, but retained some vestige of self-esteem, will avoid so revealing a profession as art. But this does not stop the others.

Fear, guilt and the quest for pity combine to set the trend of art in the same direction, in order to express, justify and rationalize the artists' own feelings. To justify a chronic fear, one has to portray existence as evil; to escape from guilt and arouse pity, one has to portray man as impotent and innately loathsome. Hence the competition among modern artists to find ever lower

levels of depravity and ever higher degrees of mawkish-ness—a competition to shock the public out of its wits and jerk its tears. Hence the frantic search for misery, the descent from compassionate studies of alcoholism and sexual perversion to dope, incest, psychosis, murder, cannibalism.

To illustrate the moral implications of this trend—the fact that pity for the guilty is treason to the innocent—I submit an enthusiastic review that commends a current movie for arousing compassion for kidnappers. "One's attention and, indeed, one's anxiety is centered more upon them than upon the kidnapped youngster," states the review. And: "As a matter of fact, the motivation is not so clearly defined that it bears analysis or criticism on psychological grounds. But it is sufficiently established to compel our anguished sympathy for the two incredible kidnappers." (*The New York Times*, November 6, 1964.)

Sewers are not very rich nor very deep, and today's dramatists seem to be scratching bottom. As to literature, it has shot its bolt. There is no way to beat the following, which I reproduce in full from the August 30, 1963, issue of *Time*. The heading is "Books," the subhead "Best Reading," then: "*Cat and Mouse*, by Günter Grass. Best-selling Novelist Grass (*The Tin Drum*) relates the torment of a young man whose prominent Adam's apple makes him an outcast to his classmates. He strives for achievement and wins it, but to the 'cat'—human conformity—he is still a curiosity."

No, all this is not presented to us "tongue in cheek." There is an old French theater that specializes in presenting that sort of stuff "tongue-in-cheek." It is called "Grand Guignol." But today the spirit of Grand Guignol has been elevated into a metaphysical system and demands to be taken seriously. What, then, is *not* to be taken seriously? Any representation of human virtue.

One would think that that maudlin preoccupation with chambers of horror, that waxworks-museum view of life, was bad enough. But there is something still

worse and, morally, more evil: the recent attempts to concoct so-called "tongue-in-cheek" thrillers.

The trouble with the sewer school of art is that fear, guilt and pity are self-defeating dead ends: after the first few "daring revelations of human depravity," people cease to be shocked by anything; after experiencing pity for a few dozen of the depraved, the deformed, the demented, people cease to feel anything. And just as the "non-commercial" economics of modern "idealists" tells them to take over commercial establishments, so the "non-commercial" esthetics of modern "artists" prompts them to attempt the takeover of commercial (i.e., popular) art forms.

"Thrillers" are detective, spy or adventure stories. Their basic characteristic is *conflict*, which means: a clash of goals, which means: purposeful action in pursuit of *values*. Thrillers are the product, the popular offshoot, of the *Romantic* school of art that sees man, not as a helpless pawn of fate, but as a being who possesses volition, whose life is directed by his own value-choices. Romanticism is a value-oriented, morality-centered movement: its material is not journalistic minutiae, but the abstract, the essential, the universal principles of man's nature—and its basic literary commandment is to portray man "as he might be and ought to be."

Thrillers are a simplified, elementary version of Romantic literature. They are not concerned with a delineation of values, but, taking certain fundamental values for granted, they are concerned with only one aspect of a moral being's existence: the battle of good against evil in terms of purposeful action—a dramatized abstraction of the basic pattern of: choice, goal, conflict, danger, struggle, victory.

Thrillers are the kindergarten arithmetic, of which the higher mathematics is the greatest novels of world literature. Thrillers deal only with the skeleton—the plot structure—to which serious Romantic literature adds the flesh, the blood, the mind. The plots in the novels of Victor Hugo or Dostoevsky are pure thriller-plots, unequaled and unsurpassed by the writers of thrillers.

In today's culture, Romantic art is virtually non-existent (but for some very rare exceptions): it requires a view of man incompatible with modern philosophy. The last remnants of Romanticism are flickering only in the field of popular art, like bright sparks in a stagnant gray fog. Thrillers are the last refuge of the qualities that have vanished from modern literature: life, color, imagination; they are like a mirror still holding a distant reflection of man.

Bear that in mind when you consider the meaning of the attempt to present thrillers "tongue-in-cheek."

Humor is not an unconditional virtue; its moral character depends on its object. To laugh at the contemptible, is a virtue; to laugh at the good, is a hideous vice. Too often, humor is used as the camouflage of moral cowardice.

There are two types of cowards in this connection. One type is the man who dares not reveal his profound hatred of existence and seeks to undercut all values under cover of a chuckle, who gets away with offensive, malicious utterances and, if caught, runs for cover by declaring: "I was only kidding."

The other type is the man who dares not reveal or uphold his values and seeks to smuggle them into existence under cover of a chuckle, who tries to get away with some concept of virtue or beauty and, at the first sign of opposition, drops it and runs, declaring: "I was only kidding."

In the first case, humor serves as an apology for evil; in the second—as an apology for the good. Which, morally, is the more contemptible policy?

The motives of both types can be united and served by a phenomenon such as "tongue-in-cheek" thrillers.

What are such thrillers laughing at? At values, at man's struggle for values, at man's capacity to achieve his values, at man; at man the hero.

Regardless of their creators' conscious or subconscious motives, such thrillers, in fact, carry a message or intention of their own, implicit in their nature: to arouse people's interest in some daring venture, to hold them in suspense by the intricacy of a battle for great stakes, to inspire them by the spectacle of human effica-

cy, to evoke their admiration for the hero's courage, ingenuity, endurance and unswerving integrity of purpose, to make them cheer his triumph—and then to spit in their faces, declaring: "Don't take me seriously— I was only kidding—who are we, you and I, to aspire to be anything but absurd and swinish?"

To whom are such thrillers apologizing? To the sewer school of art. In today's culture, the gutter-worshiper needs and makes no apology. But the hero-worshiper chooses to crawl on his belly, crying: "I didn't mean it, boys! It's all in fun! I'm not so corrupt as to believe in virtue, I'm not so cowardly as to fight for values, I'm not so evil as to long for an ideal—I'm one of you!"

The social status of thrillers reveals the profound gulf splitting today's culture—the gulf between the people and its alleged intellectual leaders. The people's need for a ray of Romanticism's light is enormous and tragically eager. Observe the extraordinary popularity of Mickey Spillane and Ian Fleming. There are hundreds of thriller writers who, sharing the modern sense of life, write sordid concoctions that amount to a battle of evil against evil or, at best, gray against black. None of them have the ardent, devoted, almost addicted following earned by Spillane and Fleming. This is not to say that the novels of Spillane and Fleming project a faultlessly rational sense of life; both are touched by the cynicism and despair of today's "malevolent universe"; but, in strikingly different ways, both offer the cardinal element of Romantic fiction: Mike Hammer and James Bond are *heroes*.

This universal need is precisely what today's intellectuals cannot grasp or fill. A seedy, emasculated, unventilated "elite"—a basement "elite" transported, by default, into vacant drawing rooms and barricaded behind dusty curtains against light, air, grammar and reality— today's intellectuals cling to the stagnant illusion of their altruist-collectivist upbringing: the vision of a cloddish, humble, inarticulate people whose "voice" (and masters) they were to be.

Observe their anxious, part-patronizing, part-obsequious pursuit of "folk" art, of the primitive, the anonymous, the undeveloped, the unintellectual—or

their "lusty," "earthy" movies that portray man as an obscene subanimal. Politically, the reality of a non-cloddish people would destroy them: the collectivist jig would be up. Morally, the existence, possibility or image of a hero would be intolerable to their overwhelming sense of guilt; it would wipe out the slogan that permits them to go on wallowing in sewers: "I couldn't help it!" A heroes-seeking people is what they cannot admit into their view of the universe.

A sample of that cultural gulf—a small sample of a vast modern tragedy—may be seen in an interesting little article in *TV Guide* (May 9, 1964), under the title "Violence Can Be Fun" and with the eloquent subtitle: "In Britain, everybody laughs at 'The Avengers'—except the audience."

The Avengers is a sensationally successful British television series featuring the adventures of secret agent John Steed and his attractive assistant Catherine Gale—"surrounded by some delightfully ingenious plots . . ." states the article. "*The Avengers* is compulsive viewing for a huge audience. Steed and Mrs. Gale are household words."

But recently "the secret sorrow of producer John Bryce was revealed: *The Avengers* was conceived as a satire of counterespionage thrillers, but the British public still insists on taking it seriously."

The manner in which that "revelation" came about is interesting. "The fact that *The Avengers* is satire was probably the best-kept secret in British television for almost a year. It might have remained that way, but the series came up for discussion during another show called *The Critics* . . ." One of these critics—to the astonishment of the others—declared that "surely everybody realized it was being played for laughs." Nobody had, but the producer of *The Avengers* confirmed that view and "moodily" blamed the public for its failure to understand his intentions: its failure to laugh at his product.

Bear in mind that Romantic thrillers are an exceedingly difficult job: they require such a degree of skill, ingenuity, inventiveness, imagination and logic—such a great amount of talent on the part of the producer or

the director or the writer or the cast, or all of them—
that it is virtually impossible to fool an entire nation for
a whole year. Somebody's values were being shamefully
exploited and betrayed, besides the public's.

It is obvious that the modern intellectuals' rush to
the thriller bandwagon was precipitated by the spectac-
ular figure and success of James Bond. But, in keeping
with modern philosophy, they want to ride the wagon
and spit at it, too.

If you think that the producers of mass-media enter-
tainment are motivated primarily by commercial greed,
check your premises and observe that the producers of
the James Bond movies seem to be intent on undercut-
ting their own success.

Contrary to somebody's strenuously spread asser-
tions, there was nothing "tongue-in-cheek" about the
first of these movies, *Dr. No*. It was a brilliant example
of Romantic screen art—in production, direction, writ-
ing, photography and, most particularly, in the per-
formance of Sean Connery. His first introduction on the
screen was a gem of dramatic technique, elegance, wit
and understatement: when, in response to a question
about his name, we saw his first close-up and he an-
swered quietly: "Bond. James Bond"—the audience, on
the night I saw it, burst into applause.

There wasn't much applause on the night when I saw
his second movie, *From Russia with Love*. Here, Bond
was introduced pecking with schoolboy kisses at the
face of a vapid-looking girl in a bathing suit. The story
was muddled and, at times, unintelligible. The skillfully
constructed, dramatic suspense of Fleming's climax was
replaced by conventional stuff, such as old-fashioned
chases, involving nothing but crude physical danger.

I shall still go to see the third movie, *Goldfinger*, but
with heavy misgivings. The misgivings are based on an
article by Richard Maibaum who adapted all three
novels to the screen (*The New York Times*, December
13, 1964).

"Fleming's tongue-in-cheek attitude toward his mate-
rial (intrigue, expertise, violence, love, death) finds a
ready mass response in a world where audiences enjoy
sick jokes," writes Mr. Maibaum. "Incidentally, it is the

aspect of Fleming which the films have most developed." So much for his understanding of the appeal of Romantic thrillers—or of Fleming.

Discussing his own work, Mr. Maibaum remarks: "Do I hear anyone asking sotto voce about the screenwriter's blushes? If he was the blushing type he wouldn't be doing Bond screenplays in the first place. Besides, it's good clean fun, or so he tells himself."

Draw your own conclusions about the nature of the ethical standards involved. Note also that the writer of the movie about "the two incredible [but sympathetic] kidnappers" did not feel called upon to blush.

"The actual characterization of James Bond ..." Mr. Maibaum continues, "was also a departure from the novels. . . . That concept retained a basic supersleuth, super-fighter, super-hedonist, super-lover of Fleming's, but added another large dimension: humor. Humor vocalized in wry comments at critical moments. In the books, Bond was singularly lacking in this." Which is *not* true, as any reader of the books can ascertain.

And finally: "A bright young producer accosted me one day with glittering eyes. 'I'm making a parody of the James Bond films.' How, I asked myself, does one make a parody of a parody? For that is precisely, in the final analysis, what we have done with Fleming's books. Parodied them. I'm not sure that Ian himself ever completely realized this."

This is said about the work of a man whose talent, achievement and fame gave a group of previously undistinguished persons their chance at distinction and at piles of money.

Observe that in the issue of humor versus thrillers, modern intellectuals are using the term "humor" as an *anti-concept,* i.e., as a "package-deal" of two meanings, with the proper meaning serving to cover and to smuggle the improper one into people's minds. The purpose is to obliterate the distinction between "humor" and "mockery," particularly *self-mockery*—and thus bring men to defile their own values and self-esteem, for fear of being accused of lacking "a sense of humor."

Remember that humor is *not* an unconditional virtue

and depends on its object. One may laugh *with* a hero, but never *at* him—just as a satire may laugh *at* some object, but *never at itself*. A composition that laughs at itself is a fraud on the audience.

In Fleming's novels, James Bond is constantly making witty, humorous remarks, which are part of his charm. But, apparently, this is not what Mr. Maibaum meant by the word "humor." What he meant, apparently, was *humor at Bond's expense*—the sort of humor intended to undercut Bond's stature, to make him ridiculous, which means: to destroy him.

Such is the basic contradiction—and the terrible, parasitic immorality—of any attempt to create "tongue-in-cheek" thrillers. It requires that one employ all the values of a thriller in order to hold the audience's interest, yet turn these values against themselves, that one damage the very elements one is using and counting on. It means an attempt to cash in on the thing one is mocking, to profit by the audience's hunger for Romanticism while seeking to destroy it. This is not the method of a legitimate satire: a satire does not share the values of that which it denounces; it denounces by means and in the context of an *opposite* set of values.

The failure to understand the nature and appeal of Romanticism is an eloquent measure of the modern intellectuals' epistemological disintegration. Only an appallingly concrete-bound, anti-conceptual mentality would lose its faculty of abstraction to such an extent as to be incapable of grasping an abstract meaning which an unskilled laborer can grasp and a United States President can enjoy. Only an arrested modern mentality would go on protesting that the events portrayed in a thriller are incredible or improbable, that there are no heroes, that "life is not like that"—all of which is thoroughly irrelevant.

Nobody takes thrillers literally, nor cares about their specific events, nor harbors any frustrated desire to become a secret agent or a private eye. Thrillers are taken symbolically; they dramatize one of man's widest and most crucial abstractions: the abstraction of *moral conflict*.

What people seek in thrillers is the spectacle of *man's*

efficacy: of his ability to fight for his values and to achieve them. What they see is a condensed, simplified pattern, reduced to its essentials: a man fighting for a vital goal—overcoming one obstacle after another—facing terrible dangers and risks—persisting through an excruciating struggle—and winning. Far from suggesting an easy or "unrealistic" view of life, a thriller suggests the necessity of a difficult struggle; if the hero is "larger-than-life," so are the villains and the dangers.

An abstraction has to be "larger-than-life"—to encompass any concretes that individual men may be concerned with, each according to the scale of his own values, goals and ambition. The scale varies; the psychological relationships involved remain the same. The obstacles confronting an average man are, to him, as formidable as Bond's adversaries; but what the image of Bond tells him is: "It can be done."

What men find in the spectacle of the ultimate triumph of the good is the inspiration to fight for one's own values in the moral conflicts of one's own life.

If the proclaimers of human impotence, the seekers of automatic security, protest that "life is not like that, happy endings are not guaranteed to man"—the answer is: a thriller is more realistic than such views of existence, it shows men the *only* road that can make any sort of happy ending *possible*.

Here, we come to an interesting paradox. It is only the superficiality of the Naturalists that classifies Romanticism as "an escape"; this is true only in the very superficial sense of contemplating a glamorous vision as a relief from the gray burden of "real-life" problems. But in the deeper, metaphysical-moral-psychological sense, it is *Naturalism* that represents an escape—an escape from choice, from values, from moral responsibility—and it is *Romanticism* that trains and equips man for the battles he has to face in reality.

In the privacy of his own soul, nobody identifies himself with the folks next door, unless he has given up. But the generalized abstraction of a hero permits every man to identify himself with James Bond, each supplying his own concretes which are illuminated and supported by that abstraction. It is not a conscious

process, but an emotional integration, and most people may not know that *that* is the reason of the enjoyment they find in thrillers. It is *not* a leader or a protector that they seek in a hero, since his exploits are always highly individualistic and un-social. What they seek is profoundly personal: self-confidence and self-assertion. Inspired by James Bond, a man may find the courage to rebel against the impositions of his in-laws—or to ask for a deserved raise—or to change his job—or to propose to the girl he loves—or to embark on the career he wants—or to defy the whole world for the sake of his new invention.

This is what Naturalistic art can never give him.

For example, consider one of the best works of modern Naturalism—Paddy Chayefsky's *Marty*. It is an extremely sensitive, perceptive, touching portrayal of a humble man's struggle for self-assertion. One can feel sympathy for Marty, and a sad kind of pleasure at his final success. But it is highly doubtful that anyone—including the thousands of real-life Martys—would be inspired by his example. No one could feel: "I want to be like Marty." Everyone (except the most corrupt) can feel: "I want to be like James Bond."

Such is the meaning of that popular art form which today's "friends of the people" are attacking with hysterical hatred.

The guiltiest men involved—both among the professionals and the public—are the moral cowards who do not share that hatred, but seek to appease it, who are willing to regard their own Romantic values as a secret vice, to keep them underground, to slip them furtively to black-market customers, and to pay off the established intellectual authorities, in the currency demanded: self-mockery.

The game will continue, and the bandwagon-riders will destroy James Bond, as they have destroyed Mike Hammer, as they have destroyed Eliot Ness, then will look for another victim to "parody"—until some future sacrificial worm turns and declares that he'll be damned if he'll allow Romanticism to be treated as bootleg merchandise.

The public, too, will have to do its share: it will have

to cease being satisfied with esthetic speakeasies, and demand the repeal of the Joyce-Kafka Amendment, which prohibits the sale and drinking of clean water, unless denatured by humor, while unconscionable rot-gut is being sold and drunk at every bookstore counter.

(January 1965)

9. Art and Moral Treason

Wнεν I saw Mr. X for the first time. I thought that he had the most tragic face I had ever seen: it was not the mark left by some specific tragedy, not the look of a great sorrow, but a look of desolate hopelessness, weariness and resignation that seemed left by the chronic pain of many lifetimes. He was twenty-six years old.

He had a brilliant mind, an outstanding scholastic record in the field of engineering, a promising start in his career—and no energy to move farther. He was paralyzed by so extreme a state of indecision that any sort of choice filled him with anxiety—even the question of moving out of an inconvenient apartment. He was stagnating in a job which he had outgrown and which had become a dull, uninspiring routine. He was so lonely that he had lost the capacity to know it, he had no concept of friendship, and his few attempts at a romantic relationship had ended disastrously—he could not tell why.

At the time I met him, he was undergoing psycho-

therapy, struggling desperately to discover the causes of his state. There seemed to be no existential cause for it. His childhood had not been happy, but no worse and, in some respects, better than the average childhood. There were no traumatic events in his past, no major shocks, disappointments or frustrations. Yet his frozen impersonality suggested a man who neither felt nor wanted anything any longer. He was like a gray spread of ashes that had never been on fire.

Discussing his childhood, I asked him once what he had been in love with (*what,* not *whom*). "Nothing," he answered—then mentioned uncertainly a toy that had been his favorite. On another occasion, I mentioned a current political event of shocking irrationality and injustice, which he conceded indifferently to be evil. I asked whether it made him indignant. "You don't understand," he answered gently. "I never feel indignation about anything."

He had held some erroneous philosophical views (under the influence of a college course in contemporary philosophy), but his intellectual goals and motives seemed to be a confused struggle in the right direction, and I could not discover any major ideological sin, any crime commensurate with the punishment he was suffering.

Then, one day, as an almost casual remark in a conversation about the role of human ideals in art, he told me the following story. Some years earlier, he had seen a certain semi-Romantic movie and had felt an emotion he was unable to describe, particularly in response to the character of an industrialist who was moved by a passionate, intransigent, dedicated vision of his work. Mr. X was speaking incoherently, but conveying clearly that what he had experienced was more than admiration for a single character: it was the sense of seeing a different kind of universe—and his emotion had been exaltation. "It was what I wanted life to be," he said. His eyes were sparkling, his voice was eager, his face was alive and young—he *was* a man in love, for the span of that moment. Then, the gray lifelessness came back and he concluded in a dull tone of voice, with a trace of tortured wistfulness: "When I came out

of the theater, I felt guilty about it—about having felt this." *"Guilty? Why?"* I asked. He answered: "Because I thought that what made me react this way to the industrialist, is the part of me that's wrong ... It's the impractical element in me ... Life is not like that ..."

What *I* felt was a cold shudder. Whatever the root of his problems, *this* was the key; it was the symptom, not of amorality, but of a profound moral treason. To what and to whom can a man be willing to apologize for the best within him? And what can he expect of life after that?

(Ultimately, what saved Mr. X was his commitment to reason; he held reason as an absolute, even if he did not know its full meaning and application; an absolute that survived through the hardest periods he had to endure in his struggle to regain his psychological health—to remark and release the soul he had spent his life negating. Due to his determined perseverance, he won his battle. Today—after quitting his job and taking many calculated risks—he is a brilliant success, in a career he loves, and on his way up to an ever-increasing range of achievement. He is still struggling with some remnants of his past errors. But, as a measure of his recovery and of the distance he has traveled, I would suggest that you re-read my opening paragraph before I tell you that I saw a recent snapshot of him which caught him smiling, and of all the characters in *Atlas Shrugged* the one whom the quality of that smile would suit best is Francisco d'Anconia.)

There are countless cases similar to this; this is merely the most dramatically obvious one in my experience and involves a man of unusual stature. But the same tragedy is repeated all around us, in many hidden, twisted forms—like a secret torture chamber in men's souls, from which an unrecognizable cry reaches us occasionally and then is silenced again. The person, in such cases, is both "man the victim" and "man the killer." And certain principles apply to them all.

Man is a being of self-made soul—which means that his character is formed by his basic premises, particularly by his basic value-premises. In the crucial formative years of his life—in childhood and adolescence—

Romantic art is his major (and, today, his only) source of a *moral* sense of life. (In later years, Romantic art is often his only experience of it.)

Please note that art is not his only source of *morality* but of a *moral sense of life*. This requires careful differentiation.

A *"sense of life"* is a preconceptual equivalent of metaphysics, an emotional, subconsciously integrated appraisal of man and of existence. *Morality* is an abstract, conceptual code of values and principles.

The process of a child's development consists of acquiring knowledge, which requires the development of his capacity to grasp and deal with an ever-widening range of abstractions. This involves the growth of two interrelated but different chains of abstractions, two hierarchical structures of concepts, which should be integrated but seldom are: the *cognitive* and the *normative*. The first deals with knowledge of the facts of reality—the second, with the evaluation of these facts. The first forms the epistemological foundation of science—the second, of morality and of art.

In today's culture, the development of a child's *cognitive* abstractions is assisted to some minimal extent, even if ineptly, half-heartedly, with many hampering, crippling obstacles (such as anti-rational doctrines and influences which, today, are growing worse). But the development of a child's *normative* abstractions is not merely left unaided, it is all but stifled and destroyed. The child whose valuing capacity survives the moral barbarism of his upbringing has to find his own way to preserve and develop his sense of values.

Apart from its many other evils, conventional morality is not concerned with the formation of a child's character. It does not teach or show him *what kind of man he ought to be* and why; it is concerned only with imposing a set of rules upon him—concrete, arbitrary, contradictory and, more often than not, incomprehensible rules which are mainly prohibitions and duties. A child whose only notion of morality (i.e., of *values*) consists of such matters as: "Wash your ears!"—"Don't be rude to Aunt Rosalie!"—"Do your homework!"— "Help papa to mow the lawn (or mama to wash the

dishes)!"—faces the alternative of: either a passively *amoral* resignation, leading to a future of hopeless cynicism, or a blind rebellion. Observe that the more intelligent and independent a child, the more unruly he is in regard to such commandments. But, in either case, the child grows up with nothing but resentment and fear or contempt for the concept of morality which, to him, is only "a phantom scarecrow made of duty, of boredom, of punishment, of pain . . . a scarecrow standing in a barren field, waving a stick to chase away [his] pleasures . . ." (*Atlas Shrugged*).

This type of upbringing is the best, not the worst, that an average child may be subjected to, in today's culture. If parents attempt to inculcate a moral ideal of the kind contained in such admonitions as: "Don't be selfish—give your best toys away to the children next door!" or if parents go "progressive" and teach a child to be guided by his whims—the damage to the child's moral character may be irreparable.

Where, then, can a child learn the concept of moral values and of a moral character in whose image he will shape his own soul? Where can he find the evidence, the material from which to develop a chain of *normative* abstractions? He is not likely to find a clue in the chaotic, bewildering, contradictory evidence offered by the adults in his day-by-day experience. He may like some adults and dislike others (and, often, dislike them all), but to abstract, identify and judge their *moral* characteristics is a task beyond his capacity. And such moral principles as he might be taught to recite are, to him, floating abstractions with no connection to reality.

The major source and demonstration of moral values available to a child is Romantic art (particularly Romantic literature). What Romantic art offers him is *not* moral rules, not an explicit didactic message, but the image of a moral *person*—i.e., the *concretized abstraction* of a moral ideal. It offers a concrete, directly perceivable answer to the very abstract question which a child senses, but cannot yet conceptualize: What kind of person is moral and what kind of life does he lead?

It is not abstract principles that a child learns from Romantic art, but the precondition and the incentive

for the later understanding of such principles: the emotional experience of admiration for man's highest potential, the experience of *looking up* to a hero—a view of life motivated and dominated by values, a life in which man's choices are practicable, effective and crucially important—that is, a *moral* sense of life.

While his home environment taught him to associate morality with *pain,* Romantic art teaches him to associate it with *pleasure*—an inspiring pleasure which is his own, profoundly personal discovery.

The translation of this sense of life into adult, conceptual terms would, if unimpeded, follow the growth of the child's knowledge—and the two basic elements of his soul, the cognitive and normative, would develop together in serenely harmonious integration. The ideal which, at the age of seven, was personified by a cowboy, may become a detective at twelve, and a philosopher at twenty—as the child's interests progress from comic strips to mystery stories to the great sunlit universe of Romantic literature, art and music.

But whatever his age, morality is a *normative* science—i.e., a science that projects a value-goal to be achieved by a series of steps, of choices—and it cannot be practiced without a clear vision of the goal, without a concretized image of the ideal to be reached. If man is to gain and keep a moral stature, he needs an image of the ideal, from the first thinking day of his life to the last.

In the translation of that ideal into conscious, philosophical terms and into his actual practice, a child needs intellectual assistance or, at least, a chance to find his own way. In today's culture, he is given neither. The battering which his precarious, unformed, barely glimpsed *moral sense of life* receives from parents, teachers, adult "authorities" and little second-hander goons of his own generation, is so intense and so evil that only the toughest hero can withstand it—so evil that of the many sins of adults toward children, *this* is the one for which they would deserve to burn in hell, if such a place existed.

Every form of punishment—from outright prohibition to threats to anger to condemnation to crass indif-

ference to mockery—is unleashed against a child at the
first signs of his Romanticism (which means: at the first
signs of his emerging sense of moral values). "Life is
not like that!" and "Come down to earth!" are the
catchphrases which best summarize the motives of the
attackers, as well as the view of life and of this earth
which they seek to inculcate.

The child who withstands it and damns the attack-
ers, not himself and his values, is a rare exception. The
child who merely *suppresses* his values, avoids commu-
nication and withdraws into a lonely private universe, is
almost as rare. In most cases, the child *represses* his
values and gives up. He gives up the entire realm of
valuing, of value choices and judgments—without
knowing that what he is surrendering is *morality*.

The surrender is extorted by a long, almost imper-
ceptible process, a constant, ubiquitous pressure which
the child absorbs and accepts by degrees. His spirit is
not broken at one sudden blow: it is bled to death in
thousands of small scratches.

The most devastating part of this process is the fact
that a child's moral sense is destroyed, not only by
means of such weaknesses or flaws as he might have
developed, but by means of his barely emerging vir-
tues. An intelligent child is aware that he does not
know what adult life is like, that he has an enormous
amount to learn and is anxiously eager to learn it. An
ambitious child is incoherently determined to make
something *important* of himself and his life. So when he
hears such threats as "Wait till you grow up!" and
"You'll never get anywhere with those childish no-
tions!" it is his virtues that are turned against him: his
intelligence, his ambition and whatever respect he
might feel for the knowledge and judgment of his el-
ders.

Thus the foundation of a lethal dichotomy is laid in
his consciousness: the *practical* versus the *moral*, with
the unstated, preconceptual implication that practicality
requires the betrayal of one's values, the renunciation
of ideals.

His rationality is turned against him by means of a
similar dichotomy: *reason* versus *emotion*. His Roman-

tic sense of life is only a *sense*, an incoherent emotion which he can neither communicate nor explain nor defend. It is an intense, yet fragile emotion, painfully vulnerable to any sarcastic allegation, since he is unable to identify its real meaning.

It is easy to convince a child, and particularly an adolescent, that his desire to emulate Buck Rogers is ridiculous: he knows that it isn't exactly Buck Rogers he has in mind and yet, simultaneously, it *is*—he feels caught in an inner contradiction—and this confirms his desolately embarrassing feeling that he is being ridiculous.

Thus the adults—whose foremost moral obligation toward a child, at this stage of his development, is to help him understand that what he loves is an abstraction, to help him break through into the *conceptual* realm—accomplish the exact opposite. They stunt his conceptual capacity, they cripple his normative abstractions, they stifle his *moral ambition,* i.e., his desire for virtue, i.e., his self-esteem. They arrest his value-development on a primitively literal, concrete-bound level: they convince him that to be like Buck Rogers means to wear a space helmet and blast armies of Martians with a disintegrator-gun, and that he'd better give up such notions if he ever expects to make a respectable living. And they finish him off with such gems of argumentation as: "Buck Rogers—ha-ha!— never gets any colds in the head. Do you know any real people who never get them? Why, *you* had one last week. So don't you go on imagining that you're better than the rest of us!"

Their motive is obvious. If they actually regarded Romanticism as an "impractical fantasy," they would feel nothing but a friendly or indifferent amusement— *not* the passionate resentment and uncontrollable rage which they do feel and exhibit.

While the child is thus driven to fear, mistrust and repress his own emotions, he cannot avoid observing the hysterical violence of the adults' emotions unleashed against him in this and other issues. He concludes, subconsciously, that *all* emotions as such are dangerous, that they are the irrational, unpredictably destruc-

tive element in people, which can descend upon him at any moment in some terrifying way for some incomprehensible purpose. This is the brick before last in the wall of repression which he erects to bury his own emotions. The last is his desperate pride misdirected into a decision such as: "I'll never let them hurt me again!" The way never to be hurt, he decides, is never to feel anything.

But an emotional repression cannot be complete; when all other emotions are stifled, a single one takes over: fear.

The element of fear was involved in the process of the child's moral destruction from the start. His victimized virtues were not the only cause; his faults were active as well: fear of others, particularly of adults, fear of independence, of responsibility, of loneliness—as well as self-doubt and the desire to be accepted, to "belong." But it is the involvement of his virtues that makes his position so tragic and, later, so hard to correct.

As he grows up, his amorality is reinforced and reaffirmed. His intelligence prevents him from accepting any of the current schools of morality: the mystical, the social or the subjective. An eager young mind, seeking the guidance of reason, cannot take the supernatural seriously and is impervious to mysticism. It does not take him long to perceive the contradictions and the sickeningly self-abasing hypocrisy of the social school of morality. But the worst influence of all, for him, is the subjective school.

He is too intelligent and too honorable (in his own twisted, tortured way) not to know that the *subjective* means the arbitrary, the irrational, the blindly emotional. *These* are the elements which he has come to associate with people's attitudes in moral issues, and to dread. When formal philosophy tells him that morality, by its very nature, is closed to reason and can be nothing but a matter of subjective choice, this is the kiss or seal of death on his moral development. His conscious conviction now unites with his subconscious feeling that value choices come from the mindless element in people and are a dangerous, unknowable, un-

predictable enemy. His conscious decision is: not to get involved in moral issues; its subconscious meaning is: *not to value anything* (or worse: not to value anything *too much*, not to hold any irreplaceable, nonexpendable values).

From this to the policy of a moral coward existentially and to an overwhelming sense of guilt psychologically, is not a very long step for an intelligent man. The result is a man such as I described.

Let it be said to his credit that he was unable to "adjust" to his inner contradictions—and that it was precisely his early professional success that broke him psychologically: it exposed his value-vacuum, his lack of personal purpose and thus the self-abnegating futility of his work.

He knew—even though not in fully conscious terms—that he was achieving the opposite of his original, preconceptual goals and motives. Instead of leading a *rational* (i.e., reason-guided and reason-motivated) life, he was gradually becoming a moody, subjectivist whim-worshiper, acting on the range of the moment, particularly in his personal relationships—by default of any firmly defined values. Instead of reaching independence from the irrationality of others, he was being forced—by the same default—either into actual secondhandness or into an equivalent code of behavior, into blind dependence on and compliance with the value-systems of others, into a state of abject conformity. Instead of pleasure, the glimpse of any higher value or nobler experience brought him pain, guilt, terror—and prompted him, not to seize it and fight for it, but to escape, to evade, to betray it (or to *apologize* for it) in order to placate the standards of the conventional men whom he despised. Instead of "man the victim," as he had largely been, he was becoming "man the killer."

The clearest evidence of it was provided by his attitude toward Romantic art. A man's treason to his art values is not the primary cause of his neurosis (it is a contributory cause), but it becomes one of its most revealing symptoms.

This last is of particular importance to the man who seeks to solve his psychological problems. The chaos of

his personal relationships and values may, at first, be too complex for him to untangle. But Romantic art offers him a clear, luminous, impersonal abstraction—and thus a clear, objective test of his inner state, a clue available to his conscious mind.

If he finds himself fearing, evading and negating the highest experience possible to man, a state of unclouded exaltation, he can know that he is in profound trouble and that his only alternatives are: either to check his value-premises from scratch, from the start, from the repressed, forgotten, betrayed figure of his particular Buck Rogers, and painfully to reconstruct his broken chain of normative abstractions—or to become completely the kind of monster he is in those moments when, with an obsequious giggle, he tells some fat Babbitt that exaltation is impractical.

Just as Romantic art is a man's first glimpse of a moral sense of life, so it is his last hold on it, his last lifeline.

Romantic art is the fuel and the spark plug of a man's soul; its task is to set a soul on fire and never let it go out. The task of providing that fire with a motor and a direction belongs to philosophy.

(*March 1965*)

10. Introduction
to *Ninety-Three**

Have you ever wondered what they felt, those first men of the Renaissance, when—emerging from the long nightmare of the Middle Ages, having seen nothing but the deformed monstrosities and gargoyles of medieval art as the only reflections of man's soul—they took a new, free, unobstructed look at the world and rediscovered the statues of Greek gods, forgotten under piles of rubble? If you have, that unrepeatable emotional experience is yours when you rediscover the novels of Victor Hugo.

The distance between his world and ours is astonishingly short—he died in 1885—but the distance between his *universe* and ours has to be measured in esthetic light-years. He is virtually unknown to the American public but for some vandalized remnants on our movie screens. His works are seldom discussed in the literary courses of our universities. He is buried under the esthetic rubble of our day—while gargoyles leer at us

* From the Introduction by Ayn Rand to *Ninety-Three* by Victor Hugo, translated by Lowell Bair. Copyright © 1962 by Bantam Books, Inc. All rights reserved.

again, not from the spires of cathedrals, but from the pages of shapeless, unfocused, ungrammatical novels about drug addicts, bums, killers, dipsomaniacs, psychotics. He is as invisible to the neo-barbarians of our age as the art of Rome was to their spiritual ancestors, and for the same reasons. Yet Victor Hugo is the greatest novelist in world literature. . . .

Romantic literature did not come into existence until the nineteenth century, when men's life was politically freer than in any other period of history, and when Western culture was still reflecting a predominantly Aristotelian influence—the conviction that man's mind is competent to deal with reality. The Romanticists were far from Aristotelian in their avowed beliefs; but their sense of life was the beneficiary of his liberating power. The nineteenth century saw both the start and the culmination of an illustrious line of great Romantic novelists.

And the greatest of these was Victor Hugo. . . .

Modern readers, particularly the young, who have been brought up on the kind of literature that makes Zola seem Romantic by comparison, should be cautioned that a first encounter with Hugo might be shocking to them: it is like emerging from a murky underground, filled with the moans of festering half-corpses, into a blinding burst of sunlight. So, by way of providing an intellectual first-aid kit, I would suggest the following:

Do not look for familiar landmarks—you won't find them; you are not entering the backyard of "the folks next door," but a universe you did not know existed.

Do not look for "the folks next door"—you are about to meet a race of giants, who might have and ought to have been your neighbors.

Do not say that these giants are "unreal" because you have never seen them before—check *your* eyesight, not Hugo's, and *your* premises, not his; it was not his purpose to show you what you had seen a thousand times before.

Do not say that the actions of these giants are "impossible" because they are heroic, noble, intelligent,

beautiful—remember that the cowardly, the depraved, the mindless, the ugly are not all that is possible to man.

Do not say that this glowing new universe is an "escape"—you will witness harder, more demanding, more tragic battles than any you have seen on pool-room street corners; the difference is only this: these battles are not fought for penny ante.

Do not say that "life is not like that"—ask yourself: *whose* life?

This warning is made necessary by the fact that the philosophical and cultural disintegration of our age—which is bringing men's intellect down to the concrete-bound, range-of-the-moment perspective of a savage—has brought literature to the stage where the concept of "abstract universality" is now taken to mean "statistical majority." To approach Hugo with such intellectual equipment and such a criterion is worse than futile. To criticize Hugo for the fact that his novels do not deal with the daily commonplaces of average lives, is like criticizing a surgeon for the fact that he does not spend his time peeling potatoes. To regard as Hugo's failure the fact that his characters are "larger than life" is like regarding as an airplane's failure the fact that it flies.

But for those readers who do not see why the kind of people that bore them to death or disgust them in "real life" should hold a monopoly on the role of literary subjects, for those readers who are deserting "serious" literature in growing numbers and searching for the last afterglow of Romanticism in detective fiction, Hugo is the new continent they have been longing to discover.

Ninety-Three (Quatrevingt-treize) is Hugo's last novel and one of his best. It is an excellent introduction to his works: it presents—in story, style and spirit—the condensed essence of that which is uniquely "Hugo-esque."

The novel's background is the French Revolution—"Ninety-three" stands for 1793, the year of the terror, the Revolution's climax. The events of the story take place during the civil war of the Vendée—an uprising of the royalist peasants of Brittany, led by aristocrats who returned from exile for a desperate attempt to

restore the monarchy—a civil war characterized by savage ruthlessness on both sides.

A great many irrelevant things have been said and written about this novel. At the time of its publication, in 1874, it was not favorably received by Hugo's enormous public or by the critics. The explanation usually given by literary historians is that the French public was not sympathetic to a novel that seemed to glorify the first Revolution, at a time when the recent blood and horror of the Paris Commune of 1871 were still fresh in the public's memory. Two of Hugo's modern biographers refer to the novel as follows: Matthew Josephson, in *Victor Hugo*, mentions it disapprovingly as a "historical romance" with "idealized characters"; André Maurois, in *Olympio ou la Vie de Victor Hugo*, lists a number of Hugo's personal connections with the setting of the story (such as the fact that Hugo's father fought in the Vendée, on the republican side), then remarks: "The dialogue [of the novel] is theatrical. But the French Revolution had been theatrical and dramatic. Its heroes had struck sublime poses and had held them to the death." (Which is a purely Naturalistic approach or attempt at justification.)

The fact is that *Ninety-Three* is *not* a novel about the French Revolution.

To a Romanticist, a background is a background, not a theme. His vision is always focused on man—on the fundamentals of man's nature, on those problems and those aspects of his character which apply to any age and any country. The theme of *Ninety-Three*— which is played in brilliantly unexpected variations in all the key incidents of the story, and which is the motive power of all the characters and events, integrating them into an inevitable progression toward a magnificent climax—is: *man's loyalty to values*.

To dramatize that theme, to isolate that aspect of man's soul and show it in its purest form, to put it to the test under the pressure of deadly conflicts, a revolution is an appropriate background to select. Hugo's story is not devised as a means of presenting the French Revolution; the French Revolution is used as a means of presenting his story.

It is not any specific code of values that concerns him here, but the wider abstraction: man's loyalty to values, whatever any man's particular values might be. Although Hugo's personal sympathy is obviously on the side of the republicans, he presents his characters with impersonal detachment, or rather, with an impartial admiration granted equally to both sides of the conflict. In spiritual grandeur, intransigent integrity, unflinching courage and ruthless dedication to his cause, the old Marquis de Lantenac, the leader of the royalists, is the equal of Cimourdain, the ex-priest who became the leader of the republicans. (And, perhaps, Lantenac is Cimourdain's superior, as far as the color and power of his characterization are concerned.) Hugo's sympathy for the gay, boisterous exuberance of the republican soldiers is matched by his sympathy for the grim, desperate stubbornness of the royalist peasants. The emphasis he projects is not: "What great values men are fighting for!" but: "What greatness men are capable of, when they fight for their values!"

Hugo's inexhaustible imagination is at its virtuoso best in an extremely difficult aspect of a novelist's task: the integration of an abstract theme to the plot of a story. While the events of *Ninety-Three* are a sweeping emotional torrent directed by the inexorable logic of a plot structure, every event features the theme, every event is an instance of man's violent, tortured, agonized, yet triumphant dedication to his values. This is the invisible chain, the corollary of the plot-line, that unites such scenes as: the ragged, disheveled young mother, staggering blindly, with savage endurance, through flaming villages and devastated fields, searching desperately for the children she has lost in the chaos of the civil war—the beggar who acts as host to his former feudal master, in a cave under the roots of a tree—the humble sailor who has to make a choice, knowing that for a few brief hours, in a rowboat, in the darkness of night, he holds the fate of the monarchy in his hands—the tall, proud figure of a man with the clothes of a peasant and the bearing of an aristocrat, who looks up from the bottom of a ravine at the distant reflection of a fire and finds himself confronted by a terrible alter-

native—the young revolutionary, pacing back and forth in the darkness, in front of a breach in a crumbling tower, torn between treason to the cause he has served all his life and the voice of a higher loyalty—the white-faced figure of a man who rises to pronounce the verdict of a revolutionary tribunal, while the crowd waits in total stillness to hear whether he will spare or sentence to death the only man he had ever loved.

The greatest example of the power of dramatic integration is an unforgettable scene which only Hugo could have written, a scene in which the agonizing intensity and suspense of a complex development are resolved and surpassed by two simple lines of dialogue: "Je t'arrête."—"Je t'approuve." ("I arrest you."— "You are right.") The reader will have to reach these lines in their full context to discover who speaks them and what enormous psychological significance and grandeur the author makes them convey.

"Grandeur" is the one word that names the leitmotif of *Ninety-Three* and of all of Hugo's novels—and of his sense of life. And perhaps the most tragic conflict is not in his novels, but in their author. With so magnificent a view of man and of existence, Hugo never discovered how to implement it in reality. He professed conscious beliefs which contradicted his subconscious ideal and made its application to reality impossible.

He never translated his sense of life into conceptual terms, he did not ask himself what ideas, premises or psychological conditions were necessary to enable men to achieve the spiritual stature of his heroes. His attitude toward the intellect was highly ambiguous. It is as if Hugo the artist had overwhelmed Hugo the thinker; as if a great mind had never drawn a distinction between the processes of artistic creation and of rational cognition (two different methods of using one's consciousness, which need not clash, but are not the same); as if his thinking consisted of images, in his work and in his own life; as if he thought in metaphors, not in concepts, in metaphors that stood for enormous emotional complexities, as hurried symbols and mere approximations. It is as if the wide emotional abstractions he handled as an artist made him too impatient for the

task of rigorous defining and of identifying that which he *sensed* rather than knew—and so he reached for any available theories that seemed to *connote*, rather than denote, his values.

Toward the close of *Ninety-Three*, Hugo the artist sets up two superlatively dramatic opportunities for his characters to express their ideas, to declare the intellectual grounds of their stand: one, a scene between Lantenac and Gauvain, in which the old royalist is supposed to defy the young revolutionary by an impassioned defense of the monarchy; the other, between Cimourdain and Gauvain, in which they are supposed to confront each other as the spokesmen for two different aspects of the revolutionary spirit. I say "supposed," because Hugo the thinker was unable to do it: the characters' speeches are not expressions of ideas, but only rhetoric, metaphors and generalities. His fire, his eloquence, his emotional power seemed to desert him when he had to deal with theoretical subjects.

Hugo the thinker was archetypical of the virtues and the fatal errors of the nineteenth century. He believed in an unlimited, *automatic* human progress. He believed that ignorance and poverty were the only cause of human evil. Feeling an enormous, incoherent benevolence, he was impatiently eager to abolish any form of human suffering and he proclaimed ends, without thinking of means: he wanted to abolish poverty, with no idea of the source of wealth; he wanted the people to be free, with no idea of what is necessary to secure political freedom; he wanted to establish universal brotherhood, with no idea that force and terror will not establish it. He took reason for granted and did not see the disastrous contradiction of attempting to combine it with faith—though *his* particular form of mysticism was not of the abject Oriental variety, but was closer to the proud legends of the Greeks, and his God was a symbol of human perfection, whom he worshiped with a certain arrogant confidence, almost like an equal or a personal friend.

The theories by which Hugo the thinker sought to implement it do not belong in the universe of Hugo the artist. When and as they are put into practice, they

achieve the opposite of those values which he knew
only as a sense of life. Hugo the artist paid for that
lethal contradiction. Even though no other artist had
ever projected so deeply joyous a universe as his, there
is a somber touch of tragedy in all his writing. Most of
his novels have tragic endings—as if he were unable to
concretize the form in which his heroes could triumph
on earth, and he could only let them die in battle, with
an unbroken integrity of spirit as the only assertion of
their loyalty to life; as if, to him, it was the earth, not
heaven, that represented an object of longing, which he
could never fully reach or win.

Such was the nature of his conflict: a professed mystic
in his conscious convictions, he was passionately in love
with this earth; a professed altruist, he worshiped man's
greatness, not his suffering, weaknesses or evils; a pro-
fessed advocate of socialism, he was a fiercely intran-
sigent individualist; a professed champion of the doc-
trine that emotions are superior to reason. he achieved
the grandeur of his characters by making them all
superbly *conscious*, fully aware of their motives and
desires, fully focused on reality and acting accordingly—
from the peasant mother in *Ninety-Three* to Jean
Valjean in *Les Misérables*. And this is the secret of
their peculiar cleanliness, this is what gives a beggar the
stature of a giant, this absence of blind irrationality and
stuporous, unfocused drifting; this is the hallmark of all
of Hugo's characters; it is also the hallmark of human
self-esteem.

On whose political-philosophical side does Victor
Hugo belong? It is not an accident that in our day, in a
culture dominated by altruistic collectivism, he is not a
favorite of those whose alleged ideals he allegedly
shared.

I discovered Victor Hugo when I was thirteen, in the
stifling, sordid ugliness of Soviet Russia. One would
have to have lived on some pestilent planet in order
fully to understand what his novels—and his radiant
universe—meant to me then, and mean now. And that
I am writing an introduction to one of his novels—in
order to present it to the American public—has, for
me, the sense of the kind of drama that he would have

approved and understood. He helped to make it possible for me to be here and to be a writer. If I can help another young reader to find what I found in his work, if I can bring to the novels of Victor Hugo some part of the kind of audience he deserves, I shall regard it as a payment on an incalculable debt that can never be computed or repaid.

11. The Goal of My Writing

THE motive and purpose of my writing is *the projection of an ideal man*. The portrayal of a moral ideal, as my ultimate literary goal, as an end in itself— to which any didactic, intellectual or philosophical values contained in a novel are only the means.

Let me stress this: my purpose is *not* the philosophical enlightenment of my readers, it is *not* the beneficial influence which my novels may have on people, it is *not* the fact that my novels may help a reader's intellectual development. All these matters are important, but they are secondary considerations, they are merely consequences and effects, not first causes or prime movers. My purpose, first cause and prime mover is the portrayal of Howard Roark or John Galt or Hank Rearden or Francisco d'Anconia *as an end in himself*—not as a means to any further end. Which, incidentally, is the greatest value I could ever offer a reader.

This is why I feel a very mixed emotion—part patience, part amusement and, at times, an empty kind of weariness—when I am asked whether I am primarily a

novelist or a philosopher (as if these two were antonyms), whether my stories are propaganda vehicles for ideas, whether politics or the advocacy of capitalism is my chief purpose. All such questions are so enormously irrelevant, so far beside the point, so much *not* my way of coming at things.

My way is much simpler and, simultaneously, much more complex than that, speaking from two different aspects. The simple truth is that I approach literature as a child does: I write—and read—for the sake of the story. The complexity lies in the task of translating that attitude into adult terms.

The specific concretes, the *forms* of one's values, change with one's growth and development. The abstraction "*values*" does not. An adult's values involve the entire sphere of human activity, including philosophy—most particularly philosophy. But the basic principle—the function and meaning of values in man's life and in literature—remains the same.

My basic test for any story is: Would I want to meet these characters and observe these events in real life? Is this story an experience worth living through for its own sake? Is the pleasure of contemplating these characters an end in itself?

It's as simple as that. But that simplicity involves the total of man's existence.

It involves such questions as: What kind of men do I want to see in real life—and why? What kind of events, that is, human actions, do I want to see taking place—and why? What kind of experience do I want to live through, that is, what are my goals—and why?

It is obvious to what field of human knowledge all these questions belong: to the field of *ethics*. What is the good? What are the right actions for man to take? What are man's proper *values*?

Since my purpose is the presentation of an ideal man, I had to define and present the conditions which make him possible and which his existence requires. Since man's character is the product of his premises, I had to define and present the kind of premises and values that create the character of an ideal man and motivate his actions; which means that I had to define

and present a rational code of ethics. Since man acts among and deals with other men, I had to present the kind of social system that makes it possible for ideal men to exist and to function—a free, productive, rational system, which demands and rewards the best in *every* man, great or average, and which is, obviously, laissez-faire capitalism.

But neither politics nor ethics nor philosophy are ends in themselves, neither in life nor in literature. Only Man is an end in himself.

Now observe that the practitioners of the literary school diametrically opposed to mine—the school of Naturalism—claim that a writer must reproduce what they call "real life," allegedly "as it is," exercising no selectivity and no value-judgments. By "reproduce," they mean "photograph"; by "real life," they mean whatever given concretes they happen to observe; by "as it is," they mean "as it is lived by the people around them." But observe that these Naturalists—or the good writers among them—are extremely selective in regard to two attributes of literature: *style* and *characterization*. Without selectivity, it would be impossible to achieve any sort of characterization whatever, neither of an unusual man nor of an average one who is to be offered as statistically typical of a large segment of the population. Therefore, the Naturalists' opposition to selectivity applies to only one attribute of literature: the content or *subject*. It is in regard to his choice of subject that a novelist must exercise no choice, they claim.

Why?

The Naturalists have never given an answer to that question—not a rational, logical, noncontradictory answer. Why should a writer photograph his subjects indiscriminately and unselectively? Because they "really" happened? To record what really happened is the job of a reporter or of a historian, not of a novelist. To enlighten readers and educate them? That is the job of science, not of literature, of nonfiction writing, not of fiction. To improve men's lot by exposing their misery? But *that* is a value-judgment and a moral purpose and a didactic "message"—all of which are forbidden by the Naturalist doctrine. Besides, to improve anything one

must know what constitutes an improvement—and to know that, one must know what is the good and how to achieve it—and to know that, one must have a whole system of value-judgments, a system of *ethics*, which is anathema to the Naturalists.

Thus, the Naturalists' position amounts to giving a novelist full esthetic freedom in regard to *means*, but not in regard to *ends*. He may exercise choice, creative imagination, value-judgments in regard to *how* he portrays things, but not in regard to *what* he portrays—in regard to style or characterization, but not in regard to *subject*. Man—the subject of literature—must not be viewed or portrayed selectively. Man must be accepted as the given, the unchangeable, the not-to-be-judged, the status quo. But since we observe that men do change, that they differ from one another, that they pursue different values, who, then, is to determine the human status quo? Naturalism's implicit answer is: everybody except the novelist.

The novelist—according to the Naturalist doctrine—must neither judge nor value. He is not a creator, but only a recording secretary whose master is the rest of mankind. Let others pronounce judgments, make decisions, select goals, fight over values and determine the course, the fate and the soul of man. The novelist is the only outcast and deserter of that battle. His is not to reason why—his is only to trot behind his master, notebook in hand, taking down whatever the master dictates, picking up such pearls or such swinishness as the master may choose to drop.

As far as I am concerned, I have too much self-esteem for a job of that kind.

I see the novelist as a combination of prospector and jeweler. The novelist must discover the potential, the gold mine, of man's soul, must extract the gold and then fashion as magnificent a crown as his ability and vision permit.

Just as men of ambition for material values do not rummage through city dumps, but venture out into lonely mountains in search of gold—so men of ambition for intellectual values do not sit in their backyards, but venture out in quest of the noblest, the purest, the

costliest elements. I would not enjoy the spectacle of Benvenuto Cellini making mud-pies.

It is the selectivity in regard to subject—the most severely, rigorously, ruthlessly exercised selectivity—that I hold as the primary, the essential, the cardinal aspect of art. In literature, this means: *the story*—which means: the plot and the characters—which means: the kind of men and events that a writer chooses to portray.

The subject is not the only attribute of art, but it is the fundamental one, it is the end to which all the others are the means. In most esthetic theories, however, the end—the subject—is omitted from consideration, and only the means are regarded as esthetically relevant. Such theories set up a false dichotomy and claim that a slob portrayed by the technical means of a genius is preferable to a goddess portrayed by the technique of an amateur. I hold that *both* are esthetically offensive; but while the second is merely esthetic incompetence, the first is an esthetic crime.

There is no dichotomy, no necessary conflict between ends and means. The end does *not* justify the means—neither in ethics nor in esthetics. And neither do the means justify the end: there is no esthetic justification for the spectacle of Rembrandt's great artistic skill employed to portray a side of beef.

That particular painting may be taken as a symbol of everything I am opposed to in art and in literature. At the age of seven, I could not understand why anyone should wish to paint or to admire pictures of dead fish, garbage cans or fat peasant women with triple chins. Today, I understand the psychological causes of such esthetic phenomena—and the more I understand, the more I oppose them.

In art, and in literature, the end and the means, or the subject and the style, must be worthy of each other.

That which is not worth contemplating in life, is not worth re-creating in art.

Misery, disease, disaster, evil, all the negatives of human existence, are proper subjects of *study* in life, for the purpose of understanding and correcting them—but are not proper subjects of *contemplation* for con-

templation's sake. In art, and in literature, these negatives are worth re-creating only in relation to some positive, as a foil, as a contrast, as a means of stressing the positive—but *not* as an end in themselves.

The "compassionate" studies of depravity which pass for literature today are the dead end and the tombstone of Naturalism. If their perpetrators still claim the justification that these things are "true" (most of them aren't)—the answer is that this sort of truth belongs in psychological case histories, not in literature. The picture of an infected ruptured appendix may be of great value in a medical textbook—but it does not belong in an art gallery. And an infected soul is a much more repulsive spectacle.

That one should wish to enjoy the contemplation of *values*, of the *good*—of man's greatness, intelligence, ability, virtue, heroism—is self-explanatory. It is the contemplation of the *evil* that requires explanation and justification; and the same goes for the contemplation of the mediocre, the undistinguished, the commonplace, the meaningless, the mindless.

At the age of seven, I refused to read the children's equivalent of Naturalistic literature—the stories about the children of the folks next door. They bored me to death. I was not interested in such people in real life; I saw no reason to find them interesting in fiction.

This is still my position today; the only difference is that today I know its full philosophical justification.

As far as literary schools are concerned, I would call myself a Romantic Realist.

Consider the significance of the fact that the Naturalists call Romantic art an "escape." Ask yourself what sort of metaphysics—what view of life—that designation confesses. An escape—from what? If the projection of value-goals—the projection of an improvement on the given, the known, the immediately available—is an "escape," then medicine is an "escape" from disease, agriculture is an "escape" from hunger, knowledge is an "escape" from ignorance, ambition is an "escape" from sloth, and life is an "escape" from death. If so, then a hard-core realist is a vermin-eaten brute who sits motionless in a mud puddle, contemplates a pigsty and

whines that "such is life." If *that* is realism, then I am an escapist. So was Aristotle. So was Christopher Columbus.

There is a passage in *The Fountainhead* that deals with this issue: the passage in which Howard Roark explains to Steven Mallory why he chose him to do a statue for the Stoddard Temple. In writing that passage, I was consciously and deliberately stating the essential goal of my own work—as a kind of small, personal manifesto: "I think you're the best sculptor we've got. I think it, because your figures are not what men are, but what men could be—and should be. Because you've gone beyond the probable and made us see what is possible, but possible only through you. Because your figures are more devoid of contempt for humanity than any work I've ever seen. Because you have a magnificent respect for the human being. Because your figures are the heroic in man."

Today, more than twenty years later, I would want to change—or, rather, to clarify—only two small points. First, the words "more devoid of contempt for humanity" are not too exact grammatically; what I wanted to convey was "*untouched*" by contempt for humanity, while the work of others was touched by it to some extent. Second, the words "possible only through you" should not be taken to mean that Mallory's figures were impossible metaphysically, in reality; I meant that they were possible only because *he* had shown the way to make them possible.

"Your figures are not what men are, but what men could be—and should be."

This line will make it clear whose great philosophical principle I had accepted and was following and had been groping for, long before I heard the name "Aristotle." It was Aristotle who said that fiction is of greater philosophical importance than history, because history represents things only as they are, while fiction represents them "as they *might be* and *ought to be.*"

Why must fiction represent things "as they might be and ought to be"?

My answer is contained in one statement of *Atlas Shrugged*—and in the implications of that statement:

"As man is a being of self-made wealth, so he is a being of self-made soul."

Just as man's physical survival depends on his own effort, so does his psychological survival. Man faces two corollary, interdependent fields of action in which a constant exercise of choice and a constant creative process are demanded of him: the world around him and his own soul (by "soul," I mean his consciousness). Just as he has to produce the material values he needs to sustain his life, so he has to acquire the values of character that enable him to sustain it and that make his life worth living. He is born without the knowledge of either. He has to discover both—and translate them into reality—and survive by shaping the world and himself in the image of his values.

Growing from a common root, which is philosophy, man's knowledge branches out in two directions. One branch studies the physical world or the phenomena pertaining to man's physical existence; the other studies man or the phenomena pertaining to his consciousness. The first leads to abstract science, which leads to applied science or engineering, which leads to technology —to the actual production of material values. The second leads to art.

Art is the technology of the soul.

Art is the product of three philosophical disciplines: metaphysics, epistemology, ethics. Metaphysics and epistemology are the abstract base of ethics. Ethics is the applied science that defines a code of values to guide man's choices and actions—the choices and actions which determine the course of his life; ethics is the engineering that provides the principles and blueprints. Art creates the final product. It builds the model.

Let me stress this analogy: art does not *teach*—it shows, it displays the full, concretized reality of the final goal. Teaching is the task of ethics. Teaching is not the purpose of an art work, any more than it is the purpose of an airplane. Just as one can learn a great deal from an airplane by studying it or taking it apart, so one can learn a great deal from an art work—about the nature of man, of his soul, of his existence. But these are merely fringe benefits. The primary purpose

of an airplane is not to *teach* man how to fly, but to give him the actual experience of flying. So is the primary purpose of an art work.

Although the representation of things "as they might be and ought to be" helps man to achieve these things in real life, this is only a secondary value. The *primary* value is that it gives him the experience of living in a world where things are *as they ought to be*. This experience is of crucial importance to him: it is his psychological life line.

Since man's ambition is unlimited, since his pursuit and achievement of values is a lifelong process—and the higher the values, the harder the struggle—man needs a moment, an hour or some period of time in which he can experience the sense of his completed task, the sense of living in a universe where his values have been successfully achieved. It is like a moment of rest, a moment to gain fuel to move farther. Art gives him that fuel. Art gives him the experience of seeing the full, immediate, concrete reality of his distant goals.

The importance of that experience is not in *what* he learns from it, but in *that* he experiences it. The fuel is not a theoretical principle, not a didactic "message," but the life-giving fact of experiencing a moment of *metaphysical* joy—a moment of love for existence.

A given individual may choose to move forward, to translate the meaning of that experience into the actual course of his own life; or he may fail to live up to it and spend the rest of his life betraying it. But whatever the case may be, the art work remains intact, an entity complete in itself, an achieved, realized, immovable fact of reality—like a beacon raised over the dark crossroads of the world, saying: "*This* is possible."

No matter what its consequences, that experience is not a way station one passes, but a stop, a value in itself. It is an experience about which one can say: "I am glad to have reached this in my life." There are not many experiences of that kind to be found in the modern world.

I have read a great many novels of which nothing remains in my mind but the dry rustle of scraps long since swept away. But the novels of Victor Hugo, and a

very few others, were an unrepeatable experience to me, a beacon whose every brilliant spark is as alive as ever.

This aspect of art is difficult to communicate—it demands a great deal of the viewer or reader—but I believe that many of you will understand me introspectively.

There is a scene in *The Fountainhead* which is a direct expression of this issue. I was, in a sense, both characters in that scene, but it was written primarily from the aspect of myself as the consumer, rather than the producer, of art; it was based on my own desperate longing for the sight of human achievement. I regarded the emotional meaning of that scene as entirely personal, almost subjective—and I did not expect it to be shared by anyone. But that scene proved to be the one most widely understood and most frequently mentioned by the readers of *The Fountainhead*.

It is the opening scene of Part IV, between Howard Roark and the boy on the bicycle.

The boy thought that "man's work should be a higher step, an improvement on nature, not a degradation. He did not want to despise men; he wanted to love and admire them. But he dreaded the sight of the first house, poolroom and movie poster he would encounter on his way. . . . He had always wanted to write music, and he could give no other identity to the thing he sought. . . . Let me see that in one single act of man on earth. Let me see it made real. Let me see the answer to the promise of that music. . . . Don't work for my happiness, my brothers—show me yours—show me that it is possible—show me your achievement—and the knowledge will give me courage for mine."

This is the meaning of art in man's life.

It is from this perspective that I will now ask you to consider the meaning of Naturalism—the doctrine which proposes to confine men to the sight of slums, poolrooms, movie posters and on down, much farther down.

It is the Romantic or value-oriented vision of life that the Naturalists regard as "superficial"—and it is

the vision which extends as far as the bottom of a garbage can that they regard as "profound."

It is rationality, purpose and values that they regard as naive—while sophistication, they claim, consists of discarding one's mind, rejecting goals, renouncing values and writing four-letter words on fences and sidewalks.

Scaling a mountain, they claim, is easy—but rolling in the gutter is a noteworthy achievement.

Those who seek the sight of beauty and greatness are motivated by *fear*, they claim—they who are the embodiments of chronic terror—while it takes courage to fish in cesspools.

Man's soul—they proclaim with self-righteous pride —is a sewer.

Well, they ought to know.

It is a significant commentary on the present state of our culture that I have become the object of hatred, smears, denunciations, because I am famous as virtually the only novelist who has declared that *her* soul is *not* a sewer, and neither are the souls of her characters, and neither is the soul of man.

The motive and purpose of my writing can best be summed up by saying that if a dedication page were to precede the total of my work, it would read: To the glory of Man.

And if anyone should ask me what it is that I have said to the glory of Man, I will answer only by paraphrasing Howard Roark. I will hold up a copy of *Atlas Shrugged* and say: "The explanation rests."

(October-November 1963)

12. The Simplest Thing in the World

A Short Story

(This story was written in 1940. It did not appear in print until the November 1967 issue of THE OBJECTIVIST, where it was published in its original form, as written.

The story illustrates the nature of the creative process—the way in which an artist's sense of life directs the integrating functions of his subconscious and controls his creative imagination.)

HENRY DORN sat at his desk and looked at a sheet of blank paper. Through a feeling of numb panic, he said to himself: this is going to be the easiest thing you've ever done.

Just be stupid, he said to himself. That's all. Just relax and be as stupid as you can be. Easy, isn't it? What are you scared of, you damn fool? You don't think you can be stupid, is that it? You're conceited, he said to himself angrily. That's the whole trouble with you. You're conceited as hell. So you can't be stupid, can you? You're being stupid right now. You've been stupid about this thing all your life. Why can't you be stupid on order?

I'll start in a minute, he said. Just one minute more and then I'll start. I will, this time. I'll just rest for a minute, that's all right, isn't it? I'm very tired. You've done nothing today, he said. You've done nothing for months. What are you tired of? That's why I'm tired—because I've done nothing. I wish I could . . . I'd give anything if I could again . . . Stop that. Stop it quick.

That's the one thing you mustn't think about. You're to start in a minute and you were almost ready. You won't be ready if you think of that.

Don't look at it. Don't look at it. Don't look at ... He had turned. He was looking at a thick book in a ragged blue jacket, lying on a shelf, under old magazines. He could see, on its spine, the white letters merging with the faded blue: *Triumph* by Henry Dorn.

He got up and pushed the magazines down to hide the book. It's better if you don't see it while you're doing it, he said. No. It's better if it doesn't see you doing it. You're a sentimental fool, he said.

It was not a good book. How do you know it was a good book? No, that won't work. All right, it *was* a good book. It's a great book. There's nothing you can do about that. It would be much easier if you could. It would be much easier if you could make yourself believe that it was a lousy book and that it had deserved what had happened to it. Then you could look people straight in the face and write a better one. But you didn't believe it. And you had tried very hard to believe that. But you didn't.

All right, he said. Drop that. You've gone over that, over and over again, for two years. So drop it. Not now ... It wasn't the bad reviews that I minded. It was the good ones. Particularly the one by Fleurette Lumm who said it was the best book she'd ever read—because it had such a touching love story.

He had not even known that there was a love story in his book, and he had not known that what there was of it was touching. And the things that were there, in his book, the things he had spent five years thinking of and writing, writing as carefully, as scrupulously, as delicately as he knew how—these things Fleurette Lumm had not mentioned at all. At first, after he had read the reviews, he had thought that these things were not in his book at all; he had only imagined they were; or else the printer had left them out—only the book seemed very thick, and if the printer had left them out, what filled all those pages? And it wasn't possible that he had not written the book in English, and it wasn't possible that so many bright people couldn't read Eng-

lish, and it wasn't possible that he was insane. So he read his book over again, very carefully, and he was happy when he found a bad sentence in it, or a muddled paragraph, or a thought that did not seem clear; he said, they're right, it isn't there, it isn't clear at all, it was perfectly fair of them to miss it and the world is a human place to live in. But after he had read all of his book, to the end, he knew that it *was* there, that it was clear and beautiful and very important, that he could not have done it any better—and that he'll never understand the answer. That he had better not try to understand it, if he wished to remain alive.

All right, he said. That's about enough now, isn't it? You've been at it longer than a minute. And you said you would start.

The door was open and he looked into the bedroom. Kitty sat there at a table, playing solitaire. Her face looked as if she were very successful at making it look as if everything were all right. She had a lovely mouth. You could always tell things about people by their mouth. Hers looked as if she wanted to smile at the world, and if she didn't it was her own fault, and she really would in a moment, because she was all right and so was the world. In the lamplight her neck looked white and very thin, bent attentively over the cards. It didn't cost any money to play solitaire. He heard the cards thumping down gently, and the steam crackling in the pipe in the corner.

The doorbell rang, and Kitty came in quickly to open the door, not looking at him, her body tight and purposeful under the childish, wide-skirted, print dress, a very lovely dress, only it had been bought two years ago and for summer wear. He could have opened the door, but he knew why she wanted to open it.

He stood, his feet planted wide apart, his stomach drawn, not looking at the door, listening. He heard a voice and then he heard Kitty saying: "No, I'm sorry, but we really don't need an Electrolux." Kitty's voice was almost a song of release; as if she were making an effort not to sound too foolish; as if she loved the Electrolux man and wished she could ask him in to

visit. He knew why Kitty's voice sounded like that. She had thought it was the landlord.

Kitty closed the door, and looked at him, crossing the room, and smiled as if she were apologizing—humbly and happily—for her existence, and said: "I don't want to interrupt you, dear," and went back to her solitaire.

All you have to do, he said to himself, is think of Fleurette Lumm and try to imagine what she likes. Just imagine that and then write it down. That's all there is to it. And you'll have a good commercial story that will sell immediately and make you a lot of money. It's the simplest thing in the world.

You can't be the only one who's right and everybody else wrong, he said. Everybody's told you that that's what you must do. You've asked for a job and nobody would give you one. Nobody would help you find one. Nobody had even seemed interested or serious about it. They said, a brilliant young man like you! Look at Paul Pattison, they said. Eighty thousand a year and not half your brain. But Paul knows what the public likes to read and gives it to them. If you'd just stop being so stubborn, they said. You don't have to be intellectual all the time. Why not be practical for a while, and then, after you've made your first fifty thousand dollars, you can sit back and indulge yourself in some more high literature which will never sell. They said, why waste your time on a job? What can you do? You'll be lucky if you get twenty-five a week. It's foolish, when you've got a great talent for words, you know you have, if you'd only be sensible about it. It ought to be easy for you. If you can write fancy, difficult stuff like that, it ought to be a cinch to toss off a popular serial or two. Any fool can do it. They said, stop dramatizing yourself. Do you enjoy being a martyr? They said, look at your wife. They said, if Paul Pattison can do it, why can't you?

Think of Fleurette Lumm, he said to himself, sitting down at his desk. You imagine that you can't understand her, but you can, if you want to. Don't try to be so complicated. Be simple. She's simple to understand. That's it. Be simple about everything. Just write a

simple story. The simplest, most unimportant story you can imagine. For God's sake, can't you think of anything that's not important, not important at all, not of the slightest possible importance? Can't you? Are you as good as that, you conceited fool? Do you really think you're as good as that? That you can't do anything unless it's great, profound, important? Do you *have* to be a world-saver all the time? Do you *have* to be a damn Joan d'Arc?

Stop kidding yourself, he said. You can. You're no better than anyone else. He chuckled. *That's* the kind of rotter you are. People tell themselves they're no worse than anyone else when they need courage. You tell yourself you're no better. I wish you'd tell me where you got that infernal conceit of yours. That's all it is. Not any great talent, not any brilliant mind—just conceit. You're not a noble martyr to your art. You're an inflated egotist—and you're getting just what you deserve.

Good, are you? What makes you think you're good? What right have you to hate what you're going to do? You haven't written anything for months. You couldn't. You can't write any more. You never will again. And if you can't write what you want to write— what business have you to despise the things people want you to write? That's all you're good for anyway, not for any great epics with immortal messages, and you ought to be damn glad to try and do it, not sit here like a convict in a death cell waiting for his picture to be taken for the front pages.

Now that's better. I think you have the right spirit now. Now you can start.

How does one start those things? . . . Well, let's see . . . It must be a simple, human story. Try to think of something human . . . How does one make one's mind work? How does one invent a story? How can people ever be writers? Come on, you've written before. How did you start then? No, you can't think of that. Not of that. If you do—you'll go completely blank again, or worse. Think that you've never written before. It's a new start. You're turning over a new leaf. There! That

was good. If you can think in lousy bromides like that, you'll do it. You're beginning to get it . . .

Think of something human . . . Oh, come on, think hard . . . Well, try it this way: think of the word "human," think of what it means—you'll get an idea somewhere . . . Human . . . What's the most human thing there is? What's the quality that all the people you know have got, the outstanding quality in all of them? Their motive power? Fear. Not fear of anyone in particular, just fear. Just a great, blind force without object. Malicious fear. The kind that makes them want to see you suffer. Because they know that they, too, will have to suffer and it makes it easier, to know that you do also. The kind that makes them want to see you being small and funny and smutty. Small people are safe. It's not really fear, it's more than that. Like Mr. Crawford, for instance, who's a lawyer and who's glad when a client of his loses a suit. He's glad, even though he loses money on it; even though it hurts his reputation. He's glad, and he doesn't even know that he's glad. God, what a story there is in Mr. Crawford! If you could put him down on paper as he is, and explain just why he is like that, and . . .

Yeah, he said to himself. In three volumes which no one would ever publish, because they'd say it was not true and call me a hater of humanity. Stop it. Stop it fast. That's not at all what they mean when they say a story is human. But it's human. But it's not what they mean. What do they mean? You'll never know. Oh yes, you do. You know it. You know it very well—without knowing. Oh, stop this! . . .

Why must you always know the meaning of everything? There's your first mistake—right there. Do it without thinking. It mustn't have any meaning. It must be written as if you'd never tried to find any meaning in anything, not ever in your life. It must sound as if that's the kind of person you are. Why do people resent people who look for a meaning? What's the real reason that . . .

STOP IT! . . .

All right. Let's try to go at it in a different way entirely. Don't start with an abstraction. Start with

something definite. Anything. Think of something simple, obvious and bad. So bad that you won't care, one way or the other. Say the first thing you can think of.

For instance, a story about a middle-aged millionaire who tries to seduce a poor young working girl. *That's* good. That's very good. Now go on with it. Quick. Don't think. Go on with it.

Well, he's a man of about fifty. He's made a fortune, unscrupulously, because he's ruthless. She's only twenty-two, and very beautiful, and very sweet, and she works in the five-and-ten. Yes, in the five-and-ten. And he owns it. That's what he is—a big tycoon who owns a whole slew of five-and-ten's. This is good.

One day he comes to this particular store, and he sees this girl and he falls in love with her. Why would he fall in love with her? Well, he's lonely. He's very terribly lonely. He hasn't got a friend in the world. People don't like him. People never like a man who's made a success of himself. Also, he's ruthless. You can't make a success of yourself unless you hold onto your one goal and drop everything else. When you have a great devotion to a goal—people call you ruthless. And when you work harder than anyone else, when you work like a freight engine while others take it easy, and so you beat them at it—people call you unscrupulous. That's human also.

You don't work like that just to make money. It's something else. It's a great, driving energy—a creative energy?—no, it's the principle of creation itself. It's what makes everything in the world. Dams and skyscrapers and transatlantic cables. Everything we've got. It comes from men like that. When he started the shipyards—oh, he's a five-and-ten tycoon—no, he isn't, to hell with the five-and-ten!—when he started the shipyards that he made his fortune from, there was nothing there but a few shacks and a lot of clam shells. He made the town, he made the harbor, he gave jobs to hundreds of people, they'd still be digging for clams if he hadn't come along. And now they hate him. And he's not bitter about it. He's accepted that long ago. He just doesn't understand. Now he's fifty years old, and circumstances have forced him to retire. He's got mil-

lions—and he's the most miserable man in the world. Because he wants to work—not to make money, just to work, just to fight and take chances—because that great energy cannot be kept still.

Now when he meets the girl—what girl?—oh, the one in the five-and-ten ... Oh, to hell with her! What do you need her for? He's married long ago—and that's not the story at all. What he meets is a poor, struggling young man. And he envies this boy—because the boy's great struggle is still ahead of him. But this boy—now *that's* the point—this boy doesn't want to struggle at all. He's a nice, able, likeable kid, but he has no real, driving desire for anything. He's been adequate at several different jobs and he's dropped them all. There's no passion to him, no goal. What he wants above all is security. He doesn't care what he does or how or who tells him to do it. He's never created anything. He's given nothing to the world and he never will. But he wants security from the world. And he's liked by everybody. And he has everybody's sympathy. And there they are—the two men. Which one is right? Which one is good? Which one's got the truth? What happens when life brings them face to face?

Oh, what a story! Don't you see? It's not just the two of them. It's more, much more. It's the whole tragedy of the world today. It's our greatest problem. It's the most important ...

Oh, God!

Do you think you can? Do you think you'll get away with it maybe, if you're very clever, if you disguise it, so they'll think it's just a story about an old man, nothing very serious, I don't mind if they miss it, I hope they miss it, let them think they're reading trash, if they'll only let me write it. I don't have to stress it, I don't have to have much of it, of what's good, I can hide it, I can apologize for it with a lot of human stuff about boats and women and swimming pools. They won't know. They'll let me.

No, he said, they won't. Don't fool yourself. They're as good at it as you are. They know their kind of story just like you do yours. They might not even be able to explain it, what it is or where, but they'll know. They

always know what's theirs and what isn't. Besides, it's a controversial issue. The leftists won't like it. It will antagonize a lot of people. What do you want a controversial issue for—in a popular magazine story?

No, go back to the beginning, where he's a five-and-ten tycoon . . . No. I can't. I can't waste it. I've got to use that story. I'll write it. But not now. I'll write it after I've written this one commercial piece. That will be the first thing I'll write after I have money. That's worth waiting for.

Now start all over again. On something else. Come on, it isn't so bad now, is it? You see, it wasn't difficult at all, thinking. It came by itself. Just start on something else.

Get an interesting beginning, something good and startling, even if you don't know what it's all about and where to go from there. Suppose you open with a young girl who lives on a rooftop, in one of those storerooms above a loft-building, and she's sitting there on the roof, all alone, it's a beautiful summer evening, and suddenly there's a shot and a window in the next building cracks open, glass flying all over the place, and a man jumps out of the window onto her roof.

There! You can't possibly go wrong on that. It's so bad that it's sure to be right.

Well . . . Why would a girl live in a loft-building? Because it's cheap. No, the Y.W.C.A. would be cheaper. Or sharing a furnished room with a girlfriend. That's what a girl would do. No, not this girl. She can't get along with people. She doesn't know why. But she can't. So she'd rather be alone. She's been very much alone all her life. She works in a huge, busy, noisy, stupid office. She likes her rooftop because when she's there alone at night, she has the whole city to herself, and she sees it, not as it is, but as it could have been. As it should have been. That's her trouble—always wanting things to be what they should be, and never are. She looks at the city and she thinks of what's going on in the penthouses, little islands of light in the sky, and she thinks of great, mysterious, breath-stopping things, not of cocktail parties, and drunks in bathrooms, and kept women with dogs.

And the building next door—it's a smart hotel, and there's this one large window right over her roof, and the window is of frosted glass, because the view is so ugly. She can't see anything in that window—only the silhouettes of people against the light. Only the shadows. And she sees this one man there—he's tall and slender and he holds his shoulders as if he were giving orders to the whole world. And he moves as if that were a light and easy job for him to do. And she falls in love with him. With his shadow. She's never seen him and she doesn't want to. She doesn't know anything about him and she never tries to learn. She doesn't care. It's not what he is. It's what she thinks of him as being. It's a love without future, without hope or the need of hope, a love great enough to find happiness in nothing but its own greatness, unreal, inexpressible, undemanding—and more real than anything around her. And . . .

Henry Dorn sat at his desk, seeing what men cannot see except when they do not know they are seeing it, seeing his own thoughts in a way of sight brighter than any perception of the things around him, seeing them, not pushing them forward, but seeing them as a detached observer without control of their shape, each thought a corner, and a bright astonishment meeting him behind each corner, not creating anything, but being carried along, not helping and not resisting, through minutes of a feeling like a payment for all the agony he would ever bear, a feeling continuing only while you do not know that you feel it . . .

And then, that evening, she is sitting alone on the roof, and there's a shot, and that window is shattered, and that man leaps out onto her roof. She sees him for the first time—and this is the miracle: for once in her life, he *is* what she had wanted him to be, he looks as she had wanted him to look. But he has just committed a murder. I suppose it will have to be some kind of justifiable murder . . . No! No! No! It's not a justifiable murder at all. We don't even know what it is—and she doesn't know. But here is the dream, the impossible, the ideal—against the laws of the whole world. Her own truth—against all mankind. She has to . . .

Oh, stop it! Stop it! Stop it!

Well . . . ?

Pull yourself together, man. Pull yourself together . . .

Well? For whom is it you're writing that story? For the *Women's Kitchen Friend?*

No, you're not tired. You're all right. It's all right. You'll write this story later. You'll write it after you have money. It's all right. It won't be taken away from you. Now sit quiet. Count ten.

No! I tell you, you *can*. You can. You haven't tried hard enough. You let it get away with you. You begin to think. Can't you think without thinking?

Listen, can't you understand a different way of doing it? Don't think of the fantastic, don't think of the unusual, don't think of the opposite of what anyone else'd want to think, but go after the obvious, the easy. Easy—for whom? Come on now. It's this: it's because you ask yourself "what if . . . ?" That starts the whole trouble. "What if it's not what it seems to be at all . . . Wouldn't it be interesting if . . ." That's what you do, and you mustn't. You mustn't think of what would be interesting. But how can I do anything if I know it isn't interesting? But it will be—to them. That's just why it will be to them—because it isn't to you. That's the whole secret. But then how do I know what, or where, or why?

Listen, can't you stop it for a little while? Can't you turn it off—that brain of yours? Can't you make it work without letting it work? Can't you be stupid? Can't you be consciously, deliberately, cold-bloodedly stupid? Can't that be done in some way? Everybody is stupid about some things, the best of us and the brightest. Everybody has blind spots, they say. Can't you make it be this?

Dear God, let me be stupid! Let me be dishonest! Let me be contemptible! Just once. Because I must.

Don't you see? It's a matter of one reversal. Just make one single reversal: instead of believing that one must try to be intelligent, different, honest, challenging, that one must do the best possible to the best of one's ability and then stretch it some more to do still better—

believe that one must be dull, stale, sweet, dishonest and safe. That's all. Is that the way other people do it? No, I don't think so. They'd end up in an insane asylum in six months. Then what is it? I don't know. It isn't that—but it works out like that. Maybe if we were told from the beginning to reverse it . . . But we aren't. But some of us get wise to it early—and then they're all right. But why should it be like that? Why should we . . .

Drop it. You're not settling world problems. You're writing a commercial story.

All right. Quick and cold now. Hold yourself tight and don't let yourself like the story. Above all, don't let yourself like it.

Let's make it a detective story. A murder mystery. You can't possibly have a murder mystery with any serious meaning. Come on. Quick, cold and simple.

There must be two villains in a mystery story: the victim and the murderer—so nobody would feel too sorry for either of them. That's the way it's always done. Well, you can have some leeway on the victim, but the murderer's *got* to be a villain . . . Now the murderer must have a motive. It must be a contemptible motive . . . Let's see . . . I've got it: the murderer is a professional blackmailer who's holding a lot of people in his clutches, and the victim is the man who's about to expose him, so the blackmailer kills this man. That's as low a motive as you could imagine. There's no excuse for that . . . Or is there? What if . . . Wouldn't it be interesting if you could prove that the murderer was justified?

What if all those people he blackmails are utter lice? The kind that do horrible things, but just manage to remain within the law, so there's no way of defending yourself against them. And this man chooses deliberately to become a crusading blackmailer. He gets things on all those people and he forces them to do justice. A lot of men make careers for themselves by knowing where some body or other is buried. Well, this man goes out after such "bodies," only he doesn't use them for personal advancement, he uses them to undo the harm these people are doing. He's a Robin Hood of black-

mail. He gets them in the only way they can be gotten. For instance, one of them is a corrupt politician, and the hero—no, the murderer—no, the *hero* gets the dope on him and forces him to vote right on a certain measure. Another one is a big Hollywood producer who's ruined a lot of lives—and the hero makes him give a talented actress a break without forcing her to become his mistress. Another one is a crooked businessman—and the hero forces him to play straight. And when the worst one of the lot—what's the worst one of the lot? a hypocritical reformer, I think—no, that's dangerous to touch, too controversial—oh, what the hell!—when this reformer traps the hero and is about to expose him, the hero kills him. Why shouldn't he? And the interesting thing about the story is that all those people will be presented just as they appear in real life. Nice people, pillars of society, liked, admired and respected. And the hero is just a hard, lonely kind of outcast.

Oh, what a story! Prove that! Prove what some of our popular people are really like! Blow the lid off society! Show it for what it's worth! Prove that the lone wolf is not always a wolf! Prove honesty and courage and strength and dedication! Prove it through a blackmailer and a murderer! Have a story with a murderer for a hero and let him get away with it! A great story! An important story which . . .

Henry Dorn sat very still, his hands folded in his lap, hunched, seeing nothing, thinking of nothing.

Then he pushed the sheet of blank paper aside and reached for the *Times'* "Help Wanted" ads.

Index

Abstractions: and man's cognitive faculty, 17; converting of, by language, into psycho-epistemological equivalents of concretes, 18, 20; normative and cognitive, 18, 36, 145; metaphysical, converting of, by art, into equivalent of concretes, 20, 23, 73; emotional, 27-28; criteria of, 36; esthetic, 36; development of child's cognitive and normative abstractions, 145, 147

Altruism: and man's culturally induced selflessness, 16; as archenemy and destroyer of Romanticism, 113-14

American Tragedy, An (Dreiser), as a bad novel, 85

Anna Christie (O'Neill), as imitation of *Camille* (Dumas *fils*), 118

Anna Karenina (Tolstoy), as an evil book, 116

Anti-art, classification and examples of, 69-70, 76-78

Aquinas, Thomas, as bridge between Aristotle and Renaissance, vii

Architecture: special attributes of as art; 46; dependence of sculpture upon, 50

Aristotle: his principle of esthetics of literature, 80, 168;

19th century guided by Aristotelian sense of life, 103; Romanticism of 19th century, and Aristotelian influence on, 103

Art: as an end in itself, 16-17; as selective re-creation of reality according to artist's metaphysical value-judgments, 19-20, 33, 45, 74-75, 77-78, 83, 96, 99; as concretization of metaphysics, 20, 45, 76, 83-84, 124-25; psycho-epistemological function of, 20; as a universal language, 20; beginning of, as adjunct of religion, 20; psycho-epistemology of, as illustrated by characterization in literature, 21, 22; as indispensable medium for communication of a moral ideal, 21; primary focus of, as metaphysical, not ethical, 22; not the means of literal transcription, 22-23; place of ethics in, dependent on metaphysical views of artist, 23; of Ancient Greece compared to art of Middle Ages, in impact on man, 23-24; as voice of the philosophy dominant in a culture, 24; role of emotions in, 24, 35; profoundly personal significance

of, for men, 24; as special province and expression of sense of life, 32, 33; as human product most personally important to man and least understood, 33; metaphysical significance of everything included in, 36, 37; and man's confirmation of his view of existence, 38; and the rational man, 38-39; and the irrational man, 39; as man's metaphysical mirror, 39; bad, as production of imitation, second-hand copying, lack of creative expression, 39-40; philosophical meaning as necessary element of work of, 40; subject of an art work, 40; style of an art work, 40-41; and mixtures of contradictory elements of reason and unreason, 39; theme of an art work, 40; objective evaluation of work of, 42; and personal choices in enjoyment of, 43; translating meaning of art work into objective terms, 44; conceptual nature of, 47; valid forms of, 73; as a unifier of man's consciousness, 73; how new subcategories arise, 73; limits on freedom of stylization in, 75; integration as the essence of, 76; as man's psycho-epistemological conditioner, 77; universality as important attribute of, 84; as concretization of values, 86; and philosophy, relationship between, 97; non-existence of, today, as vital cultural movement, 119-20; and attitudes of collectivist estheticians and intellectuals toward popular values in, 127; as barometer of a culture, 128, 129-30; the end and the means in, as worthy of each other, 166; as the technology of the soul, 169; as product of philosoph-

ical disciplines—metaphysics, epistemology, ethics, 169; see also Modern art
Astaire, Fred, 68
Atlas Shrugged (Ayn Rand): theme of, 81-82; plot-theme of, 82; quoted on conventional view of morality, 146; quoted on man as a being of self-made soul, 168-9
Avengers, The, successful British TV series, 135

Ballet: as a system of dance, 67-68; essentials of its image of man, 68; "modernization" of, 69-70
Balzac, Honoré de, as Naturalist writer, 116
Benefield, Barry, as popular-fiction writer, 111
Brothers Karamazov, The (Dostoevsky), characterization in, 114
Brown, Fredric, science fiction writing of, 121
Byron, Lord, and "Byronic" view of existence, 109

Camille (Dumas fils), and imitations of, 118
Capitalism: destruction of, in politics, 102; 19th-century Romanticists as enemies of, 105
Cat and Mouse (Günter Grass), Time quoted on, 131
Characterization in novel: as essential attribute, 80, 87-94; definition of, 87; extreme degree of selectivity required in, 87; achieved by action and dialogue, 87-88; error of asserting nature of characters in narrative passages without supporting action, 87-88; and portrayal of essential traits of personality, 88; and revelation of motivation, 88; consistency as a major requirement of, 89;

maintaining inner logic of, 89; and faculty of volition, 100-1; and Romantic novelists, 107-8, 114-15; and popular fiction, 111; and the Naturalists, 117-18

Chayefsky, Paddy, and modern Naturalist work *Marty*, 140

Child's development: of moral sense of life, 144-48; contribution of Romantic art to, 144-45, 146-47, 151-52; of cognitive and normative abstractions, 145, 147; and imposition of set of rules by conventional morality, 145-6; learning concept of moral values, 146-7; and sins of adults in regard to child's understanding of morality, 147-51; dichotomy in consciousness of the practical versus the moral, 148-49

Choreographer: nature and demands of his role, 70

Chronicle: characteristics of, 82, 123-24; return of modern literature to art form of, 127-28

Classicism: Romanticism as rebellion against, 103-4; rules of, as improper criteria of esthetic value, 104; school of, improperly regarded as representative of reason, 104

Cognitive faculty: as determining the proper forms of art, 70, 77-70

Collectivism: resurgence of, and effect of, on Romanticism, 124; advocacy of, by today's estheticians and intellectuals, 127; altruistic, today's culture as dominated by, 160

Color harmony: a legitimate element in painting, 75

"Color symphonies": as anti-art, 76

Concepts, nature and function of, 17-18

Conceptual consciousness: disintegration of, as the goal of modern art, 76-77

Connery, Sean, performance of, in *Dr. No*, 136

Consciousness: of man, art as serving a need of, 17; art as confirming or denying efficacy of, 24; integrating mechanism of, and sense of life, 25, 26, 27; as soul, 28-29, 169; and faculty of volition, 100; concern of top-rank Romantic writers with, 107

Creative process, a short story by Ayn Rand as illustrative of nature of, 173-85

Crime and Punishment (Dostoevsky), motivation revealed in, 88

Cubism, 41

Culture: art as mirror of a culture's philosophy, 97-98; art as barometer of, 128, 129-30; state of, and today's art, 130, 172

Dali, Salvador, style of, 41

Dance: as a performing art, 66; as system of motion expressing a metaphysical view of man, 66-69; its relation to music, 68-70

Decorative arts: their nature and proper task, 74-75

Definitions: as guardians of rationality, 77

Determinism: philosophical and esthetic contradictions in, 23, 116; philosophy dominated by doctrine of, 101-2; as basic premise of writers' presentation of man prior to 19th century, 123

Diatonic scale: development of, 63

Dr. No (Fleming), 136

Don Carlos (Schiller), vi

Dostoevsky, Feodor: choice of subject by, 40; reasons for liking work of, 43; as master

of integration of theme and plot structure, 86-87; and use of motivation in *Crime and Punishment,* 88; as top-rank Romantic novelist, 107; characterizations in novels of, 114

Dramatic arts: subcategories of, 71; importance of the play, 71; director as integrator, 71-72

Dreiser, Theodore, and a bad novel, 85

Dumas, Alexander, as Romantic novelist, 107-8

Emotional abstractions, 27-28; and individual's view of himself, 27; "important to me" as criterion of selection in, 27-28

Epistemology: of physical sciences and of humanities, 15-16; man's need of, 30; as abstract base of ethics, 169; *see also* Psycho-epistemology

Esthetics: Objectivist, 20; criteria of judgment in, 42-43; as branch of philosophy, 42; principles of, 42-43; of literature, Aristotelian principle of, 80; destruction of Romanticism in, 102; field of, and mysticism, 102; Romanticism in, as unrelated to theories of "Romantic" philosophers, 106; state of, today, and prospects for philosophical Renaissance, 122; vacuum in, of our age, 123-28

Ethics: as normative science, 18; link between metaphysics and, 18-19, 28, 169; and artist's conceptual theory of, 22; place of, in work of art dependent on metaphysical views of artist, 23; metaphysical value-judgments as base of, 28; man's need of, 30; destruction of individualism in, 102; need of Western culture for a new code of,

122; epistemology, as abstract base of, 169; relation of, to art, 169; teaching as task of, 169-70

Existentialists: philosophical view of existence of, 109; sense of life achieved by, 128

Ferber, Edna, as popular-fiction writer, 111

Fiction: and identification of reader with characters in, 37; difference between real-life news story and, 37-38; four essential attributes of, 80; and history, difference between representations of, 80, 168; integration of theme and plot as cardinal principle of, 85; motivation as a key-concept in, 88-89; *see also* Novel; Popular fiction

Film directors: Fritz Lang's work, 72

Flaubert, Gustave, style of, 41

Fleming, Ian: as top-rank writer of popular fiction, 110; thrillers of, 134, 136-37, 138

Fountainhead, The (Ayn Rand): character of Howard Roark in, 22; Gail Wynand's conflict of values in, 84; two scenes from, as illustration of process of characterization, 89-94; example from, of Classicism surviving into 20th century, 104; quotation from, 168; quoted on meaning of art in man's life, 171; "The explanation rests," paraphrase of quotation from, 172

From Russia with Love (Fleming), 136

Goldfinger (Fleming), 136

Gone With the Wind (Mitchell): theme of, 81, 86; plot-theme of, 86

Goya, Francisco de, choice of subject by, 40

Grand Guignol of old French theater, 131

Grass, Günter, *Time* quoted on *Cat and Mouse* of, 131

Hamilton, Donald, as top-rank writer of popular fiction, 110

Hawthorne, Nathaniel, as writer of top-rank Romantic novel, 107

Helmholtz, Herman Ludwig Ferdinand von: on mathematical nature of musical perception, 56-57; on major and minor keys, 60

Henry, O., as great Romantic writer, 110, 128

Hindu dance: its image of man, 67-68

Hippies: as products of "Progressive" education, 64; their reversion to the music of the jungle, 64

Hitchcock, Alfred, 121

Horror Story, in "serious" and popular fiction, 112-13

Hugo, Victor: choice of subject by, 40; style of, as blend of reason and passionate emotion, 41; reasons for liking work of, 43; as master of integration of theme and plot structure, 86; historical essays interrupting stories of, 86; universe of, contrasted with Schopenhauer's, 106; as top-rank Romantic novelist, 107, 154; characterizations in novels of, 114, 160-61; introduction by Ayn Rand to his *Ninety-Three*, 153-61; rediscovering novels of, 153, 155; as greatest novelist in world literature, 154; intellectual first-aid kit for reading and appreciation, of, 154-55; and conflict in his sense of life, 158-61; the thinker, as archetypical of the virtues and fatal errors of 19th

century, 159; novels of, as experience for the reader, 170-71

Humor, in "tongue-in-cheek" thrillers, 133, 137-138

Hurst, Fannie, as popular-fiction writer, 111

Identity, Law of: man's need of definitions as resting on, 78

Impressionists, their work contrasted with Vermeer's, 48-49

Industrial Revolution, 103

Integration: as psycho-epistemological key to reason, 77

Irrationalism: philosophy dominated by doctrine of, 101-2; sense of life achieved by apostles of, 128

It Can't Happen Here (Lewis), as novel of Naturalistic school with Romantic approach, 109

Josephson, Matthew, as biographer of Victor Hugo, 156

Karloff, Boris, movies of, as archetype of the Horror Story, 113

Lady of the Camellias, The (Dumas *fils*), and imitations of, 118

Lang, Fritz: as director, 71-72; his film *Siegfried* as best of Romantic movies, 72, 111

Language: as means of retaining concepts, 17-18; function of, in converting abstractions into concretes, 18, 20

Les Misérables (Hugo): theme of, 81, 85-86; plot-theme of, 86; characterizations in, 114

Levin, Ira, the supernatural in writing of, 121

Lewis, Sinclair: and his characterization of Babbitt, 21; choice of subject by, 40;

style of, 40-41; as writer of
Naturalistic school, 109, 119

Libretto, its function in operas
and operettas, 71

Liszt, Franz, his musical
composition *St. Francis
Walking on the Waters,* 52

Literary style: fundamental
elements of, 94; and choice of
words, 94; and choice of con-
tent, 94; comparison of, in
excerpts from two novels, 94-
96; as most complex aspect of
literature, and as most
revealing psychologically, 96;
not an end in itself, 96; *see
also* Style of novel

Literature: by what means it re-
creates reality, 46-47; its
integration of concepts to
percepts, 47; as ruler and
term-setter in movies and
television, 71; Aristotelian
principle of esthetics of, 80;
novel as major literary form,
80; and mind-body dichotomy
that plagues it, 87; and basic
premises of Romanticism and
Naturalism regarding exis-
tence of man's volition, 99-
102; and rules of Classicism,
104; "serious" and popular,
and the Horror Story, 112-13;
eclectic shambles of today's,
119; nonexistence of today, as
vital cultural movement, 119-
20; and presentation of man,
prior to 19th century, 123;
modern, essential nature of
man as represented in, 125;
modern, return of, to art form
of the chronicle, 127-28; as
barometer of a culture, 129-
30; selectivity of subject in, as
cardinal aspect of, 166; the
ends and the means in, as
worthy of each other, 166; *see
also* Fiction; Novel; Popular
fiction; Thrillers

Logic: how its destruction made
modern art possible, 77

Magic Mountain, The (Mann),
as bad novel, 85

Maibaum, Richard, quoted on
screenplays of Fleming's
novels, 136-37, 138

Man: as a being of self-made
soul, 28-29, 144, 169; and his
need of philosophy, 30; art
as his psycho-epistemological
conditioner, 77; as an end in
himself, 164

Man Who Laughs, The (Hugo),
characterization in, 114

Manifesto, dictionary definition
of, v

Mann, Thomas, and a bad
novel, 85

Marguerite and Armand
(ballet), 70

Marty (Chayefsky), as work of
modern Naturalism, 140

Maurois, André, as biographer
of Victor Hugo, 156

Metaphysics: link between ethics
and, 18-19, 28, 169; as science
dealing with fundamental
nature of reality, 19; and
value-judgments, 19; art as
concretization of, 20, 76, 84,
124-25; man's need of, 30; of
artist, and subject of his art
work, 40, 78; of Naturalism,
41, 126; music and dance as
expressive of metaphysical
view, 61, 67

Metaphysics in Marble (Sures),
magazine article, 49

Michelangelo, choice of subject
by, 40; his *Pietà,* 50

Mind, man's: current assaults
on, 76-77

Mitchell, Margaret, and plot
structure in *Gone With the
Wind,* 86

Modern art: disintegration of
man's consciousness as goal
of, 76-79; its practitioners
and admirers, 77; as
demonstration of cultural
bankruptcy of our age, 128;
and composite picture of man,

130; and presentation of emotions dominating modern man's sense of life, 130-31; and moral implications of trend toward lower levels of depravity in, 130-31

Modern dance, characterized as neither modern nor dance, 69-70

Modern philosophy, as source and sponsor of modern art, 76-77

Moral sense of life: development of, in child, 145-48; contribution of Romantic art to developing of, 145, 146-47, 151-52; and morality, differentiation between, 145; sins of adults toward child in developing of, 147-51

Moral treason, and art, 142-52

Morality: and moral sense of life, differentiation between, 145; and imposition of set of rules on the developing child, 145-46; as a normative science, 147-48; mystical, social, subjective schools of, 150

Motion pictures: role of literature and visual arts in, 71-72; work of Fritz Lang as director, 71-72; reason for failure to develop as great art, 72

Motivation, as a key-concept in psychology and in fiction, 88-89

Movies, and Romanticism, 111-12

Music: distinguished from other arts, 46, 50; pattern from musical perception to emotional response, 50-53; psycho-epistemological nature of man's response to, 51, 53, 57-64; role of sense of life in the response to, 51-53, 58-61; hypothesis as to how and why it evokes emotions, 54-64; mathematical nature of musical perception, 57-58, 61-62; metaphysical factors in enjoyment of, 61; effects on mind of primitive and Oriental types, 62-63; so-called "modern," why it is not music, 64; as related to the various performing arts, 69-71

Mysticism: primitive epistemology of, 15-16; and esthetics, 102; of Plato, 103; resurgence of, in later part of 19th century, and effect of on Romanticism, 124

Myths of religion, 25

Naturalism: and anti-value orientation in work of art, 23; type of argument in evaluating work of art, 37; and objection to plot of novel as artificial contrivance, 83-84, 117; and denial of existence of man's faculty of volition, 99, 101, 116, 124; and assumption of mantle of reason and reality, 105, 106; disintegration of, 115; Shakespeare as spiritual father of, 115-16; journalistic approach of Naturalist writers, 116, 124; and substitution of statistics for standard of value, 117, 124; and element of characterization, 117; final remnants of, with nothing to say about human existence, 117; Romanticism outlasted by, 117; value in a Naturalist's work and in a Romanticist's, 118; and imitator's, 118-19; and end of, with WW II, 119; as man's new enemy in art in later part of 19th century, 124; as dedicated to negation of art, 124; and substitution of the collective for the objective,

125; basic metaphysical
premise of, 125; doctrines of
literary school of, 164-65; and
"compassionate" studies of
depravity, 167

Ninety-Three (Hugo):
Introduction to, by Ayn Rand,
v, ix, 153-61; as uniquely
"Hugo-esque," 155; appraisal
by two of Hugo's biographers
of, 156; man's loyalty to
values as theme of, 156;
characterization in, 157, 160;
and integration of theme
and plot, 157-58; grandeur
as leitmotif of, 158

Notre-Dame de Paris (Hugo),
characterization in, 114

Novel: essential attributes of,
80, 93-94; theme of, 80, 81,
82, 93; plot of, 80, 82-87, 93-
94; characterization of, 80,
87-92, 93-94; style of, 80, 94;
as major literary form, 81;
shortcomings resulting in a
bad novel, 81, 85; as re-
creation of reality, 81-82;
plot-theme of, 85-86, 93-94;
and integration of major
attributes of, 93, 97;
top-rank Romantic
novelists, 107; second-rank
Romantic novelists, 107-8;
relation of thrillers to novels
of serious Romantic litera-
ture, 132; Victor Hugo as
greatest novelist in world
literature, 154; and start and
culmination of illustrious line
of Romantic novelists in 19th
century, 154; and the
Naturalist, 164-65; *see also*
Fiction; Popular fiction;
Thrillers

Objectivism: *passim*
Objectivist, The, magazine, ix,
173
O'Hara, John: style of, 41; as
best of Naturalism's
contemporary survivors, 119

*Olympio ou la Vie de Victor
Hugo* (Maurois), appraisal of
Ninety-Three in, 156
One Lonely Night (Spillane),
style of, 94-96
O'Neill, Eugene, as imitator of
Dumas *fils,* in *Anna Christie,*
118
*On the Sensations of Tone as a
Physiological Basis for the
Theory of Music*
(Helmholtz), 56, 60
Opera, function of music and
libretto in, 71
Oriental music, 54, 62

Painting: distinguished from
other arts, 46; role of sensory
and conceptual factors in,
47-49; color harmony in, 75
Pantomime: dance distinguished
from, 67; classified as non-art,
70
Performing artist: his task, 64-
65; basic principles applicable
to, 65-66
Performing arts: relation to
primary arts, 64-65, 73;
psycho-epistemological role
of, 65; application of basic
artistic principles to, 65-66;
inversion of ends and means,
in, 65-66
Philosophy: as determinant of
trends of world, vii; of life,
and full conceptual control,
29; and setting of criteria of
emotional integrations, 29-30;
man's need of, 30-31, 119; of
man, as chosen by his mind or
by chance, 30; love as
expression of, 33; of artist,
truth or falsehood of, 39; and
art, relationship between, 77,
97; its practical importance,
77; the consequences of
default in, 77; Aristotle's
esthetics of literature, 80, 168;
modern, as swamp breeding
ground of aborted art, 98;

dominated by doctrines of irrationalism and determinism, 102; since Renaissance, retrogression of, to mysticism of Plato, 103; Romantic movement in, as unrelated to Romanticism in esthetics, 106; new schools of, as progressively dedicated to negation of, 124; anti-rational, and emotions dominating modern man's sense of life, 130

Photography: as not an art, 74

Pietà (Michelangelo), 50

Plot of novel: as essential attribute, 80, 82-87, 93-94; definition of, 80, 100; as dramatization of goal-directed action, 82, 86; Naturalists' objection to, as artificial contrivance, 83-84, 117; and presentation of conflict of values, 84; serving same function as steel skeleton of skyscraper, 84; and events, as expressing meaning of novel, 85; as not represented by physical action divorced from ideas and values, 86-87; and premise of man's possession of faculty of volition, 100, 102; plotlessness, and premise of man's lack of volition, 100-1; and antagonism of today's esthetic spokesmen toward Romantic premise in, 102; and top-rank Romantic novelists, 107-8; and second rank of Romantic novelists, 107-8; and popular fiction, 111; and imitators of Romanticists, 118

Plot-theme of novel, 85-87, 93-104; as core of its events, 85; and top-rank Romantic novelists, 107-8

Poe, Edgar Allan, as modern ancestor of the Horror Story, 113

Poem, basic attributes of, 81

Popular fiction: common-sense ideas and values as base of, 110; and absence of explicitly ideational element, 110; categories of, 110; contemporary examples of best writers of, 110; characteristics of writing below top level of, 110-11; "slick-magazine" type of, 111; and the Horror Story, 112-13

Possessed, The (Dostoevsky), characterization in, 114

Primitive music, 62-63

"Progressive" education, hippies as products of, 64

Psycho-epistemology: definition of, 18; in art as illustrated by characterization in literature, 20, 21-22; and concretization of cognitive abstractions, 20; and concretization of normative abstractions, 20, 21-22; and metaphysical views of artist, 23; and process of communication between artist and viewer or reader, 35: of artist, and style of his art work, 40; role of in man's musical responses, 51, 53, 57-64; art as the conditioner of, 77; consonant with reality and man's nature, 128

Quo Vadis (Sienkiewicz): as top-rank Romantic novel, 107; characterizations in, 115

Rand, Ayn: hypothesis on nature of man's response to music, 57-64; favorite form of dance, 69; goal of writing of, v, 162-72; projection of an ideal man as motive and purpose, 162, 163-64; portrayal of a moral ideal as end in itself, 162; what is *not* the purpose of, 162; and irrelevancy of questions about primacy of the novelist or

the philosopher in her writing, 162-63; and basic test for any story, 163; defining and presenting conditions making possible an ideal man, 163-64; presentation of Man as an end in himself, 164; Naturalism, as literary school diametrically opposed to, 164-65; selectivity in regard to subject, 166-67; as Romantic Realist, 167; manifesto of, as stated by Howard Roark in *The Fountainhead,* quoted, 168; and esthetic principle of Aristotle, 168; and present state of our culture, 172

Reality: man's acquiring and retaining his knowledge of, 18, 23; man's applying his knowledge of, 18; art as selective re-creation of, according to artist's metaphysical value-judgments, 19-20, 33, 83, 84, 97, 99; metaphysics as science dealing with fundamental nature of, 19; and an art work's support or negation of one's fundamental view of, 24; religion as attempt to offer comprehensive view of, 25; and artist's metaphysical evaluation of facts, 36; stylizing of, by artist, 36; novel as re-creation of, 81-82; Romanticism's break with, 105-6; psycho-epistemology consonant with facts of, 128

Reason: its relation to man's survival, 77; modern philosophers' war against, 77

Religion: beginning of art as adjunct to, 20; mythology of, as concretization of its moral code, 21-22; as primitive form of philosophy, 25; myths of, 25; and Romanticists, 105

Robinson, Bill, 68

Rolland, Romain, as romanticizing Naturalist writer, 119

Romanticism: and value orientation in work of art, 23; and recognition of man's faculty of volition, 99, 100, 101, 106, 123; practically non-existent in today's literature, 101; antagonism of today's esthetic spokesmen toward Romantic premise in art, 102; destruction of, in esthetics, 102; of 19th century, and influences of Aristotelianism and capitalism, 103; as rebellion against Classicism, 103-4; primacy of values brought to art by, 104; and irony of definition declaring it as based on primacy of emotions, 104-5; and break with reality, 105-6; philosophers as contributors to confusion surrounding term, 106; definition of, as volition-oriented school, 107; and top-rank Romantic novelists and playwrights, 106-7; and second rank of Romantic writers, 108; and writers with mixed premise of volition, 108-9; philosophically as crusade to glorify man's existence, 109-10; psychologically experienced as desire to make life interesting, 110; virtues and potential flaws of, as seen in popular literature, 110; and movies and television, 111-12; and attempt to eliminate from Romantic fiction, 112; altruist morality as archenemy and destroyer of, 113; final remnants of, 115; outlasted by Naturalism, 117; value in a Romanticist's work and in a Naturalist's, 117-18; and end of great era of, with WW I, 119; remnants of, in popular media, 120-21; and escape into the super-

natural, 120-21; and coming of age, with rebirth of reason and philosophy, 122; as great new movement in art in 19th century, 123; treated as bootleg merchandise, 129-41; and development of moral sense of life, 145, 146, 147, 150-51, 152

Rosemary's Baby (Levin), use of the supernatural in, 121

Rostand, Edmond, as top-rank Romantic playwright, 107

Royal Ballet, performance of *Marguerite and Armand*, 70

Ruy Blas (Hugo), vi

Satire, legitimate, contrasted with "tongue-in-cheek" thrillers, 138

Scarlet Letter, The (Hawthorne), as top-rank Romantic novel, 107

Schelling, Friedrich, 106

Schiller, Friedrich, as top-rank Romantic playwright, 107

Schopenhauer, Arthur, 106

Scott, Walter, as Romantic novelist, 108

Sculpture: of Ancient Greece and of Middle Ages, difference in presentation of man in, 36-37; nature of, and relation to other arts, 46, 49-50

Selectivity, as a basic principle of the arts, 65, 166

Sense of life: definition of, 24, 25-26, 34, 145; and integrating mechanism of the subconscious, 25, 26, 27; and rational philosophy, 26; dominated by fear, 26, 130-31, 150; formed by process of emotional generalization, 27; and early value-integrations, 29; as integrated sum of a man's basic values, 29; and adolescence, 29; matching conscious convic-

tions, in fully integrated personality, 29; transition from guidance by, to guidance by conscious philosophy, 29-30; and conflict between conscious convictions, 30; changing and correcting of, 31; profoundly personal quality of, 31; relation of, to personality, 31; as sense of one's own identity, 31; as integration of mind and values, 31-32; love and art, as special province and expression of, 32-33; of artist, and control and integration of his work, 34-35; of viewer or reader, and response to work of art, 35; projecting of, in subject and style of work of art, 40; and intellectual approach, difference between, in response to work of art, 43; and evaluation of work of specific writers, 43; role of in music, 51-53, 58-61; role of in dance, 67; Aristotelian, 19th century guided by, 103; of Romanticists, and cultural atmosphere of 19th century, 103-4; of modern man, emotions dominating, 130; *see also* Moral sense of life

Serling, Rod, as Naturalist writer, and as Romanticist, 121

Shakespeare, William: choice of subject by, 40; as spiritual father of Naturalism, 115-16

Siegfried (Fritz Lang), as best of Romantic movies, 72, 111

Sienkiewicz, Henryk: as writer of top-rank Romantic novel, 107; and characterizations in *Quo Vadis*, 115

"Slick-magazine" type of Romanticists, 112, 119

Soul: man as a being of self-made soul, 28-29, 144-45, 169; art as the technology of, 169

Spillane, Mickey: reasons for liking work of, 43; style of, in *One Lonely Night,* 94-96; as top-rank writer of popular fiction, 110; thrillers of, 134

St. Francis Walking on the Waters (Liszt), a musical composition, 52

Stage director: nature and demands of his role, 70-72

Style of art work: as expression of view of man's consciousness, 40; as product of artist's psycho-epistemology, 40; response of man to, 41; as most complex element of art, 41; and so-called "painterly" school, 41; Cubism, 41; importance of, to artist and to reader or viewer, 42; and psycho-epistemological sense of life, 42

Style of novel: as a major attribute, 80, 94-96; as means by which other attributes are presented, 94; comparison of, in excerpts from two novels, 94-96; *see also* Literary style

Stylization, *see* Selectivity

Subject of art work: as expression of view of man's existence, 40; artist's choice of, 40; and projection of view of man's place in universe, 40; selectivity in, as cardinal aspect of art, 165-66

Sullivan, Louis H., principle of architecture of, 81

Symbolism of primitive terror in presentation of man, 126

Tap dancing, 68-69

Television: physical action in dramas of, 86-87; and Romanticism, 111-12; *The Twilight Zone,* series on, 120; *The Avengers,* British series on, 135

Theater: legitimate vs. illegitimate innovations in, 73-74

Theme of art work, as link uniting subject and style, 40

Theme of novel: as essential attribute, 80, 81-82, 93, 94; purpose of novel defined by, 81; presented in terms of action, 82; as core of its abstract meaning, 85; and top-rank Romantic novelists, 107; and second rank of Romantic novelists, 108; and popular fiction, 111; in modern literature, 126

Thrillers: "tongue-in-cheek," 132, 133, 136, 138; as detective, spy, or adventure stories, 132; conflict as basic characteristic of, 132; as simplified version of Romantic literature, 132; relation of, to novels of serious Romantic literature, 132; humor in "tongue-in-cheek" thrillers, 133, 136-38; social status of, and gulf between the people and their alleged intellectual leaders, 134; modern intellectuals' rush to the bandwagon of, 136; as dramatization of abstraction of moral conflict, 138; as spectacle of man's efficacy, 138-39; and ultimate triumph of the good, 139

Tolstoy, Leo: choice of subject by, 40; evaluating work of, 43; as Naturalist writer, 116, 117, 118

Twilight Zone, The, series on TV, as symbolic projection of remnants of Romanticism, 120

Value-judgments, metaphysical: as foundation of moral values, 19; of artist, and selective re-creation of reality, 19-20, 33, 65, 78, 83, 84, 97, 99; as base of ethics, 28; derived from an explicit metaphysics, 30

Values: conflicts of, 84; art as concretization of, 86-87; primacy of, brought to art by Romanticists, 104-5; common-sense values distinguished from conventional, 110; moral, child's learning concept of, 146-47

Venus de Milo, 50

Vermeer, Jan: choice of subject by, 40; style of, 41, 48-49

Verne, Jules, as writer of science fiction, 109

Victor Hugo (Josephson), appraisal of *Ninety-Three* in, 156

"Violence Can Be Fun," article in *TV Guide* on *The Avengers,* quoted, 135

Volition: man's possession of, as premise of Romanticism, 99, 100, 101, 106, 123; man as not possessed of, as premise of Naturalism, 99, 100, 101, 116, 123; and importance of establishing as function of man's rational faculty, 106; confusion on, between esthetic Romanticists and "Romantic" philosophers, 106; full commitment to premise of, by Romantic writers, 107, 108; commitment to premise of, by writers in regard to existence but not to consciousness, 108-9; commitment to premise of, by writers in regard to consciousness but not to existence, 109

War and Peace (Tolstoy), 118

Web and the Rock, The (Wolfe), style of, 94-96

Wells, H. G., as writer of science fiction, 109

Wolfe, Thomas: style of, 41; in *The Web and the Rock,* 94-96

Zen Buddhists, sense of life achieved by, 128

Zola, Émile: choice of subject by, 40; as Naturalist writer, 116, 154